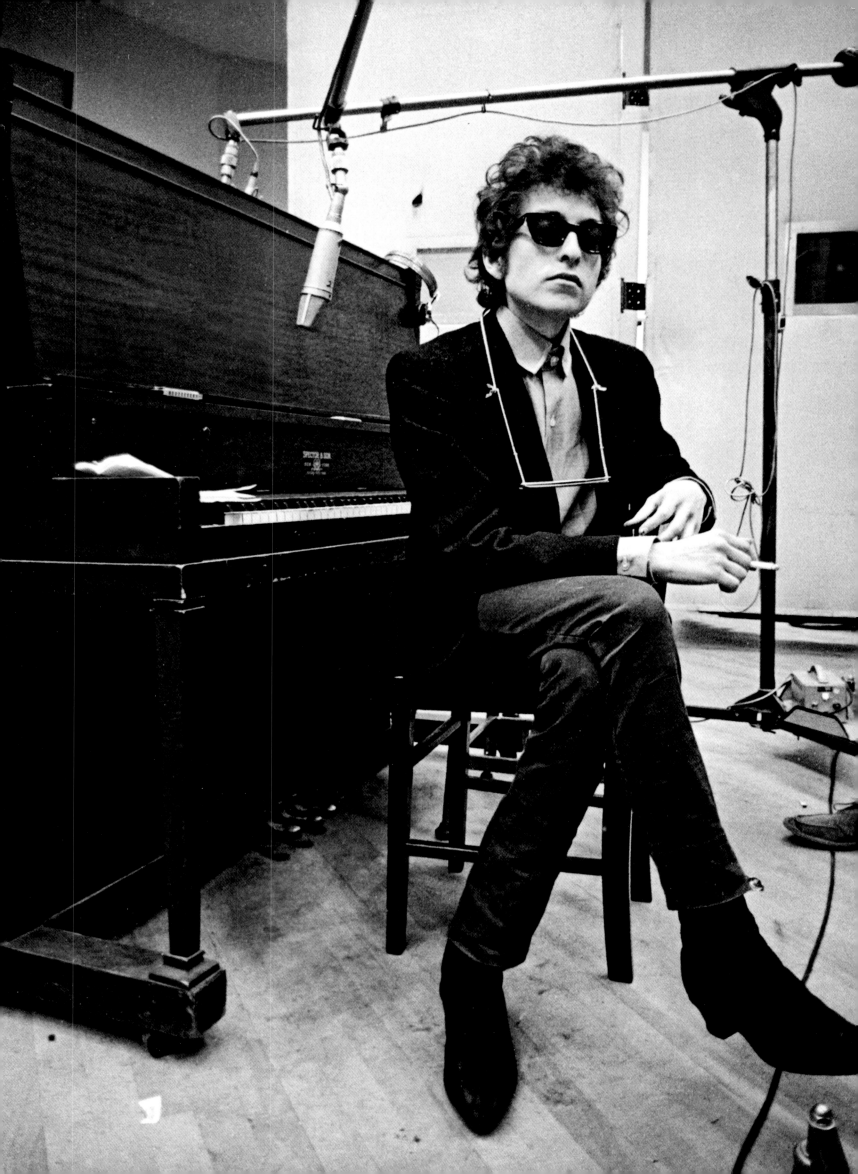

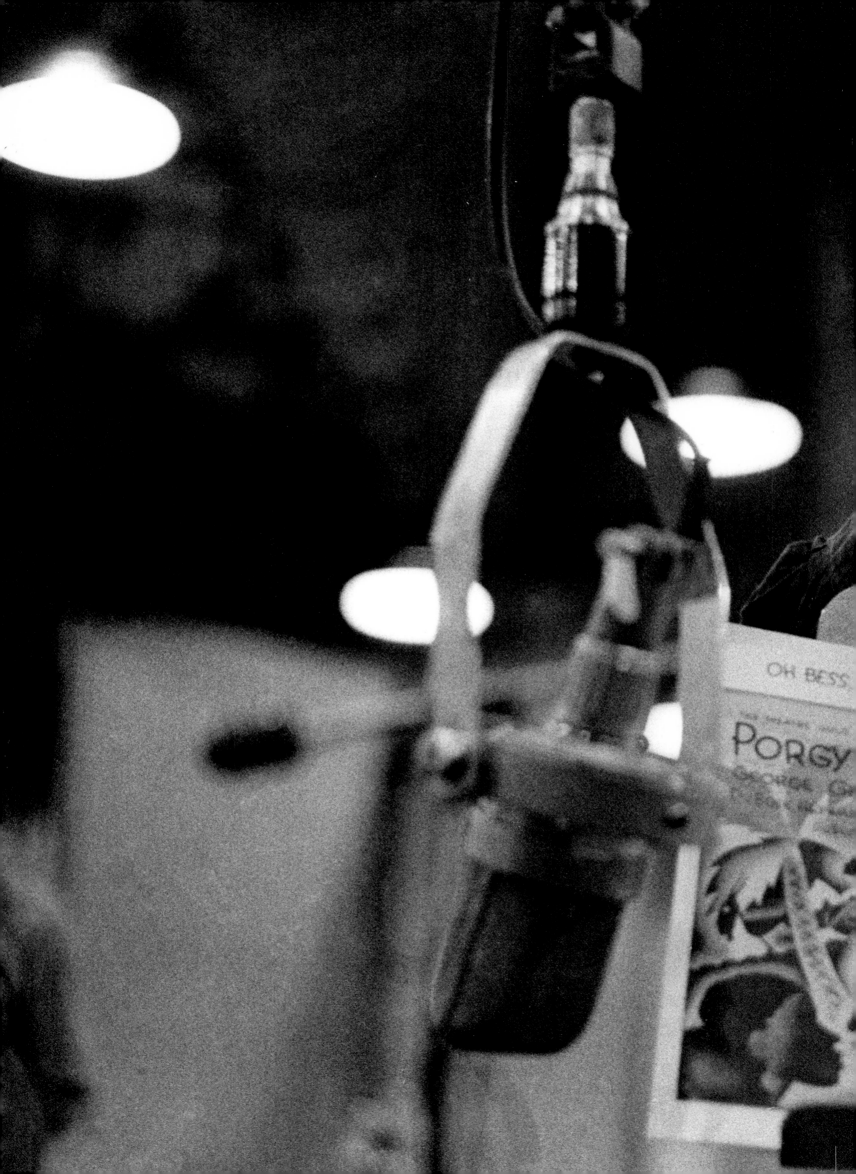

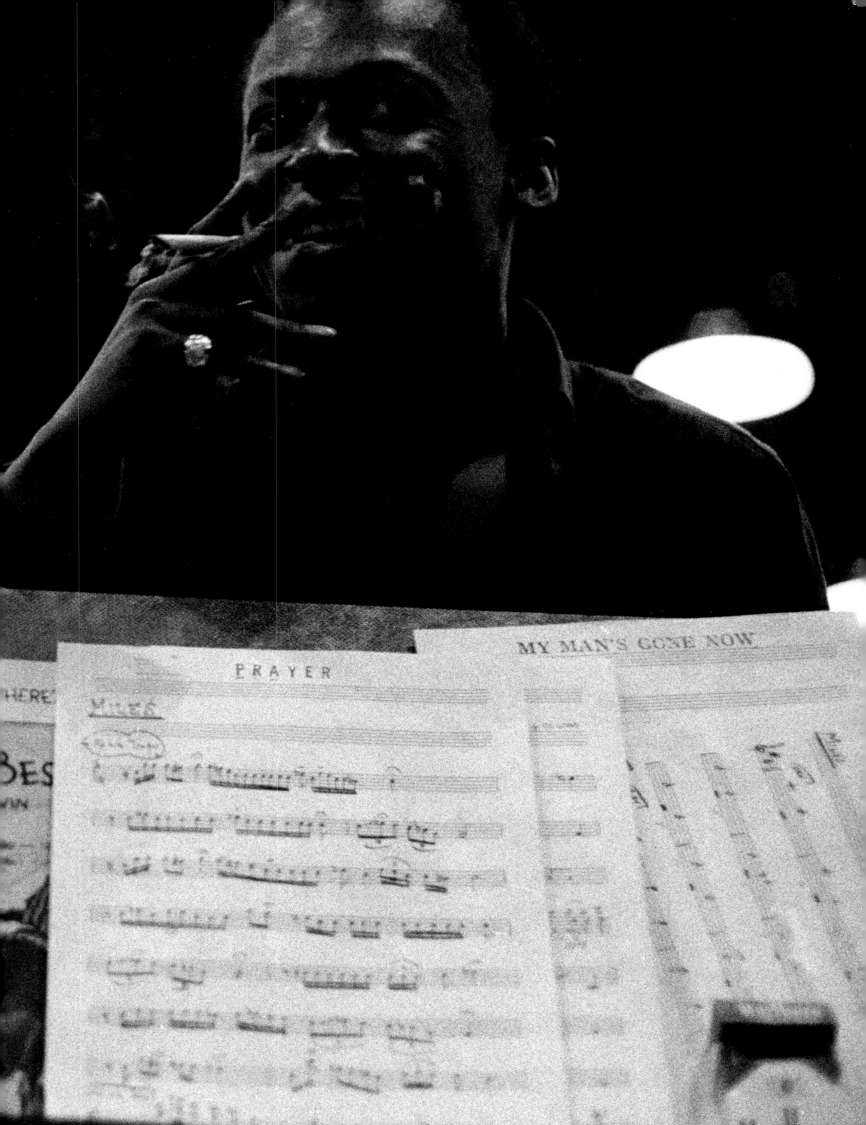

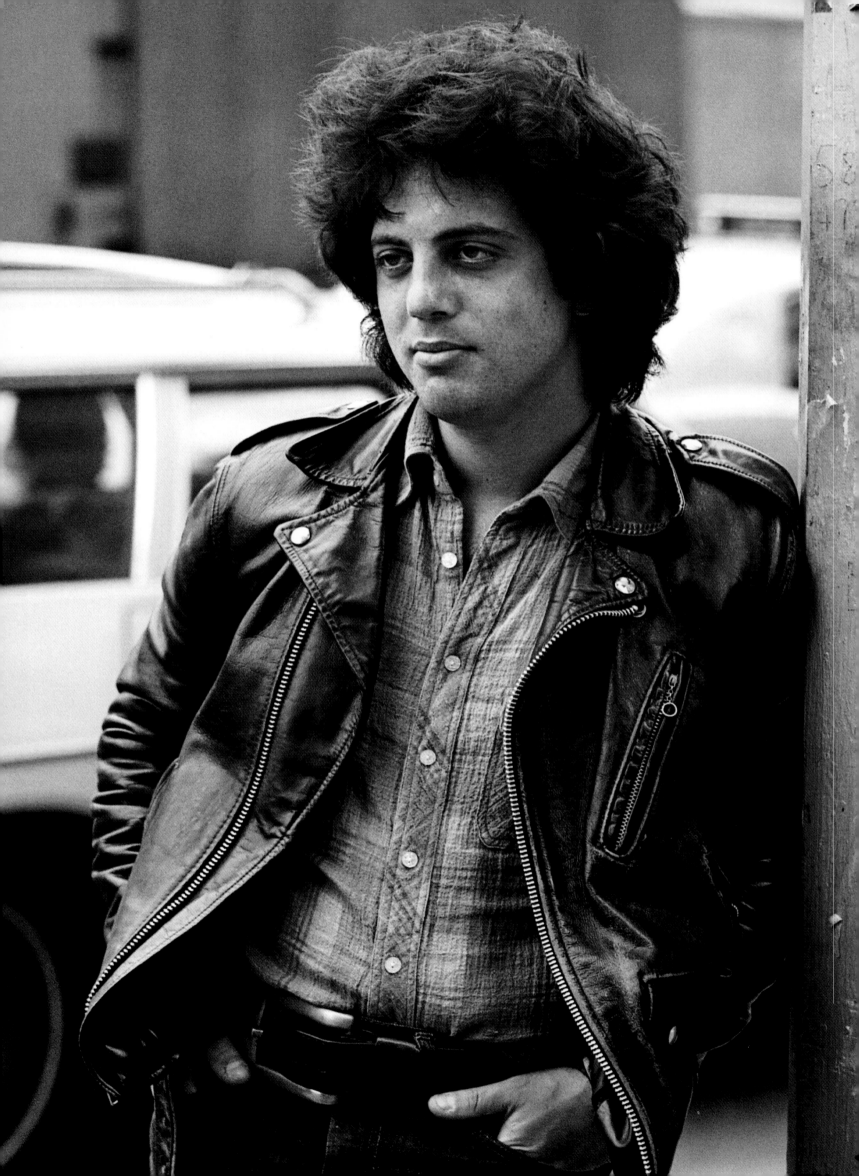

KEEPING TIME

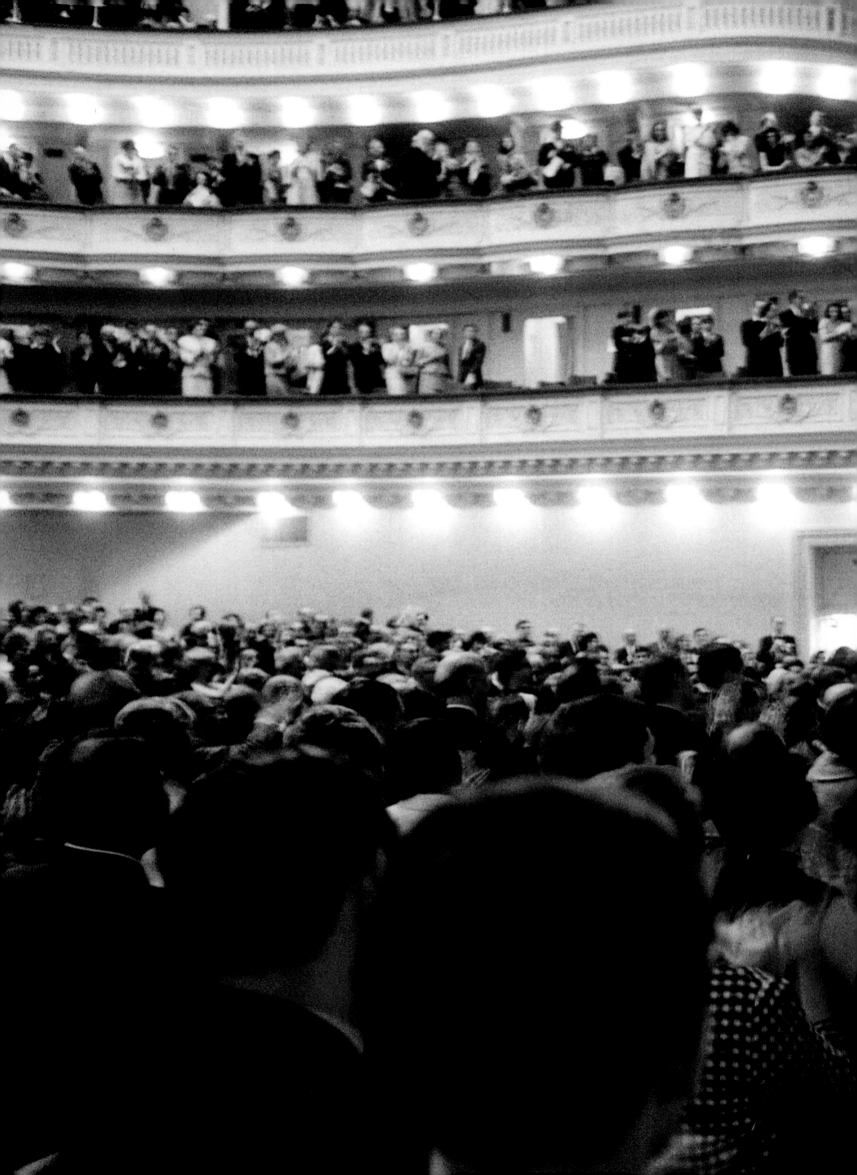

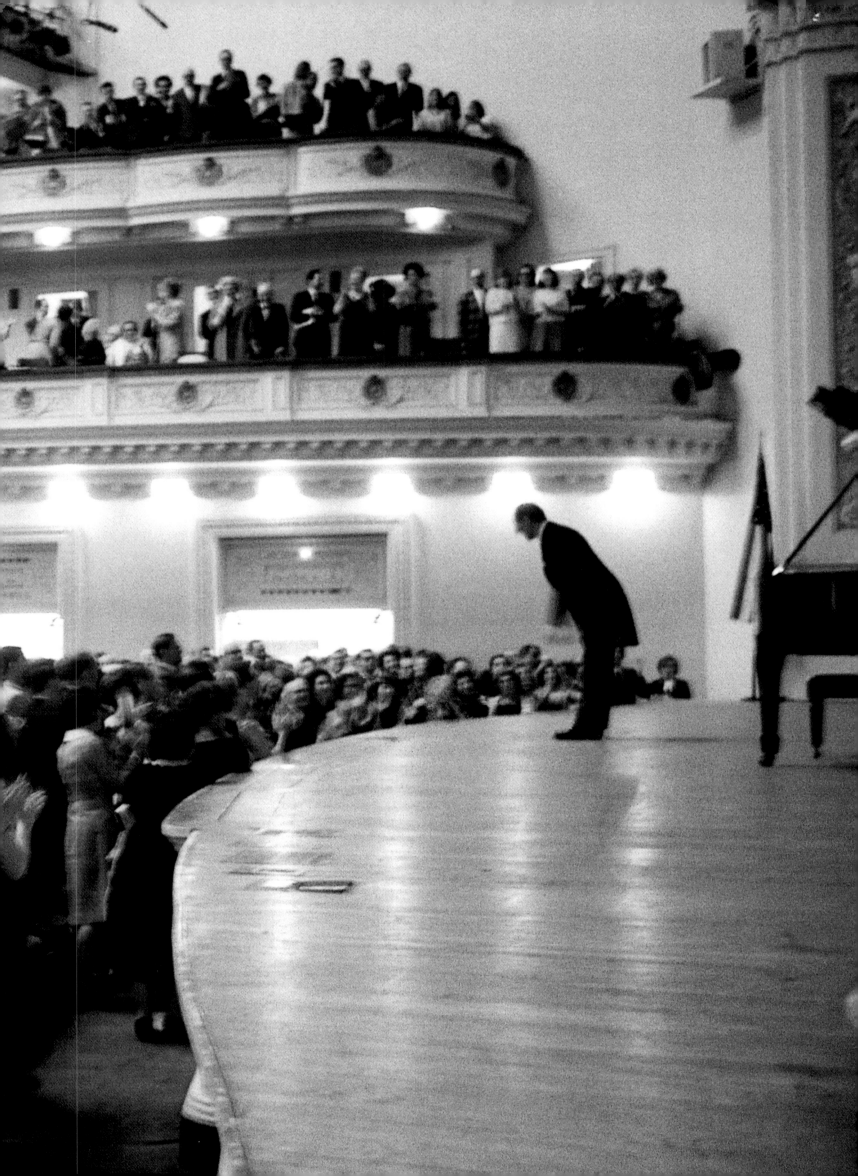

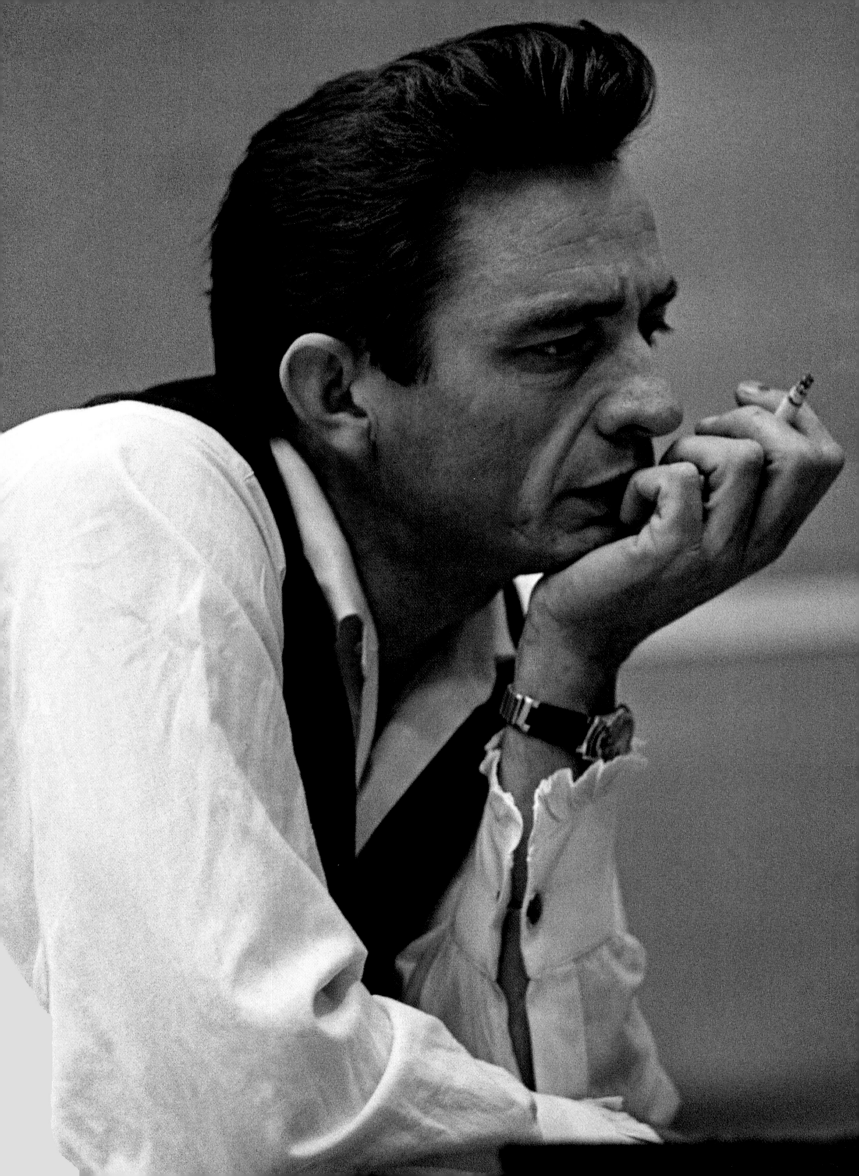

KEEPING TIME

THE PHOTOGRAPHS OF DON HUNSTEIN

The Unseen Archive of Columbia Records

TEXT BY

JON PARELES

EDITED BY

LEO SACKS

FOREWORD BY

ART GARFUNKEL

INSIGHT
EDITIONS

San Rafael, California

CONTENTS

 Barbra Streisand

 Johnny Mathis

 Tony Bennett

 Leonard Bernstein

 Glenn Gould

 Igor Stravinsky

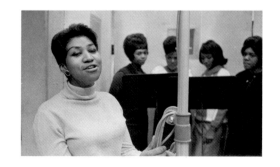

 Aretha Franklin

 Mahalia Jackson

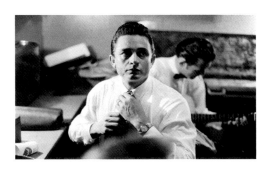

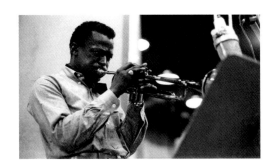

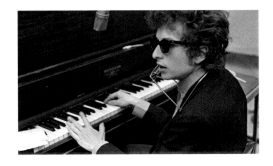

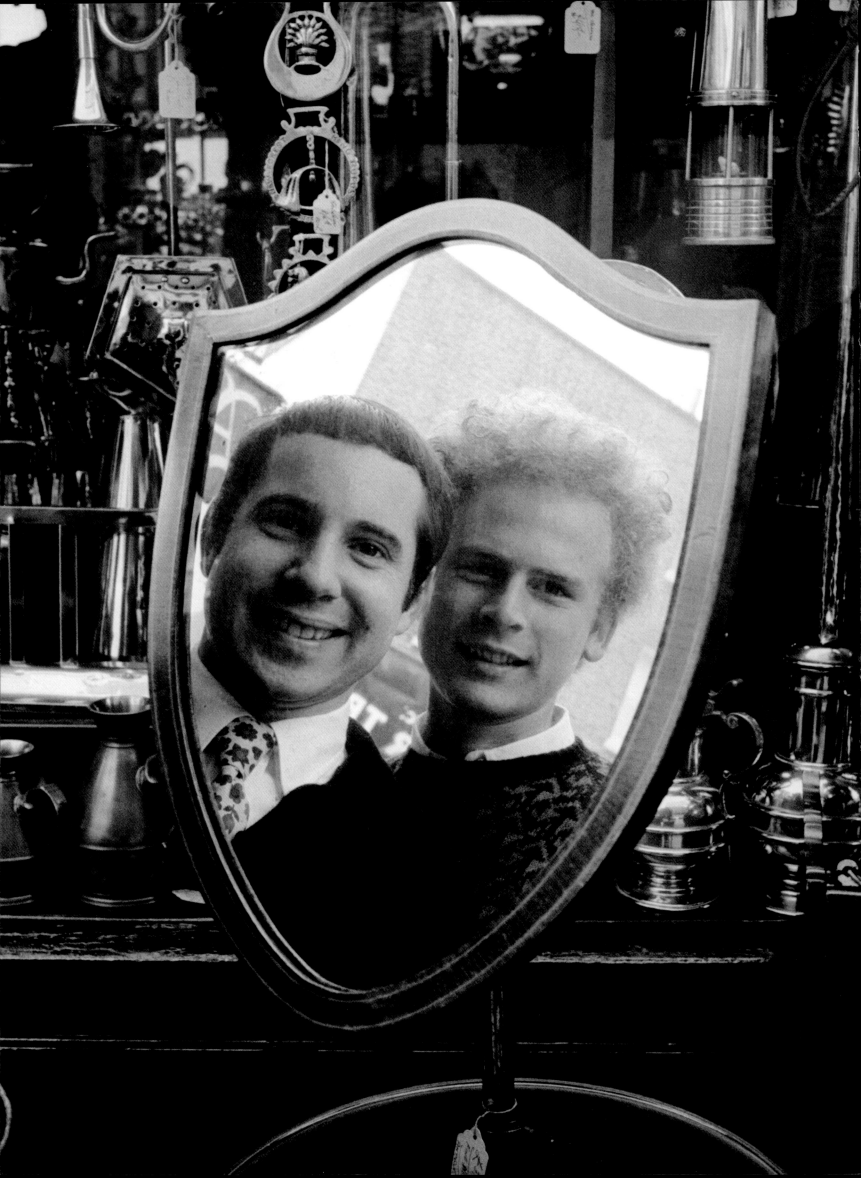

FOREWORD

by ART GARFUNKEL

". . . he turned out to be one of us . . ."

I have faced the camera many times in my long career. The job is to find rapport with that machine. If it sounds like a forced task, that's because it is. To bring a look of sincerity to the exchange is the devil's business. It is show business—to bring your sense of truth to the lens, the microphone, the machinery, and to do it on call; as an appointment. Only a magician can assist in this duality and walk away with "the shot."

Along comes Don Hunstein. The human exchange with him *is* sincere; it's funny; it relaxes the subject. Hanging out with Don overrides the self-consciousness of picture taking. It was 1964 when Paul and I hung out with Don. We worked together in the Berkshires, at the top of Manhattan, at the Cloisters. We were new stars on Columbia. We were to carry the charisma; Don's was in his professional pocket. But he turned out to be one of us, and so the whole thing worked. Now it's over forty years later. Many photo sessions have gone down for me since then, but I don't know when it ever worked so well again.

Paul Simon, left, and Art Garfunkel,
London, October 1966.

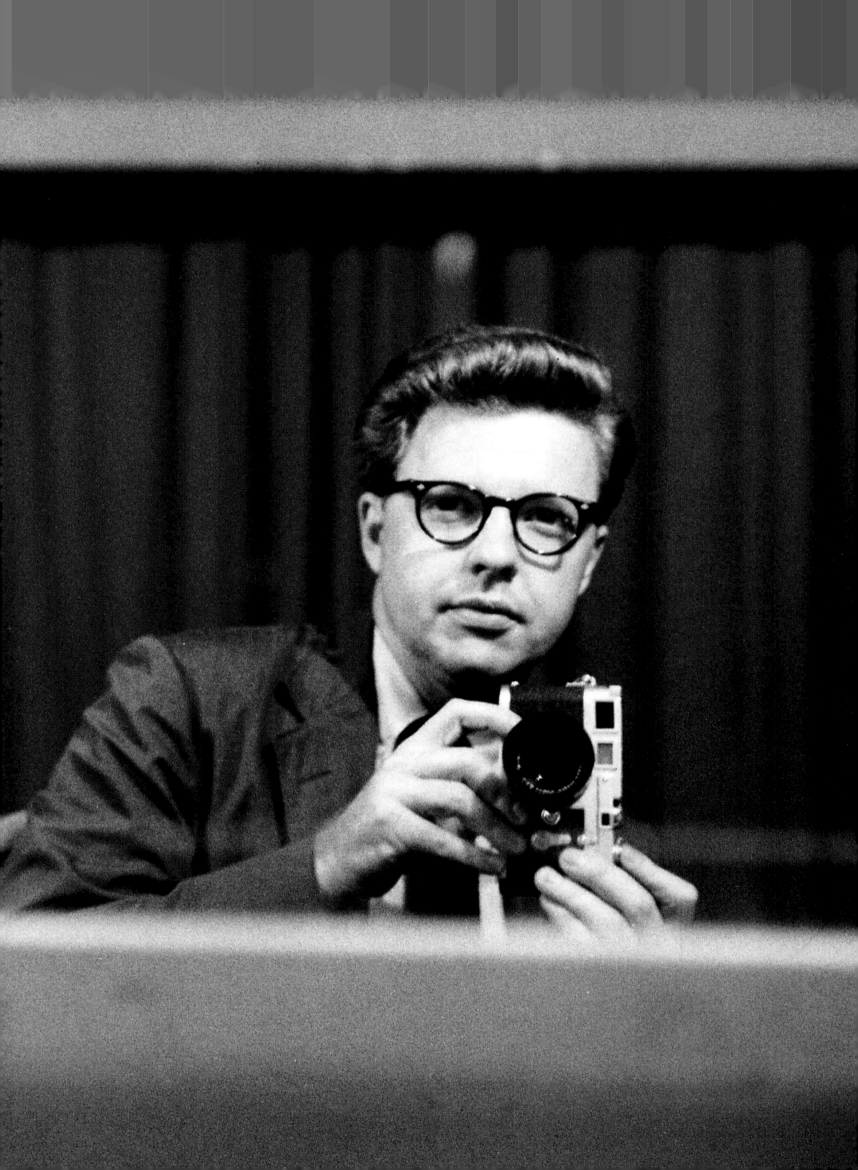

INTRODUCTION:
TIME KEEPER

by JON PARELES

"Discretion was the better part of valor. Shoot, then disappear."

—DON HUNSTEIN

O f the countless images that the photographer Don Hunstein shot in a five-decade career, a select few hang on the walls of his Upper West Side apartment in New York. Two make a diptych: a pair of photographs taken, moments apart, at the 1959 sessions for Miles Davis's landmark album, *Kind of Blue.*

One photo focuses on Davis himself, cradling his trumpet, thoughtful and far-seeing. The other blurs Davis to show his discovery and a musical catalyst in his quintet: the determined young saxophonist John Coltrane (pages 150-151).

Each photo is nothing less than an iconic moment from jazz history, a rare inside glimpse of a masterpiece being made. And together they are more than that. They give visual form to jazz itself, to music shaped by individual musicians and instantaneous change, in which the focus can shift from player to player at any moment. It's just one of the intimate, quietly astute musical and psychological insights to be gleaned from Hunstein's extraordinary body of work.

Hunstein himself shrugs off any such grand concept for his images. "There was nothing metaphysical about what I did," he said in conversation with the music producer Leo Sacks. "I'd just like to think I had a good eye for detail, that I captured the moment at hand. But mostly, I just did my job." That job was as staff photographer for Columbia Records, through three decades of its heyday.

Hunstein was born in 1928 in Saint Louis and lived there until he graduated from Washington University in 1950. He got serious about photography, working with a Leica IIIg, while serving with the Air Force in Korea. Back in civilian life, a college roommate invited Hunstein to New York in 1954. He shopped his photographs to Madison Avenue ad agencies and worked as a studio assistant at a large commercial photo house, then as the assistant to the former entertainment editor of *Life* magazine. The contacts led him to a job at a rapidly expanding Columbia Records.

Don Hunstein, self-portrait with a
Leica IIIg camera, 1959.

TOP: Out of the Air Force and new on the job, June 1956. Photo by Guy Gillette.
ABOVE: Columbia Records' 30th Street Studios, located at 207 East 30th Street in Manhattan; once a house of worship, musicians called it "The Church."
OPPOSITE TOP: Singer Philippé "Soul" Wynne, New York, October 1980.
OPPOSITE BOTTOM: Bassist Paul Chambers, left, and saxophonist Cannonball Adderley, New York, 1959.

"The label was growing, and so was the record business, and Columbia's publicists needed someone to handle the flow of stills to the media," he remembered. "Someone trusted my judgment!"

He quickly moved into the job of staff photographer, and there he stayed until Columbia dismantled its in-house photo studio in 1986. For the label, Hunstein photographed classical virtuosos and jazz masters, soul belters and country patriarchs, folkies and rockers, Broadway casts and spoken-word poets, legends in the making and flashes in the pan.

As the years and decades rolled by, Hunstein unself-consciously built a visual chronicle of music and culture throughout the second half of the twentieth century. His photographs trace changes in fashion and performance styles through the decades. Hunstein's archives move from the buttoned-down 1950s to the casual 1960s to the over-the-top 1970s to the stylized 1980s, and from the restrained professional entertainer to the aggressively self-marketed star. For better and worse, Hunstein's filter was the roster of Columbia Records and its associated labels; it is, inevitably, an incomplete musical panorama. Nevertheless, the list is simply astonishing.

Hunstein photographed Miles Davis, Duke Ellington, Billie Holiday, Louis Armstrong, Charles Mingus, Thelonious Monk. He photographed Glenn Gould, Leonard Bernstein, Vladimir Horowitz, Pablo Casals, Igor Stravinsky, Philip Glass, Plácido Domingo, Yo-Yo Ma. He photographed Barbra Streisand, Perry Como, Robert Goulet. He photographed Aretha Franklin, Mahalia Jackson, Janis Joplin, Sam Cooke, Labelle, Teddy Pendergrass, Minnie Riperton, Luther Vandross. He photographed Allen Ginsberg and Langston Hughes. He photographed Johnny Cash, George Jones, Charlie Daniels, the Flying Burrito Brothers. He photographed Pete Seeger, Simon and Garfunkel, the Byrds, Joan Baez, Phoebe Snow, and, extensively, Bob Dylan, including Dylan's first two album covers.

Though he worked mostly in New York City, Hunstein also traveled where the company's assignments led. His work carried him to Moscow with Leonard Bernstein and the New York Philharmonic, and to Warsaw where a reverent Bernstein played Chopin's own piano. He ventured to Nashville to photograph country stars, to London for British rockers, and to Havana Jam in 1979, when American and Cuban musicians long separated by politics got a precious chance to learn from one another.

In an era before home video and reality TV, before

the making-of documentaries and cell phone cameras, before MTV and Facebook, Hunstein's career gave him close-up access to moments the public would never see otherwise. He photographed musicians at work and musicians unwinding, musicians very conscious of creating an image and musicians with their guards down. For many listeners, Hunstein's images of Davis, Dylan, Gould, Monk, and Bernstein have grown inseparable from the artists' music. Hunstein's photos were, in those less exhibitionistic times, the lasting, iconic images of the musicians, to be pondered and scrutinized on album covers or in magazines.

While Hunstein did capture some extraordinary shots of performers onstage, he preferred making photographs that were set outside the spotlight: backstage, at recording sessions, in musicians' homes, on the street, in the Columbia photo studio he ran until 1986. They were rarer, more private moments, but Hunstein claims his reasons were pragmatic. "Less distracting," he said.

For Hunstein, a typical day's work left little time for grand artistic aspirations. "There was the album cover shoot in the morning and then, after lunch, a session with a newly promoted Columbia executive to send to the trades," Hunstein recalled. "Later that evening, I could be at a recording session that could last until the wee hours." He was dedicated to his work. Hunstein's 1966 honeymoon trip to Europe, the beginning of his marriage to his wife, DeeAnne, included a stopover in London to photograph Simon and Garfunkel while they were on tour.

Hunstein's job, clearly, was to present attractive images of Columbia Records stars. But his bedrock instincts were journalistic: He photographed realities, not fantasies. "I was merely a living witness," Hunstein said. "What does any good journalist do? Record what's going on. Observe the artist and their expressions, then leap in. You've got to react to something that's happening, or anticipate that it's about to happen."

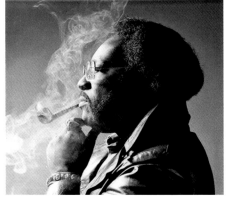

He generally approached his subjects as a documentarian saving the moment— keeping the time—rather than as a fashion photographer contriving and glamorizing a pose. Hunstein cites as his model the French photographer Henri Cartier-Bresson, who championed the "decisive moment," the image that captures the unique, fleeting alignment of an event and a composition in light and shade. "To take photographs means to recognize—simultaneously and within a fraction of a second—both the fact itself and the rigorous organization of visually perceived forms that gives it meaning," Cartier-Bresson wrote in a 1976 essay, "The Mind's Eye."

Keeping Time unmistakably demonstrates Hunstein's sense of visual form as he worked within and beyond the necessities of the job at hand. Whether his subjects were looking directly into his camera or going about their business while he observed them, his photos appear strictly matter-of-fact. But their straightforward reportage can't conceal their visual elegance. The shots were often taken for workaday purposes, like publicity handouts or trade magazine stories. But grouped as they are in this book, their aesthetic choices add up.

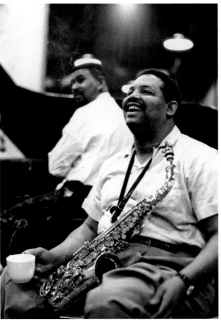

Consider Hunstein's many recording studio photographs. The studios hold microphones, sheet music, equipment, and tendrils of smoke, along with the musicians and their instruments. They are unromantic workaday spaces, places of professional camaraderie; musicians concentrate, joke around, confer, play. Hunstein appreciated the *Kind of Blue* sessions—which, like many he photographed, took place at Columbia's own 30th Street Studios—not only for their music, but for their no-frills setting.

"There were no special effects, just ordinary ceiling lights," he told the jazz critic Ashley Kahn for the book *Kind of Blue: The Making of the Miles Davis Masterpiece* (Da Capo

Press, 2001). "It was great for what I did because there was an overall lighting, nice and even. It was the plainest kind of situation."

But in his photographs, Hunstein's recording studios are not plain. With their shadows and their calibrated depth of field, their mixture of sharpness and softness, they can be as mysterious as film noir stills. Each image hints at the intangible but crucial decisions, the pressures and inspirations, that will shape the music made by these particular musicians in this particular room. The photographs are by nature silent, but they are charged with musical possibility and human character.

Hunstein's images of a ravaged but noble Billie Holiday, of a studious Julie Andrews, of Bob Dylan intent at an upright piano in his rock-star shades, are glimpses of artists thinking and creating, not preening. Surely the shutter must have clicked, but the reverie seems unbroken. Hunstein was always careful to stay the inconspicuous observer. He eased himself into his subjects' confidence: listening, watching, telling a joke or two. Then, it seems, he all but vanished into the background as far as the musicians were concerned, even with his camera in hand. He was a company-sanctioned spy of sorts, but one who was as respectful as he was probing.

"I followed my guidelines, always," Hunstein said. "Discretion was the better part of valor. Shoot, then disappear. I never photographed during takes. I never wanted to be in the way, to be intrusive. I hope I never was."

BELOW: Julie Andrews creating the role of Eliza Doolittle in *My Fair Lady* with Stanley Holloway, left, and Rex Harrison.
OPPOSITE LEFT: Don and DeeAnne Hunstein at a reception for Leonard Bernstein, center, in New York, December 1974. Photo by Art Maillet.
OPPOSITE RIGHT: Don, late 1960s. Photo by Urve Kuusik.

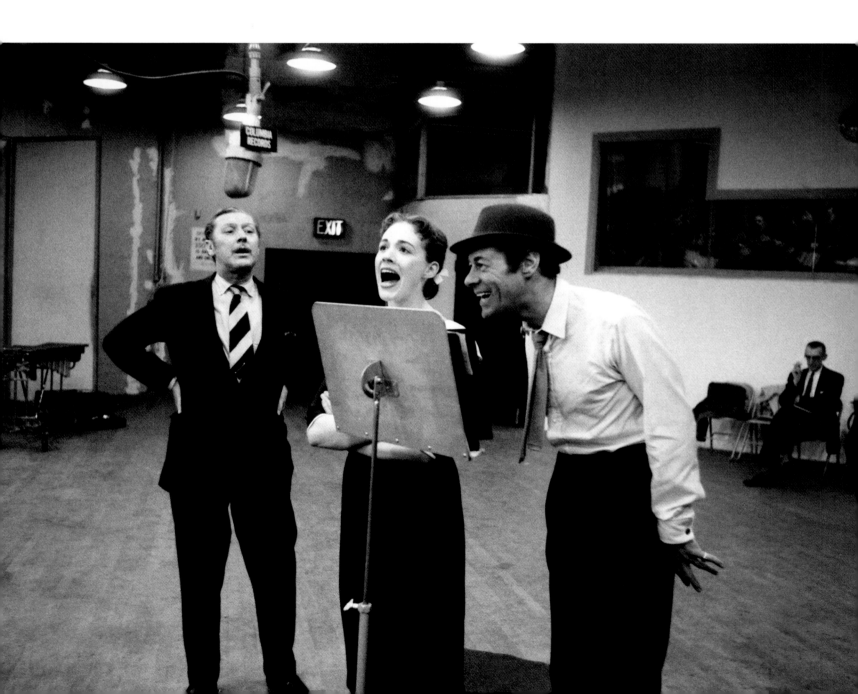

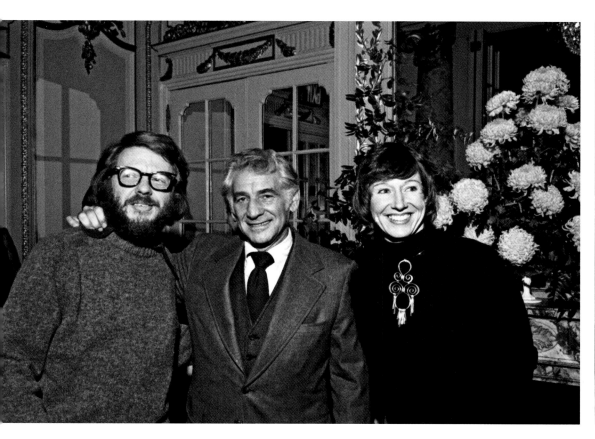 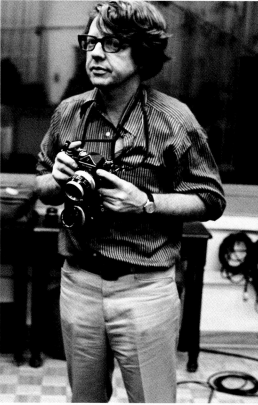

Hunstein was also thoroughly adept at making photo-studio portraits. From the beginning, his jobs at Columbia included not only casual shots and documentation, but also art-directed concept photos intended to fit (and market) the twelve-by-twelve square of an LP cover. Through the decades, Hunstein also adapted to performers' growing sophistication and control—sometimes defensive, sometimes flamboyant—over their public presentation. Remnants of innocence were rapidly giving way to artifice.

Hunstein's seventies-era photos of Nashville's rhinestone cowboys and of R&B singers on the roster of Philadelphia International Records—musical opposites but sartorial kin in their fur, leather, sequins, and studs—demonstrate how a Hunstein photo could relish a costume in all its gaudy detail. But in the performers' faces, his journalistic side persists: he brings out the flesh-and-blood humanity behind the showmanship. Hunstein photographed artists, not mannequins.

It must be Hunstein's own amiability that's reflected back at him in more informal portraits, like the ones he made of Aretha Franklin, Johnny Cash, and—sitting perched on a windowsill at Columbia Records' offices for the cover of his debut album—Bob Dylan. The young performers look baby-faced and trusting, with their ambitions clear and their public masks not yet firmly in place. "I tried to create an atmosphere so the artist was relaxed and open," Hunstein recalled. "That was essential. That was key."

Some of Hunstein's subjects, like the Canadian pianist Glenn Gould, deliberately posed themselves for him. To much of the outside world, Gould was a reclusive figure who gave up a concert career for the perfectibility of studio recording, but he welcomed Hunstein periodically through the years. Gould stationed himself in playful, canny poses, hinting at the geometric thinking that he brought to his repertory of Bach and Mozart. One Hunstein photo became the model for a statue of Gould that now stands at the Glenn Gould Studio at the Canadian Broadcasting Centre in Toronto.

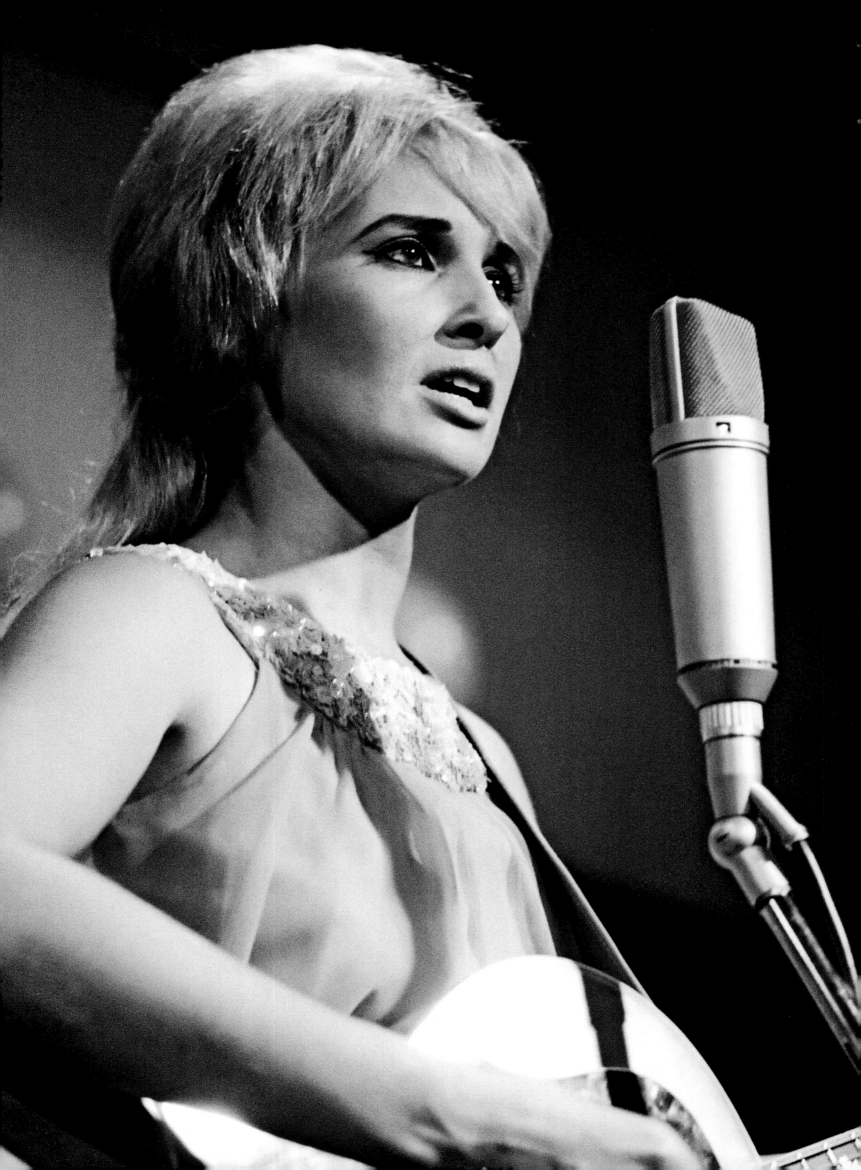

"Gould often wouldn't let anybody else take his picture," DeeAnne Hunstein explained. "Part of it was Don's manner of treating all the people that he photographed. He didn't treat them like celebrities or stars or anything like that. They were just people he was photographing, and he liked being on a one-to-one level with everyone."

The Bob Dylan of the early 1960s, with his career rocketing from Greenwich Village folk clubs to Carnegie Hall and Newport Folk Festival appearances, repeatedly faced Hunstein's camera. The photos capture a young musician inventing himself on the fly, already a knowing media figure.

What may be Hunstein's best-known photo is the cover of *The Freewheelin' Bob Dylan*, as he and his girlfriend, Suze Rotolo, walk down the middle of a snowy Jones Street (pages 200-201). It's an image of youthful Greenwich Village bohemia that mixed candor and calculation.

"Dylan himself was by then already quite image conscious and self-assured," Hunstein said about that afternoon, "and he knew how to play to the camera." Hunstein had photographed Dylan and Rotolo in their West Fourth Street apartment; Hunstein thought it was "bleak." He wanted to try outdoors, in the neighborhood. Although it was a bitterly cold winter day, Rotolo later told the *New York Times*, Dylan "wore a very thin jacket, because image was all." And Hunstein had to work fast. "The light was fading so quickly," he said, "that I was able to shoot only one color roll and a few black and whites." They were enough.

The remarkable breadth of Hunstein's portfolio—which encompasses Count Basie and the Clash, Dmitri Shostakovich and Tony Bennett, the Mormon Tabernacle Choir and Blue Öyster Cult—is inseparable from the history of Columbia Records, which assembled an artist roster that now seems almost impossibly diverse. It's a memorial to an era when major labels took themselves seriously as libraries of culture.

Founded in 1888, Columbia is the oldest surviving brand name in recorded music. Technologically, Columbia had successfully placed its bet in 1948 on the ascendance of the 33 ⅓ rpm LP. The longer recording time and lower noise of LPs made them a welcome format for classical music, jazz, and Broadway cast albums, while it gave pop singers a chance to simulate the concert experience of varied moods and tempos. Like other major labels—particularly its main rival at the time, RCA—Columbia strove to serve diverse consumer tastes.

"This business is like running a gambling house," Columbia's president, Goddard Lieberson, told *Time* magazine in 1959. "You've got to cover yourself in all directions."

He was being playful, but Columbia did set out to release a broad spectrum of music. It also conscientiously documented the making of that music, sending Hunstein to sessions, like those for *Kind of Blue*, that proved to be historic. In the 1950s, Columbia was the genteel major label, with an extensive catalog of symphonies, musicals, and forward-looking jazz. Under the A&R guidance of ("Sing Along with") Mitch Miller, the label famously steered clear of rock-and-roll ruffians, preferring pop crooners like Johnny Mathis and Frankie Laine. (We can only speculate about what Hunstein's camera would have made of the wild men of 1950s rock and R&B.) Bob Dylan was an unplugged folksinger, in the mold of Woody Guthrie and Pete Seeger, when Columbia signed him; Aretha Franklin was aiming for jazz clubs.

But by the late 1960s, Columbia was catching up with current rock. It scrambled to get into psychedelia, landing Janis Joplin, the Byrds, and the Electric Flag (and a chance for Hunstein to photograph them). Yet into the 1970s and 1980s, even as it aimed for rock, R&B, and country hits, Columbia held on to its jazz and classical

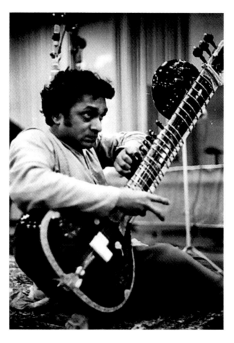

OPPOSITE: Singer Tammy Wynette, Nashville, 1967.
ABOVE: Recording session with Indian sitar master Ravi Shankar, 1957.

divisions. The overwhelming range of Columbia's roster kept Hunstein's workdays stimulating, and made his catalog of photographs into what is now an invaluable trove.

Those days are gone. In the digitized twenty-first century, major labels have been embattled on many fronts, forcing cutbacks in every department. Their artist rosters have dwindled to concentrate on narrowly targeted radio hits. Columbia no longer runs its own recording studio. And its in-house photo studio, once Hunstein's domain, was dismantled in the 1980s. (Fortunately, the photo archives were maintained.)

So *Keeping Time* is a triple memento. It's a quietly revealing close-up of artists who graced and transfigured the twentieth century. It's a keepsake from an era when media companies deeply embraced their role as curators of culture. Most of all, it's the legacy of a photographer who worked for both musicians and their label, for art and commerce enmeshed, gradually and modestly revealing an enduring vision of his own.

JON PARELES *is the chief pop music critic for the* New York Times.

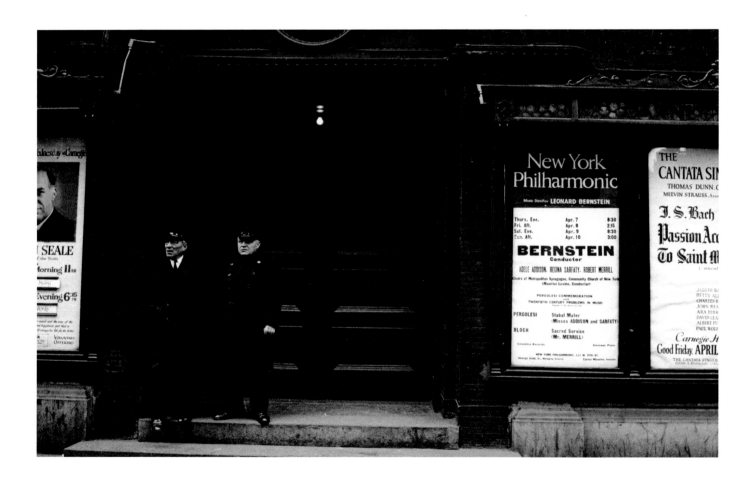

ABOVE: Chauffeurs outside Carnegie Hall, New York, April 1960.
OPPOSITE: Tony Bennett performs at the CBS Records New Talent Party, September 1956.
PAGES 24-25: Barbra Streisand performing at Café Bon Soir, New York, 1962.
PAGE 27: Sessions for *Je m'Appelle Barbra*, January 1966.
PAGES 28-29: Recording *Harold Sings Arlen (with friend)* with songwriter
Harold Arlen, right, November 1965.

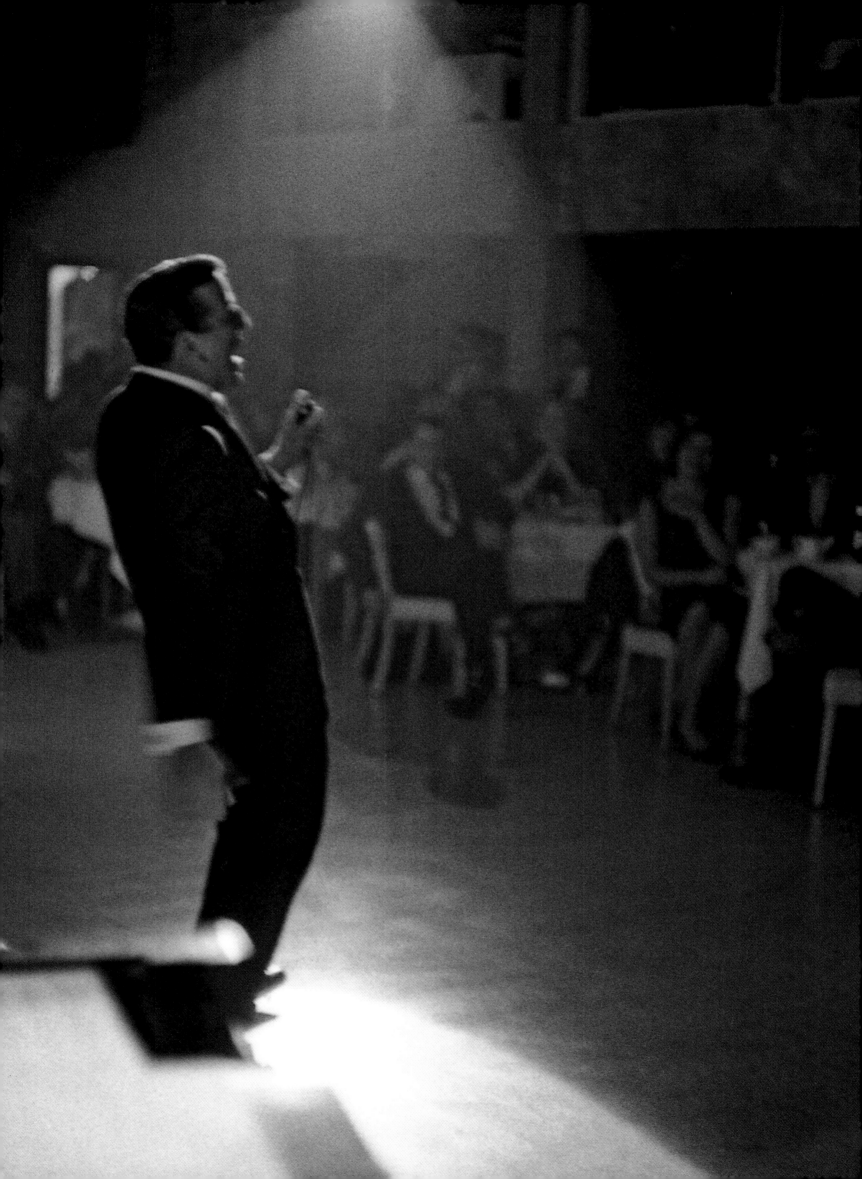

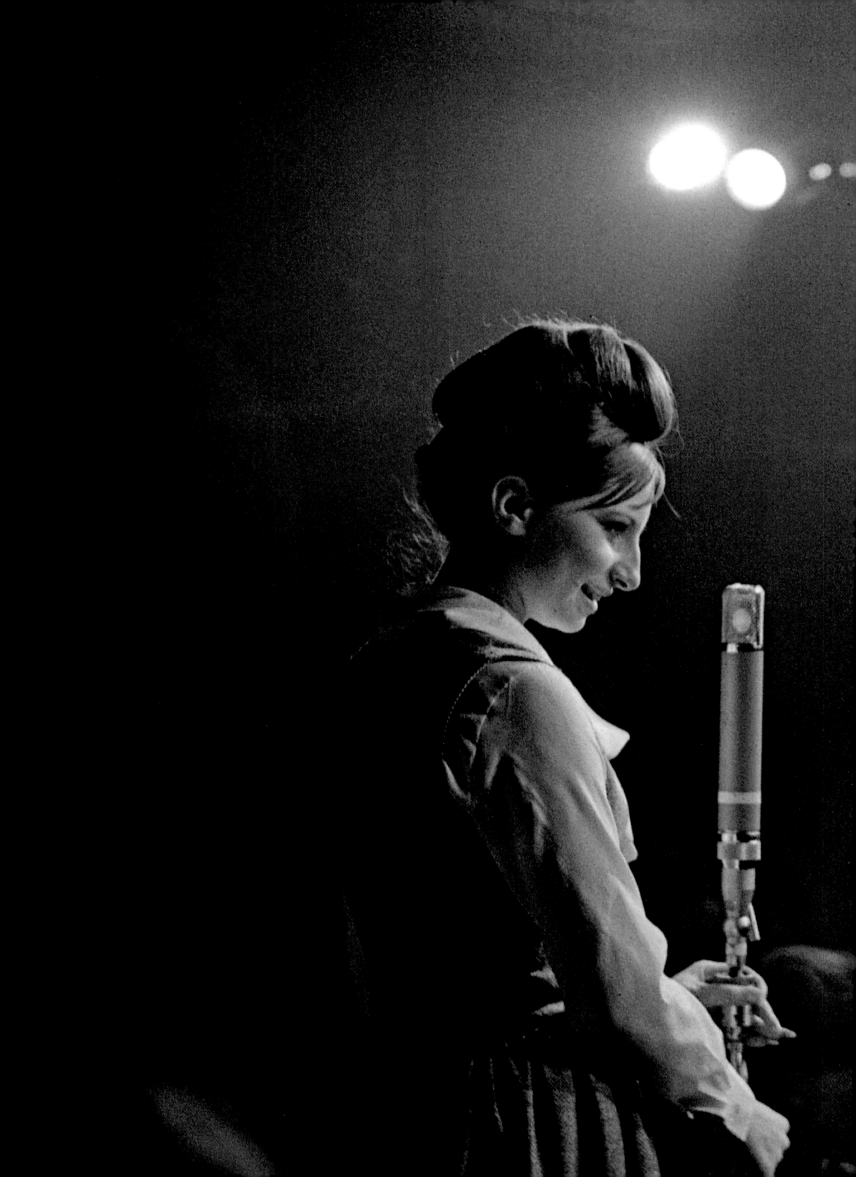

BARBRA STREISAND

BARBRA STREISAND DIDN'T STAY IN CABARETS very long. With a voice that could rise from lustrous delicacy to brassy yet poised emotional peaks, she triumphed in the early 1960s, a pop holdout when rock was on the rise. Her career would encompass Broadway, television, movies, and Top 10 hits, and she would go on to reap awards and instantly sell out arenas. Ever polished, yet with the face of a (Brooklyn) girl next door, Streisand has made virtuosity approachable—and still boffo. She recorded nearly all the albums of a five-decade catalogue for Columbia, where, early on, she allowed Don Hunstein to capture rare candid images of her—a professional at work, glamor set aside.

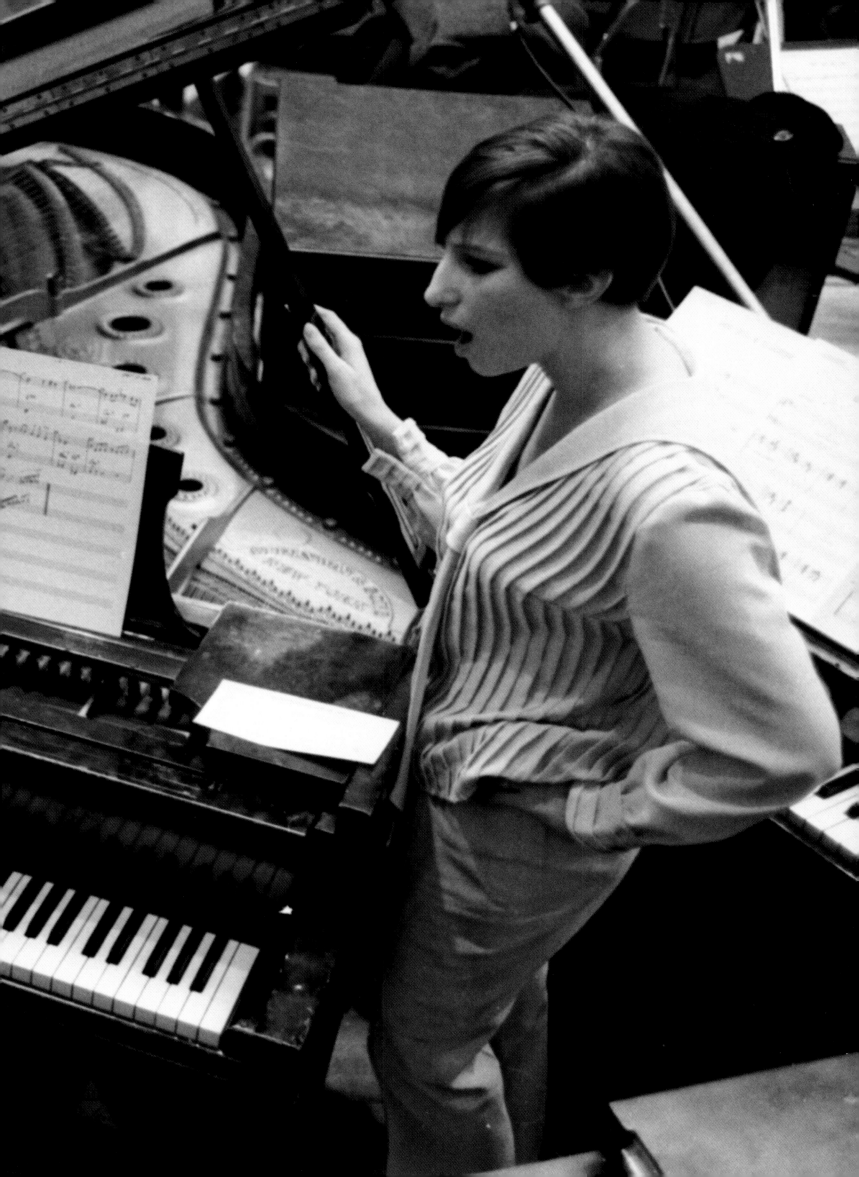

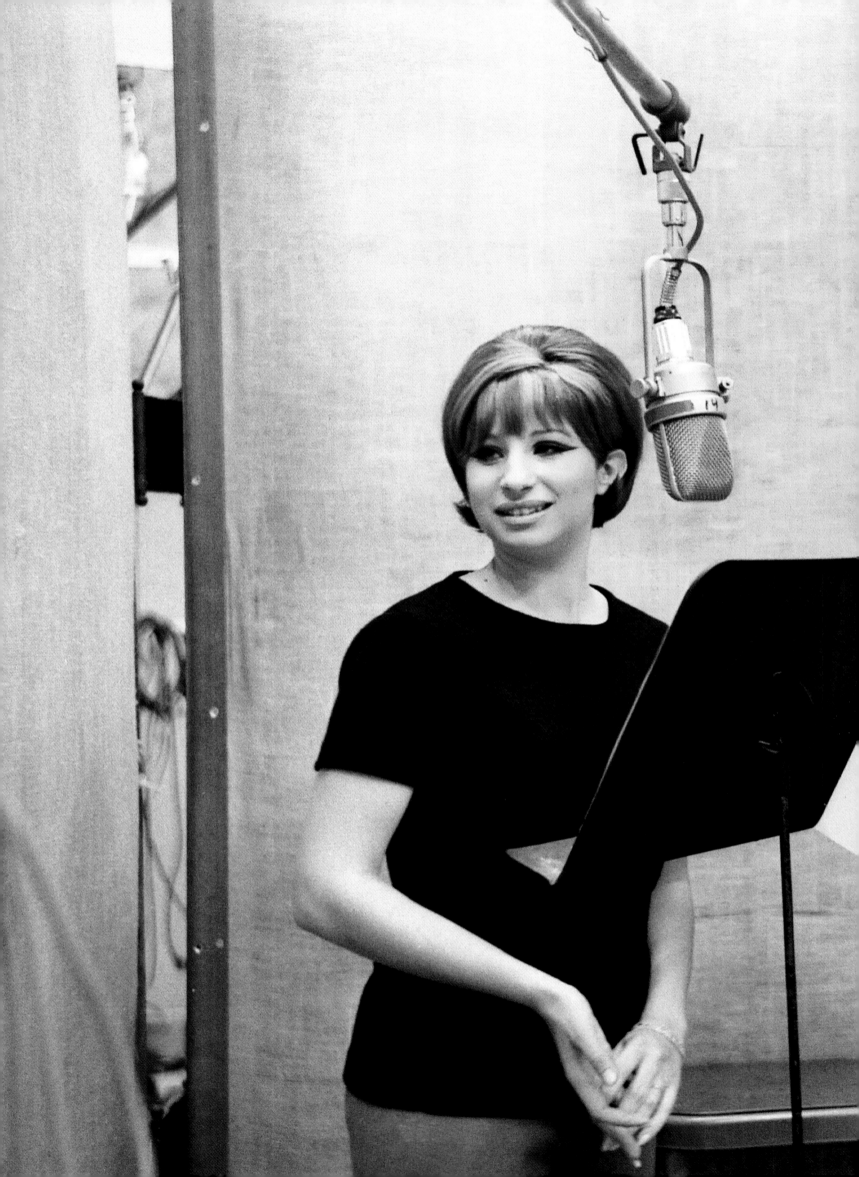

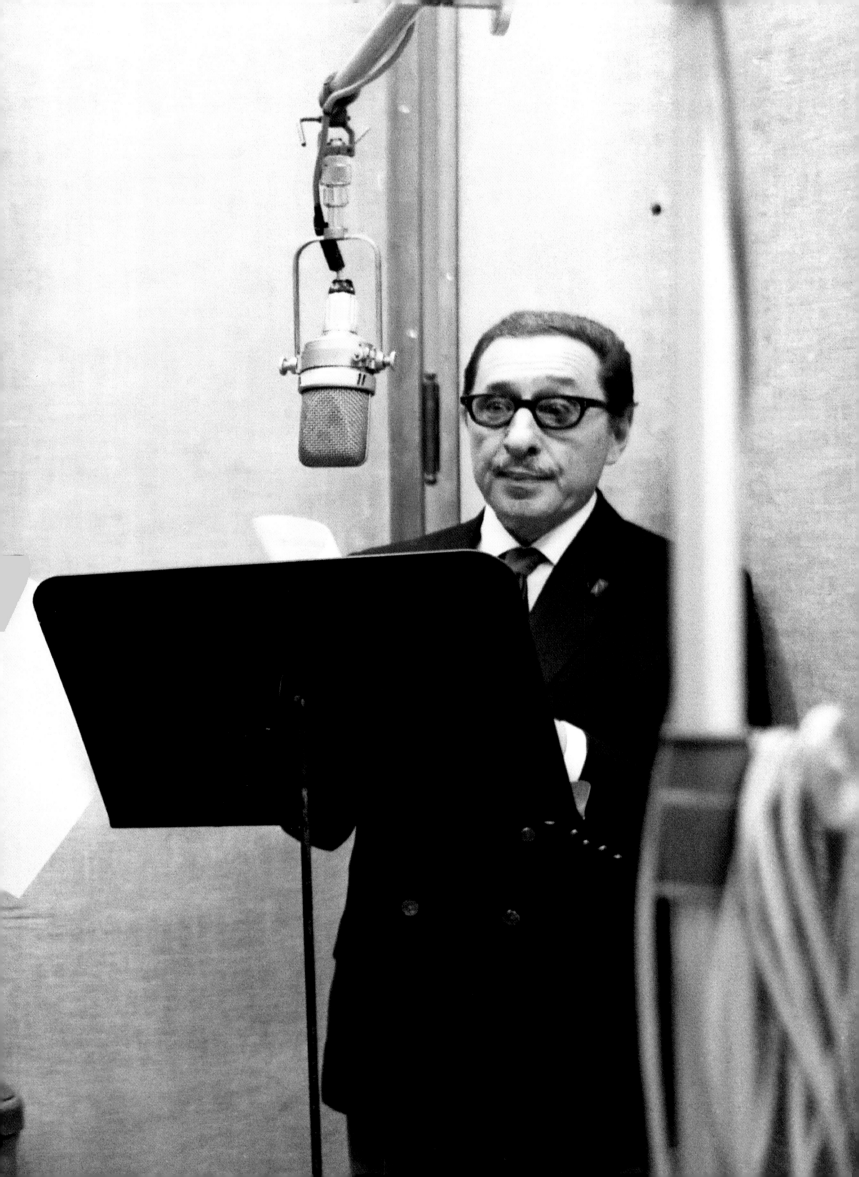

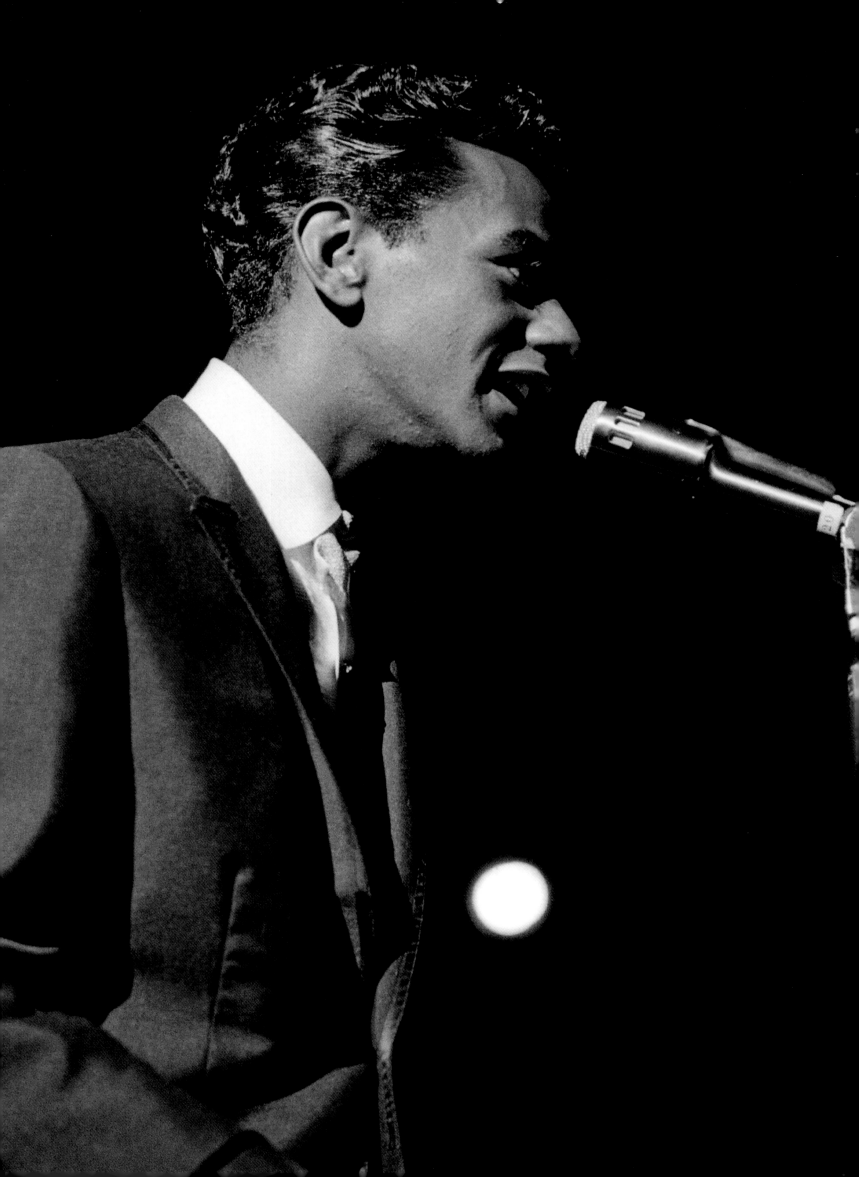

Johnny Mathis setting the standard for effortless seduction
at the Coconut Grove, Los Angeles, January 1960.

JOHNNY MATHIS

THE SMOOTHEST OF THE SMOOTH, Johnny Mathis defined pop ballad singing in the late 1950s. Both opera training and the example of jazz-rooted pop hit-makers like Nat King Cole shaped his perfect enunciation, his controlled vibrato, and his endlessly sustained phrases. Mathis started his Columbia Records career on the jazz side, working with Gil Evans, among others, but he found his commercial glory when he started crooning plushly arranged romantic pop like "Wonderful! Wonderful!," "Chances Are," and "Misty." His voice, still tremulous and pure into the twenty-first century, has continued to defy gravity for five decades.

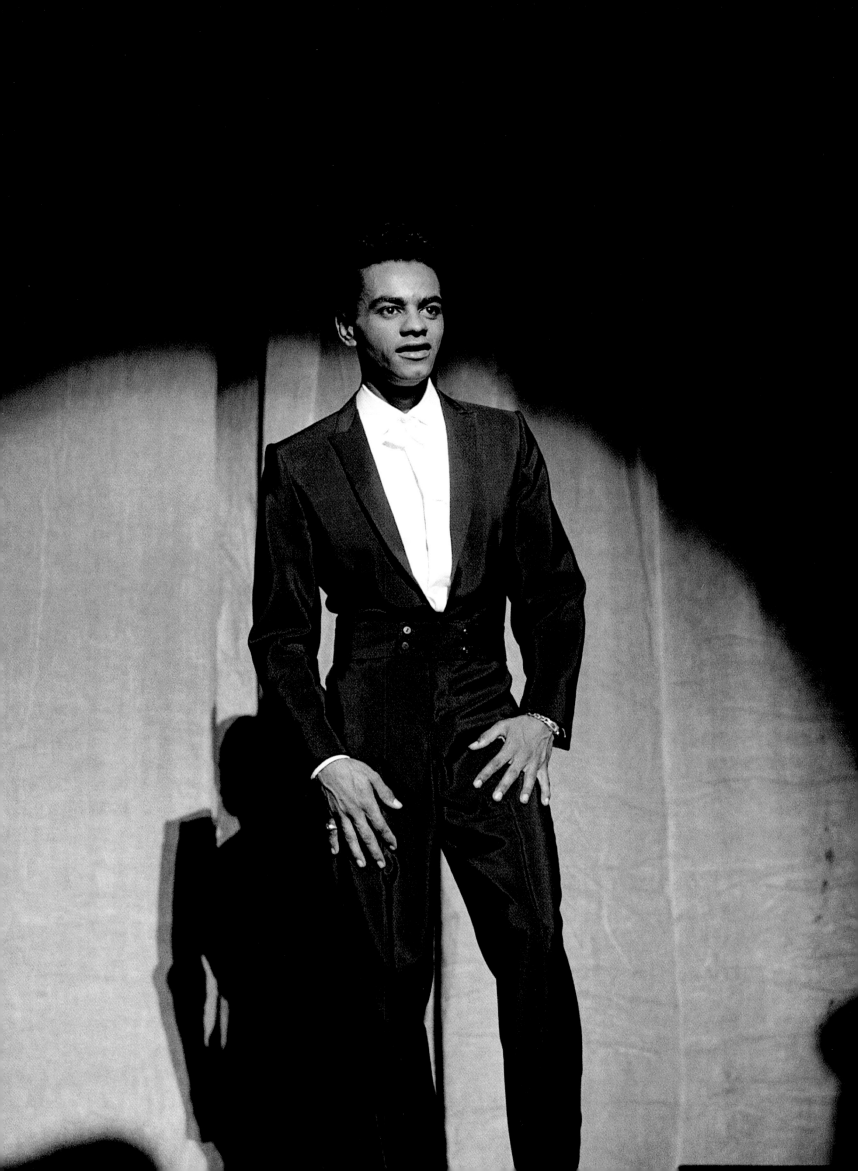

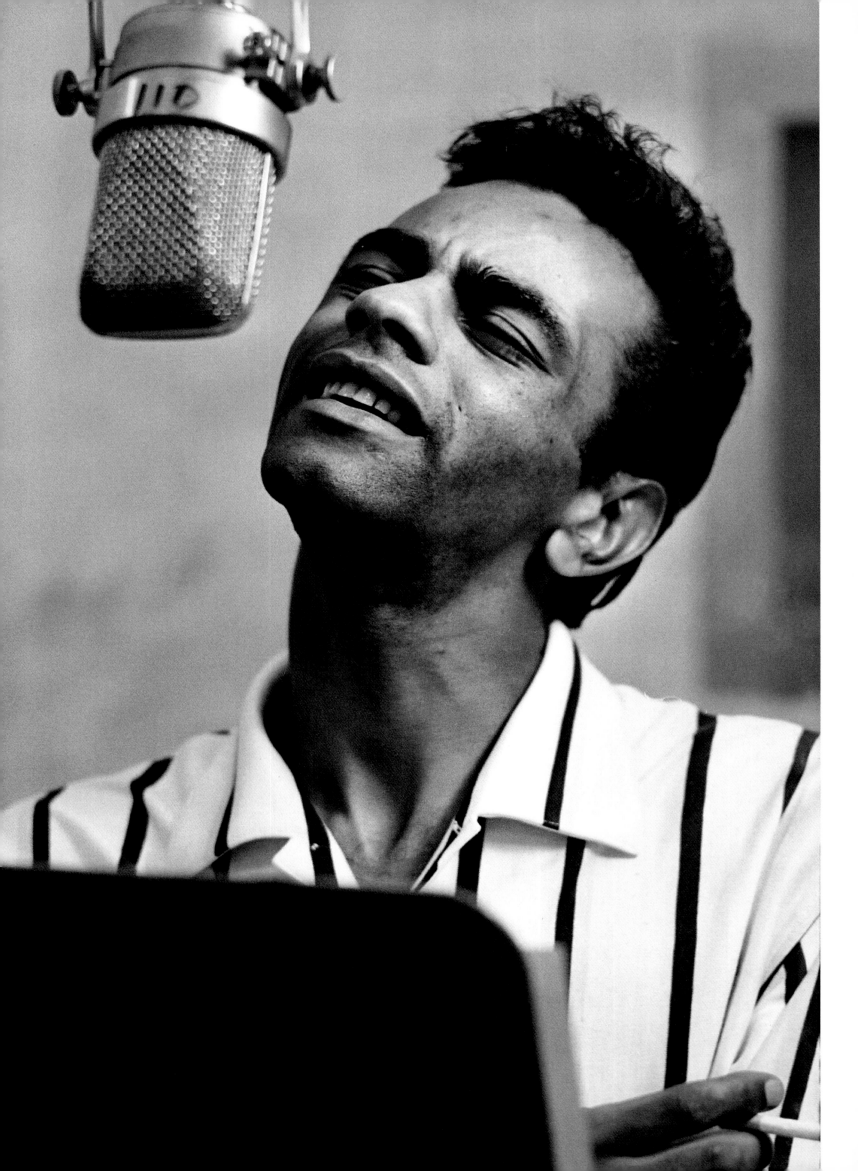

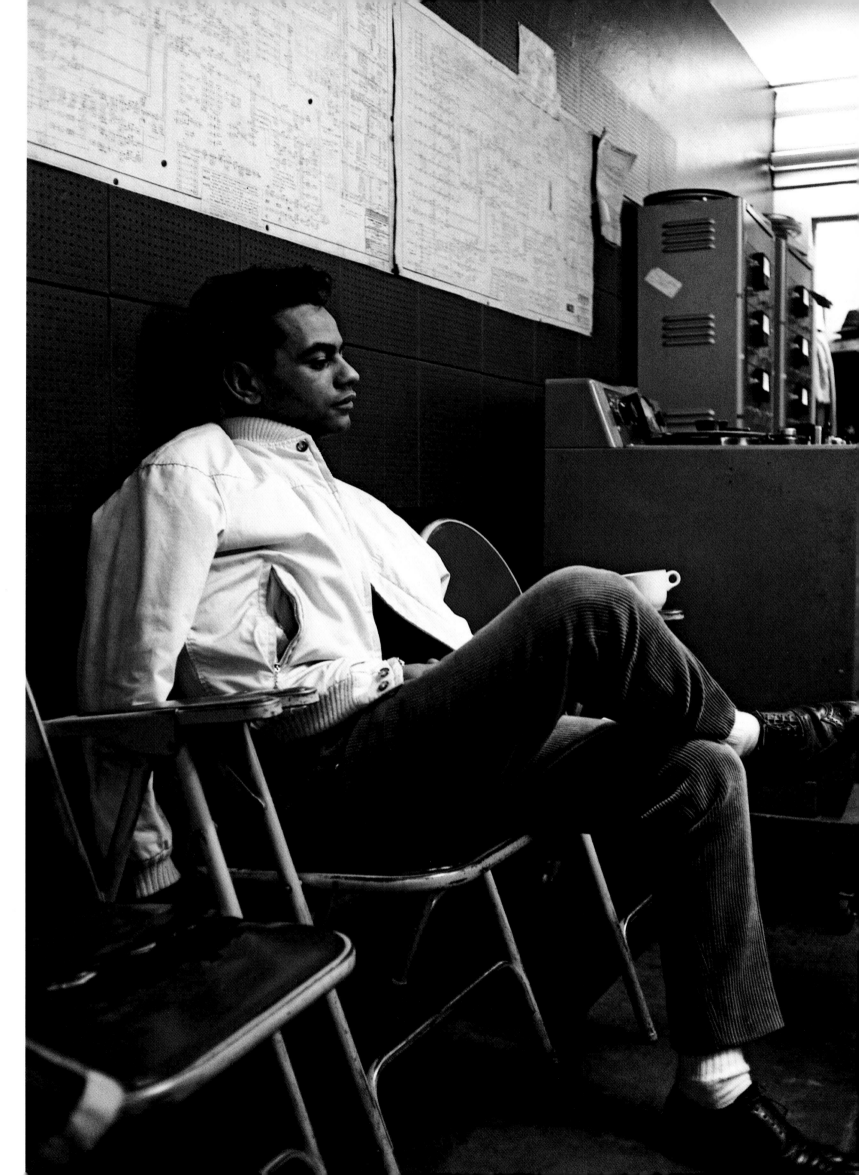

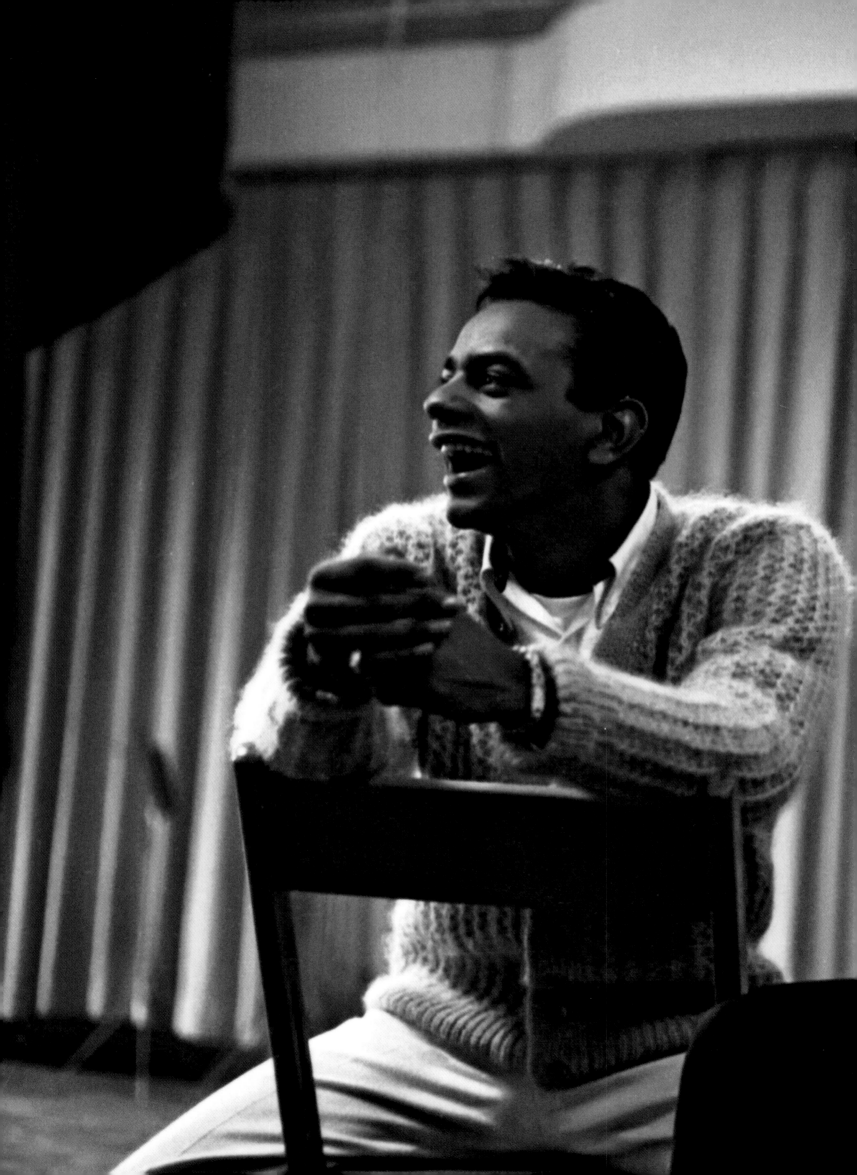

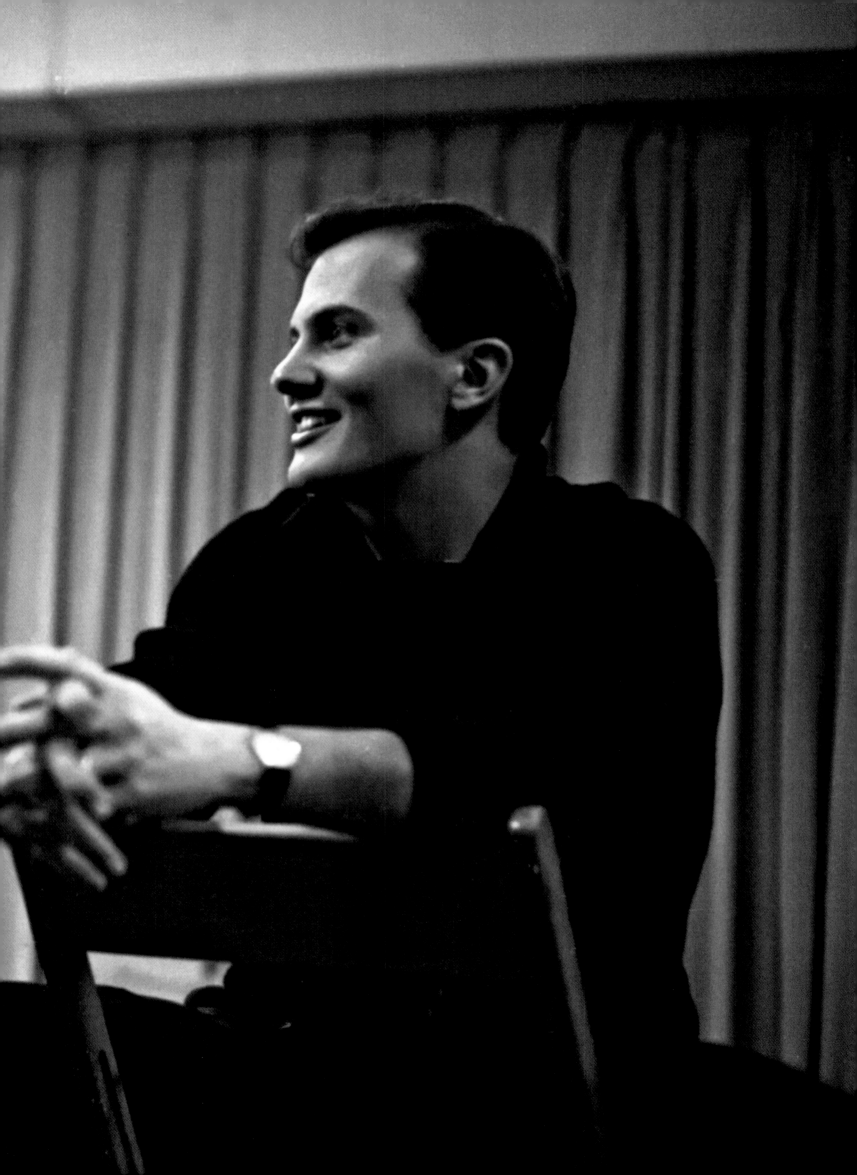

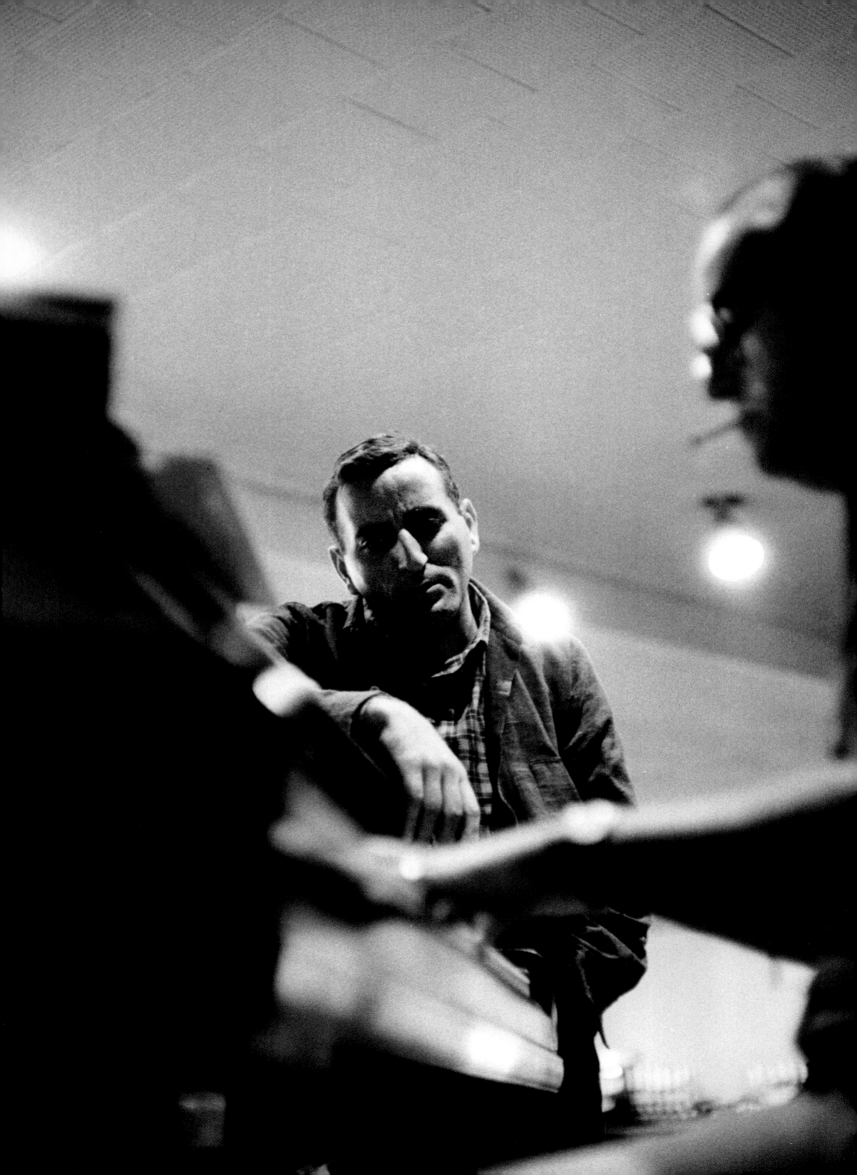

TONY BENNETT

TONY BENNETT TAKES ON A SONG as if he's giving it a firm handshake: no pretensions or affectations, just making a warm and direct connection. The repertory of show tunes and jazz standards sometimes called the Great American Songbook has had no more durable advocate than Anthony Dominick Benedetto, born in Queens in 1926, and still swinging today. Though he had his first hits as a pop crooner, he decided to put jazz at the core of his music, enduring through eras in which he has been seen as hip, passé, and then very cool again, spanning collaborators from Count Basie to Lady Gaga. His explanation: "I never sing a song that's badly written."

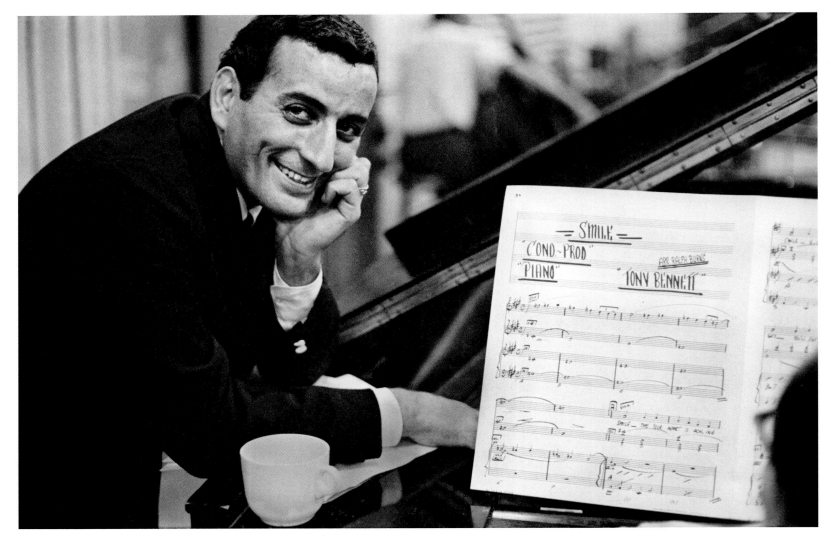

PAGE 40: Tony Bennett collaborating with pianist and arranger Ralph Burns, late 1950s.
ABOVE & PAGES 44-45: Reflecting Charlie Chaplin's "Smile," June 1959.
OPPOSITE: Conferring with Mitch Miller, left, Columbia's head of A&R from
1950-1965 and star of the television show *Sing Along with Mitch*.

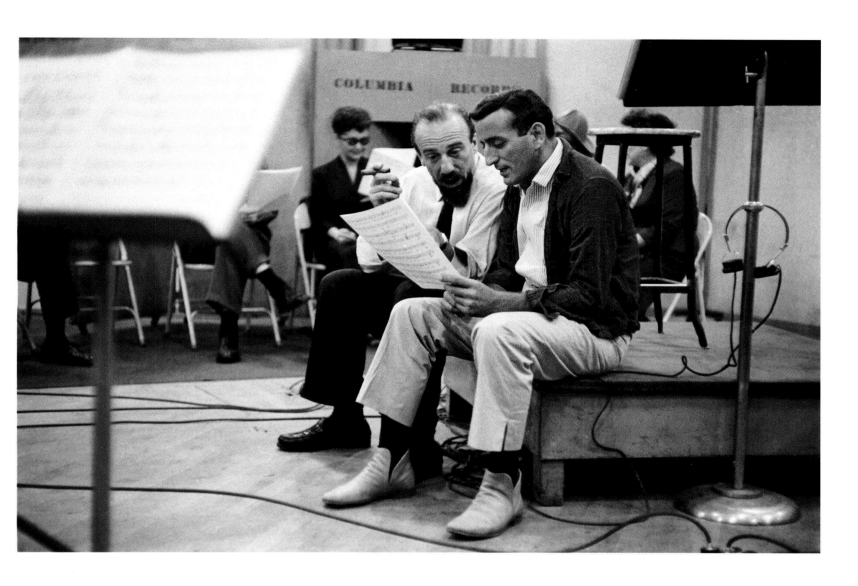

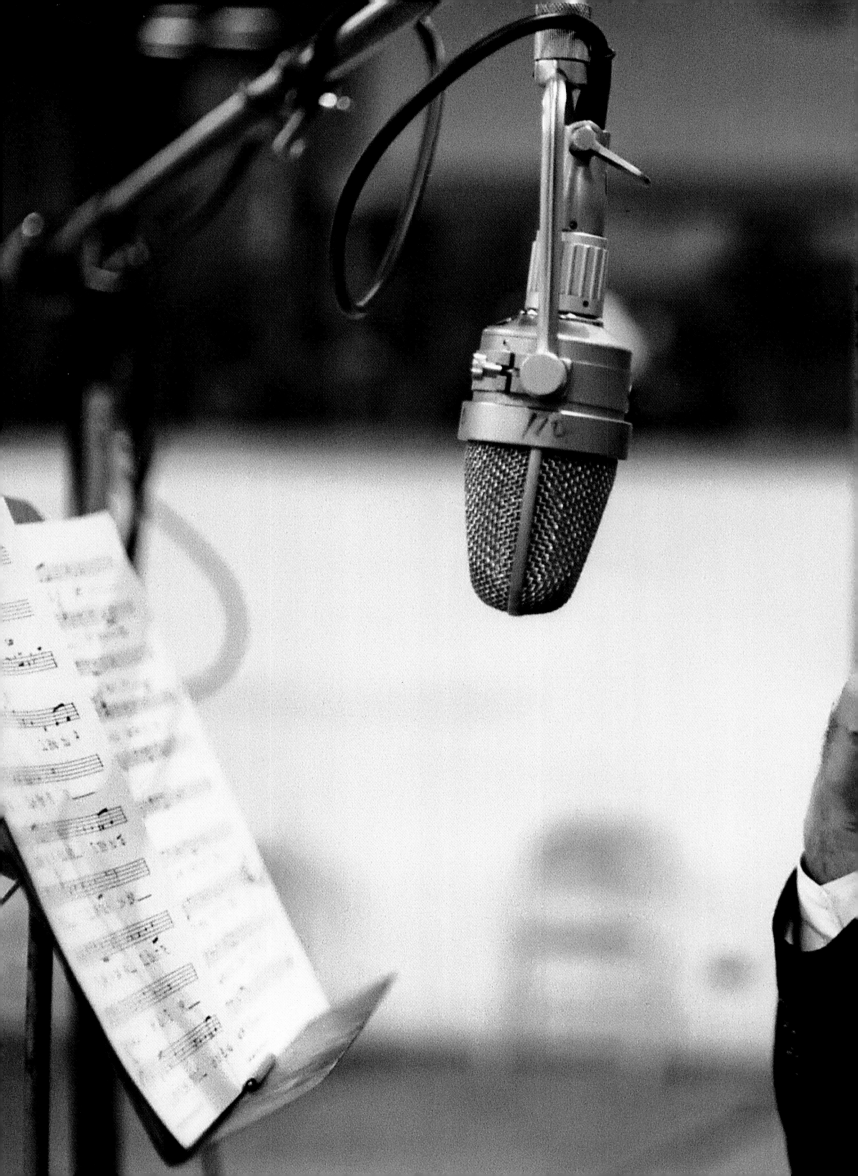

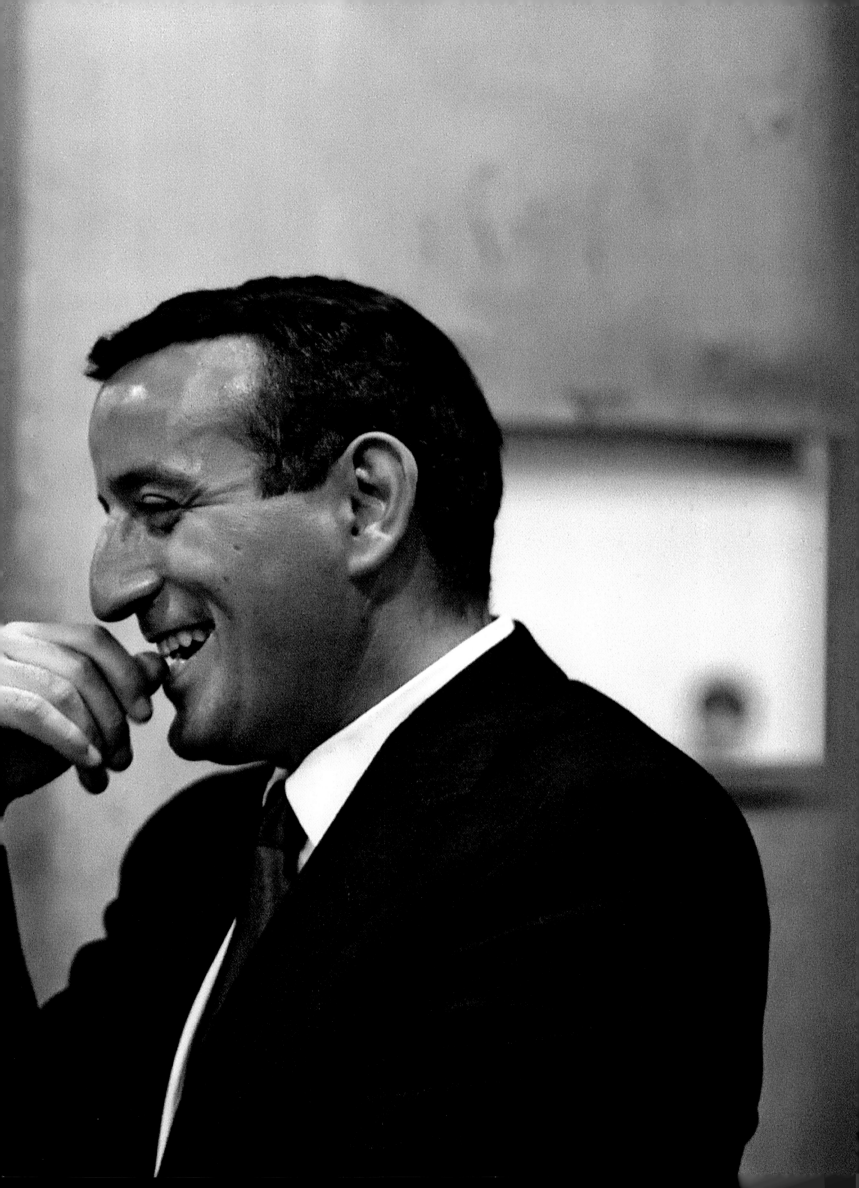

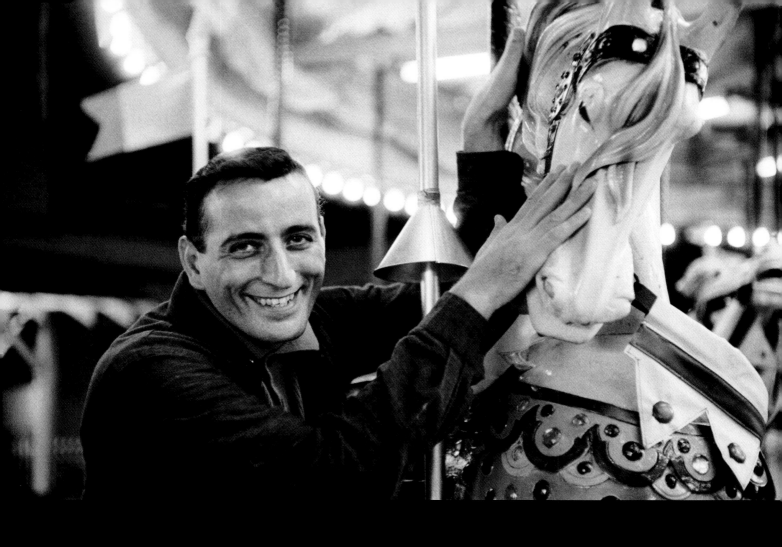

ABOVE: Riding the carousel in Central Park, New York, December 1957.
OPPOSITE: Late 1950s.

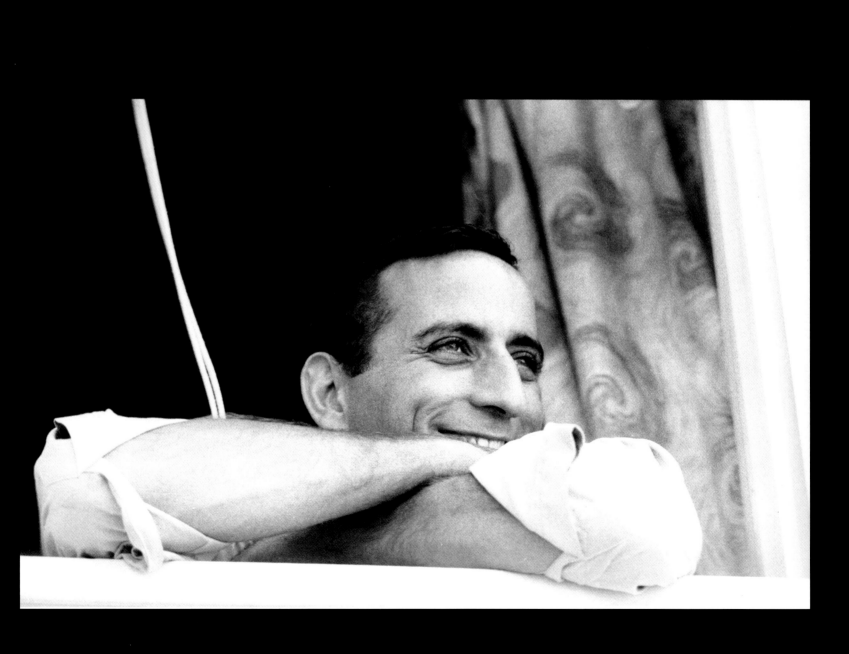

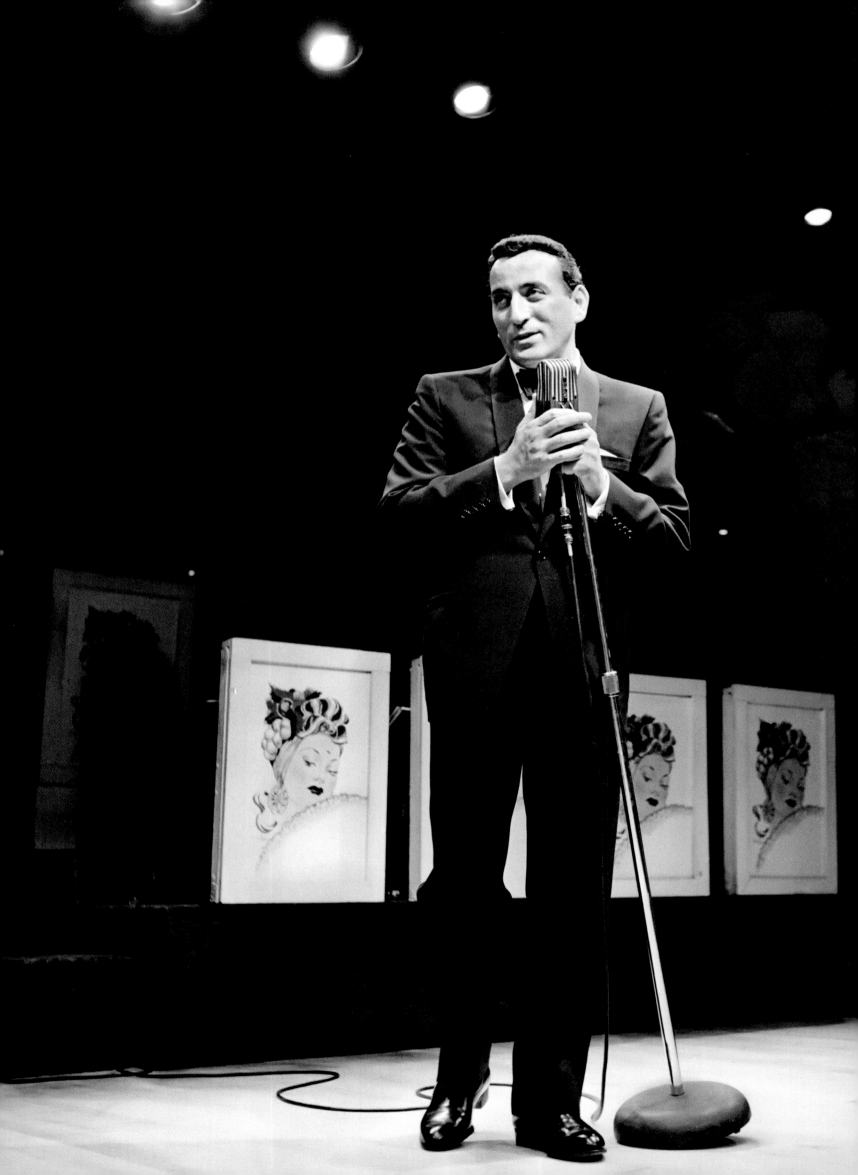

LEFT: Live at the Copacabana, New York, March 1956.
PAGES 50-51: Nightclub performance, Miami, December 1957.

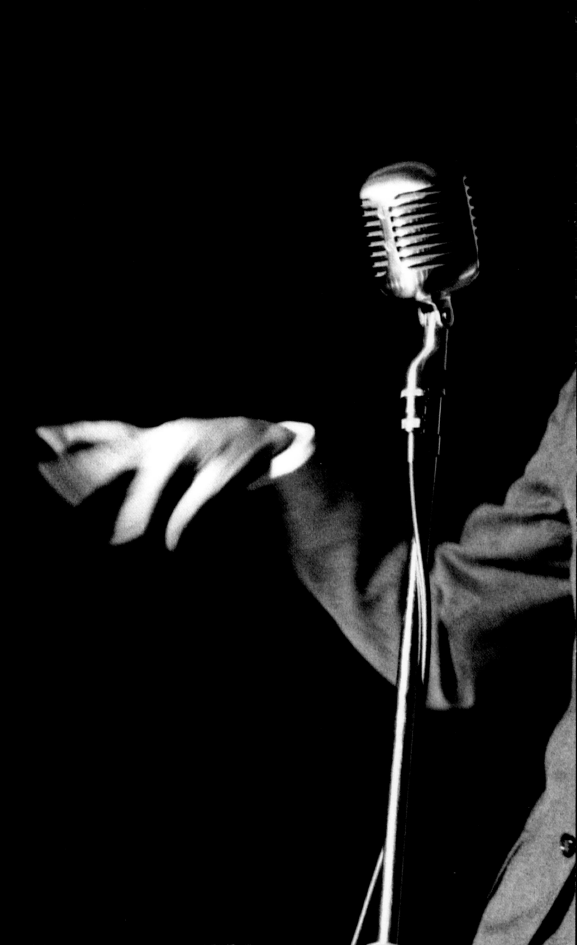

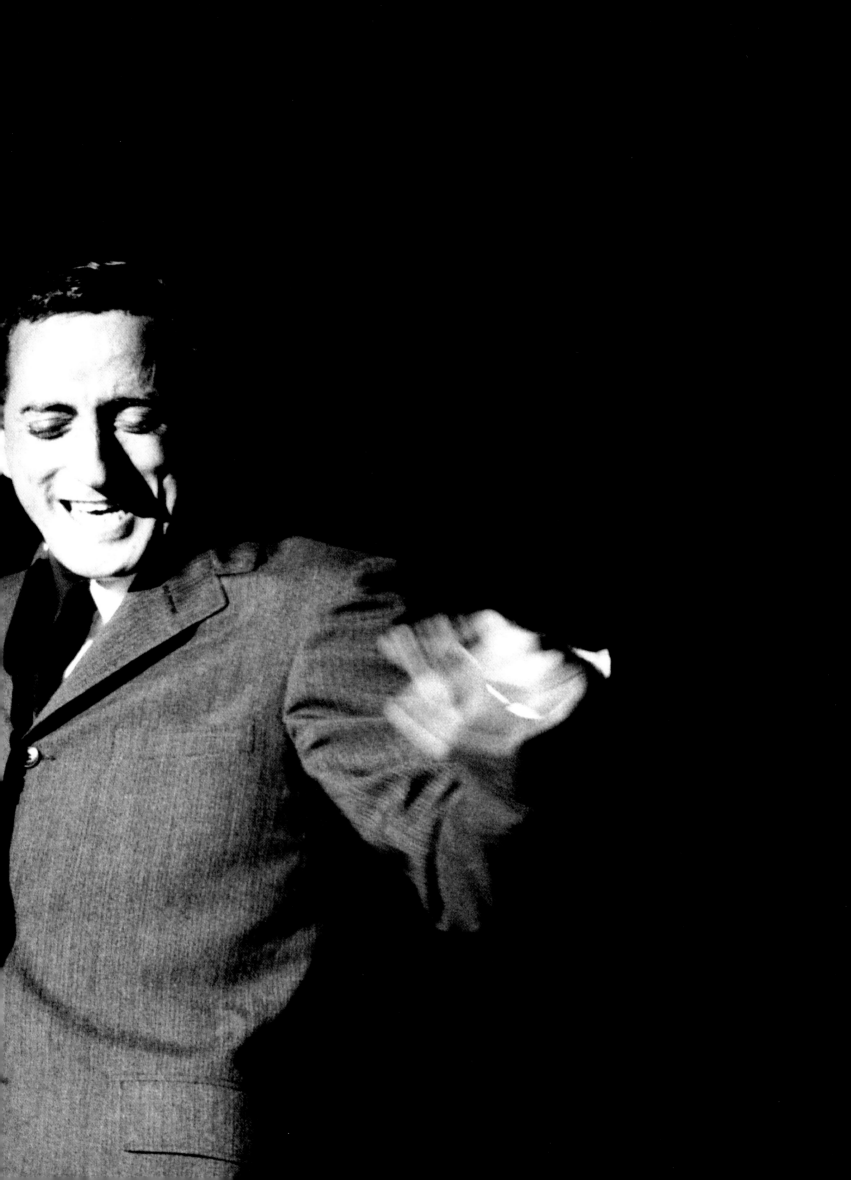

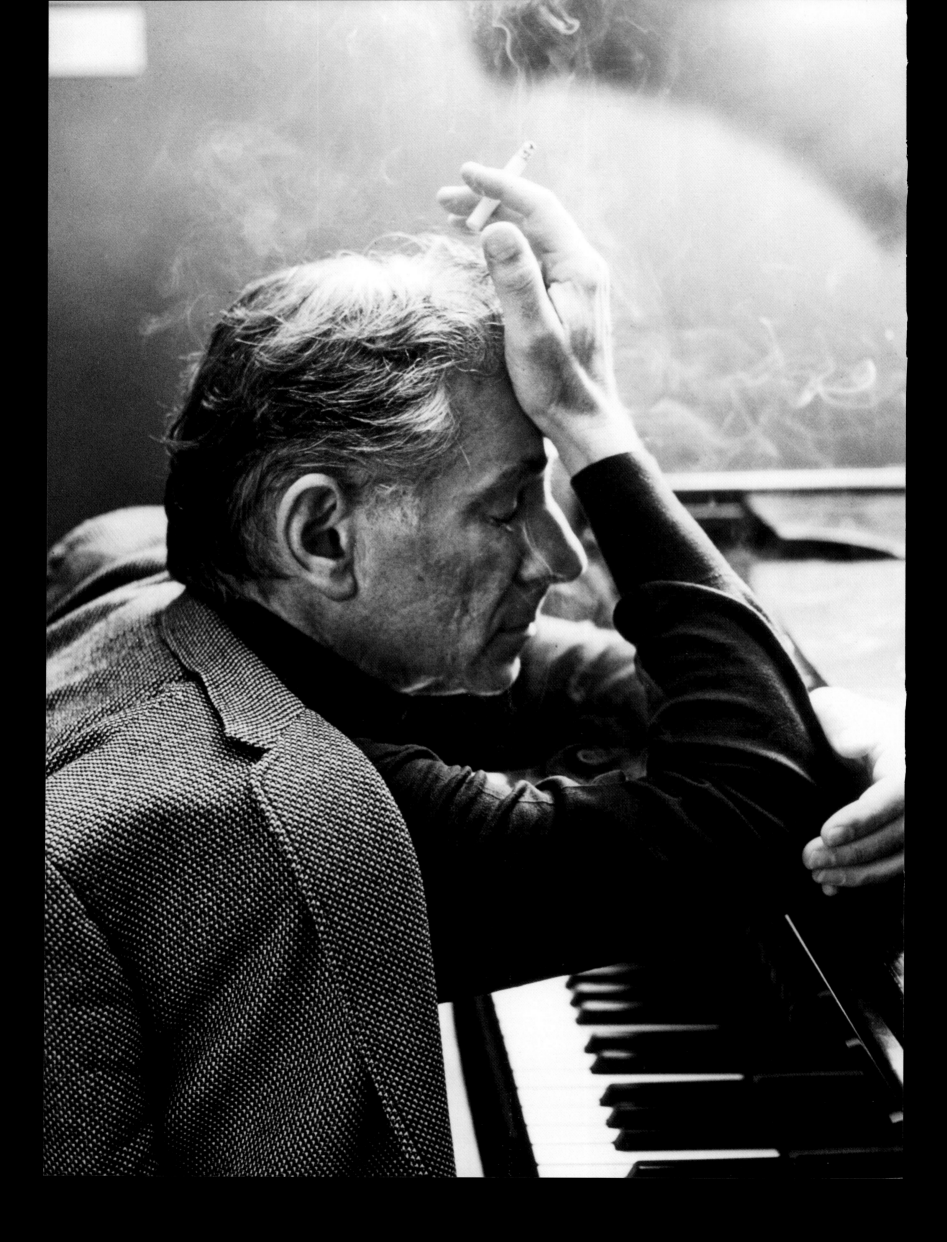

LEONARD BERNSTEIN

CLASSICAL MUSIC GOT A JOLT of American charisma from Leonard Bernstein, the music director of the New York Philharmonic from 1958 to 1969 and the composer of symphonies, operas, ballets, and Broadway musicals. To an entire generation he was the kindly, enthusiastic face of classical music, anything but stuffy. He was the articulate host of the Young People's Concerts on television. He was a balletic figure on the podium, conducting with his whole face and body. He was a passionate advocate for Gustav Mahler and for contemporary American composers. And he was a knowing connoisseur of popular music who infused his own compositions—not least the indelible score for *West Side Story*—with the verve of jazz and Latin music. Bernstein traveled the world, galvanizing listeners and revealing cultural links, proving that the music he loved was no museum piece.

PAGE 52: Leonard Bernstein, New York, February 1970.
RIGHT: Recording Stravinsky's *Oedipus Rex* with the
Boston Symphony Orchestra, Cambridge, Massachussetts,
December 1972.

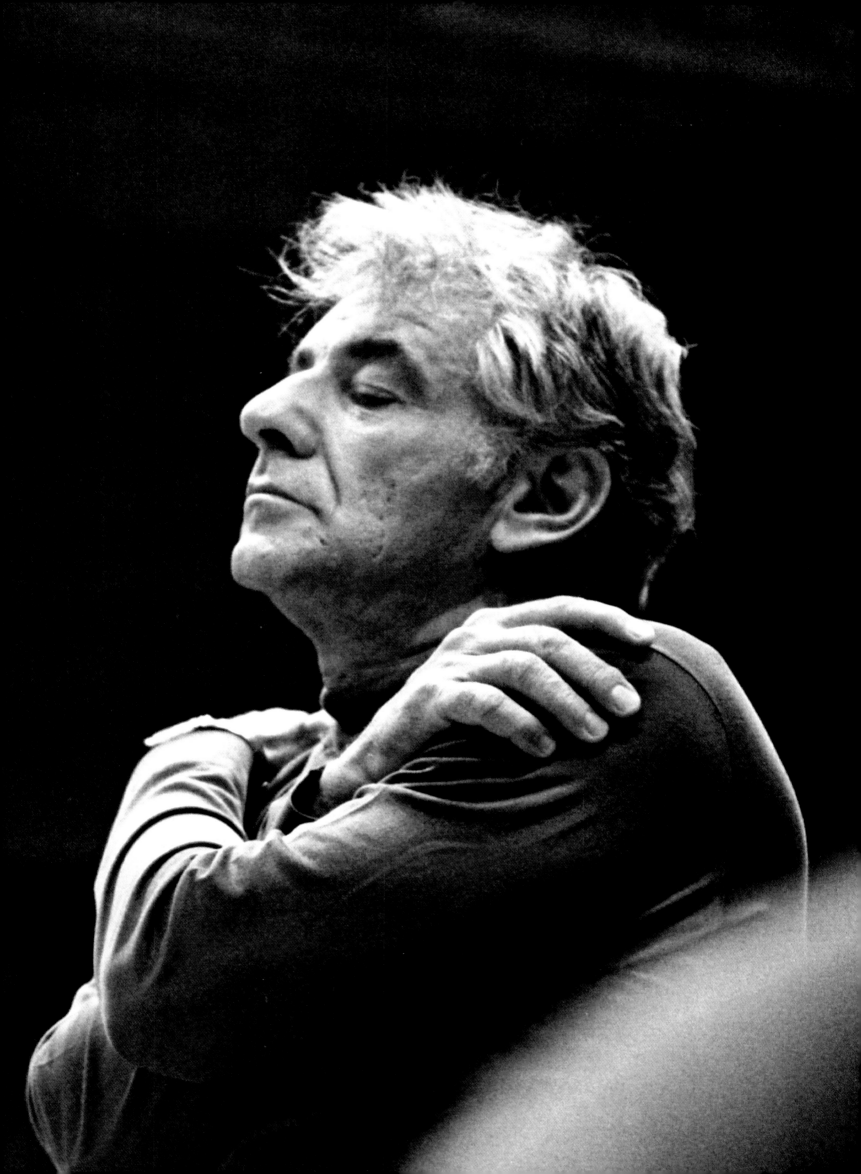

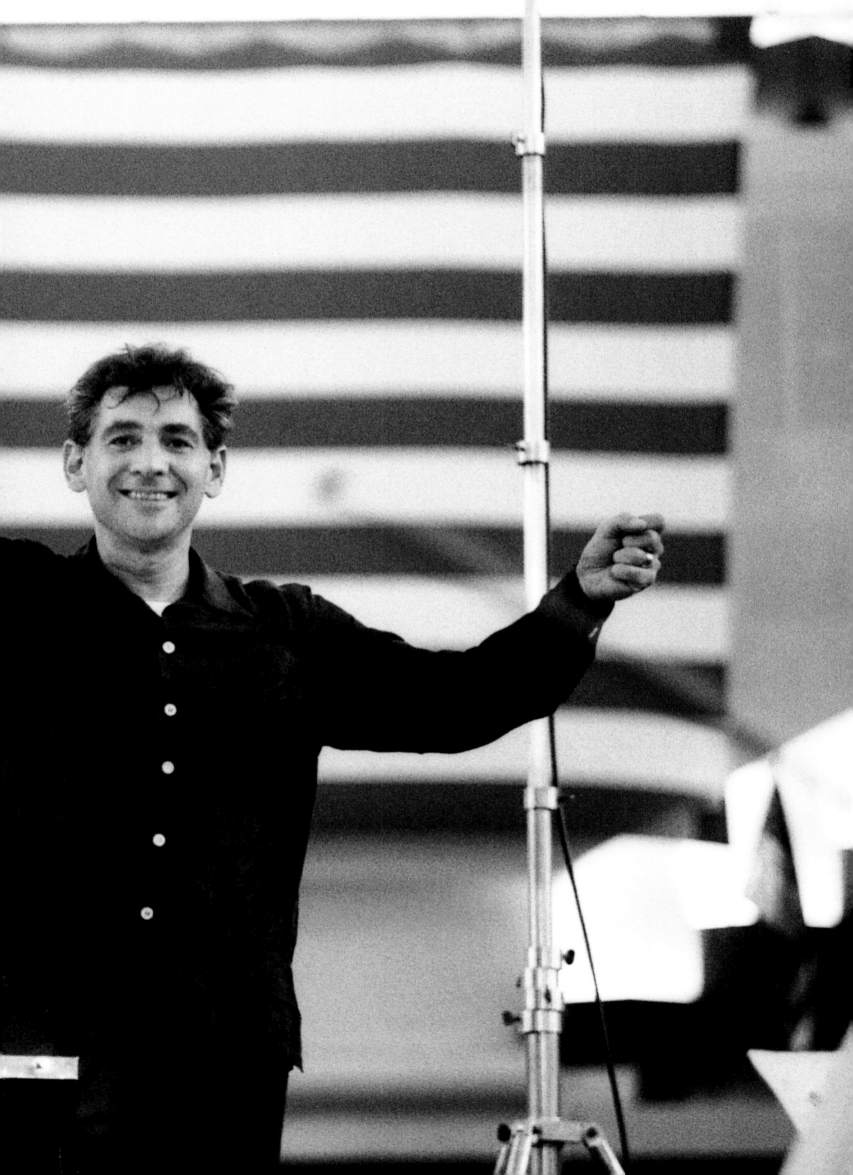

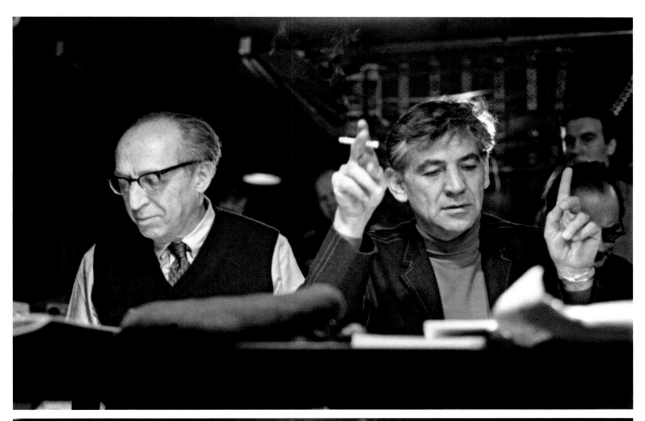

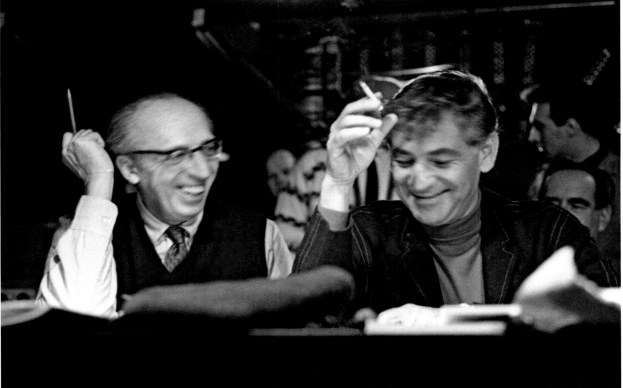

PAGES 56-57: Rehearsing Gershwin's *An American in Paris*
at the St. George Hotel, Brooklyn, New York, January 1959.
OPPOSITE, TOP & ABOVE: Recording *Appalachian Spring*
with Aaron Copland, left, January 1964.

Leonard Bernstein,
January 1959.

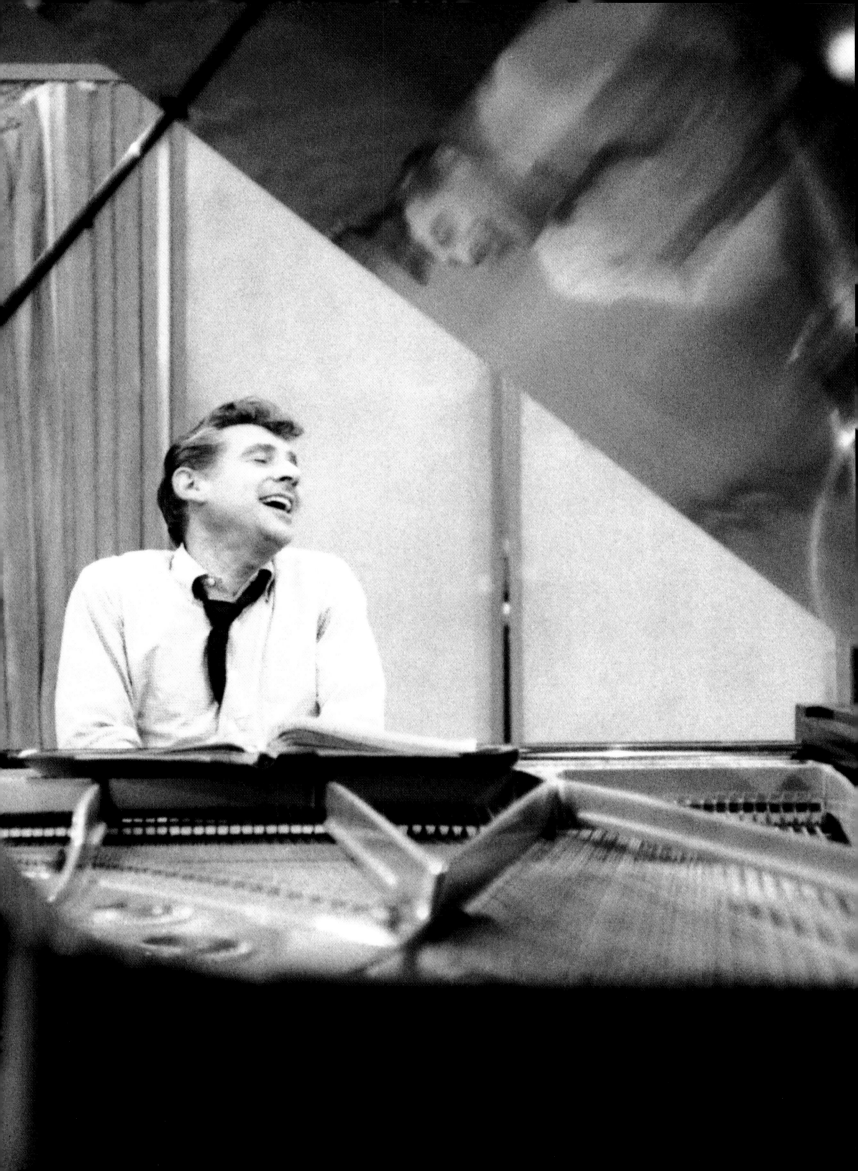

GLENN GOULD

IN 1955, WHEN HE WAS TWENTY-TWO, the Canadian pianist Glenn Gould recorded a revelatory performance of Bach's *Goldberg Variations* that would shake up the classical world: analytical and songful, brash and elegant, idiosyncratic and authoritative. It introduced a musician who could never be conventional. He sat in a low chair at the piano, his face close to the keyboard, humming and grunting as he played, rarely ever using the sustain pedal. In 1964, he withdrew from live performance in favor of the perfectibility of music edited in the recording studio: "The concert is dead," he declared. He grew reclusive in his later years. But he was not shy about the camera, particularly Don Hunstein's; through the years they conspired together on images full of experiments and mischief.

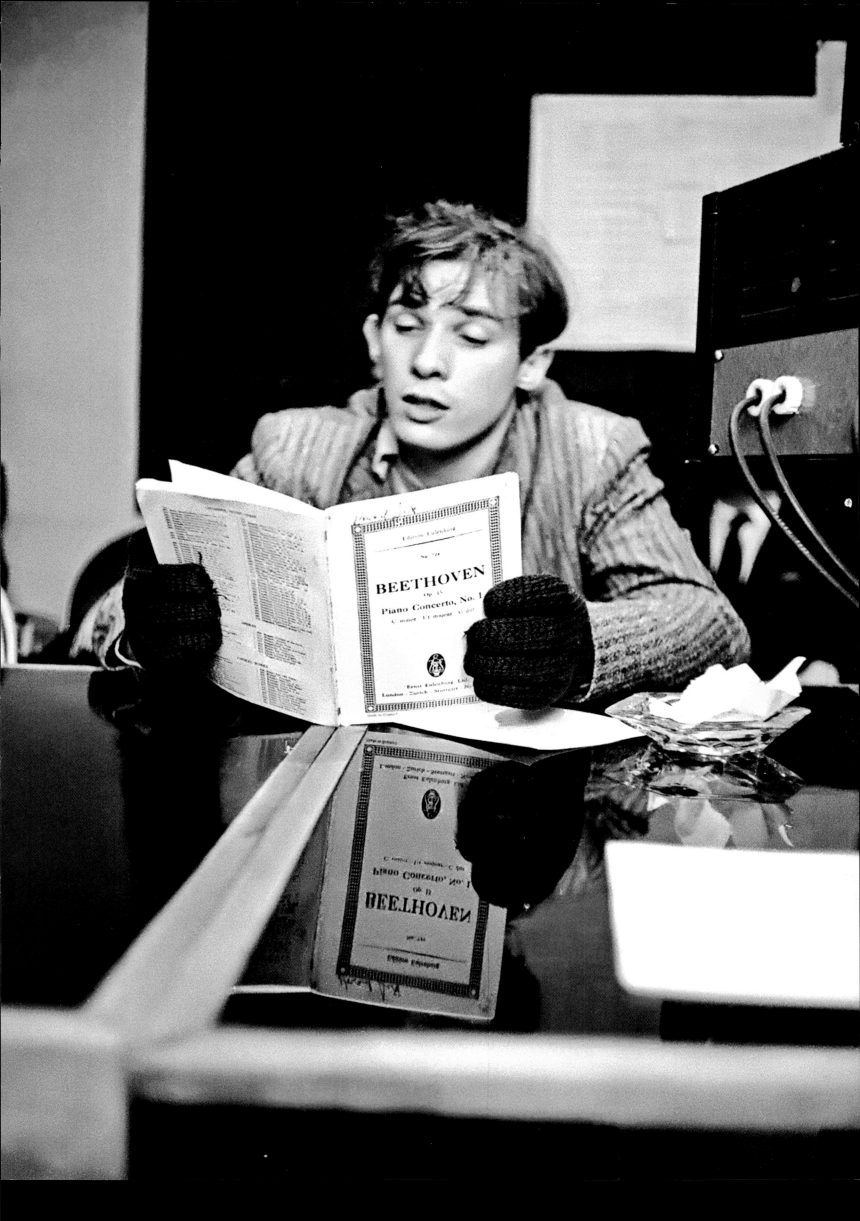

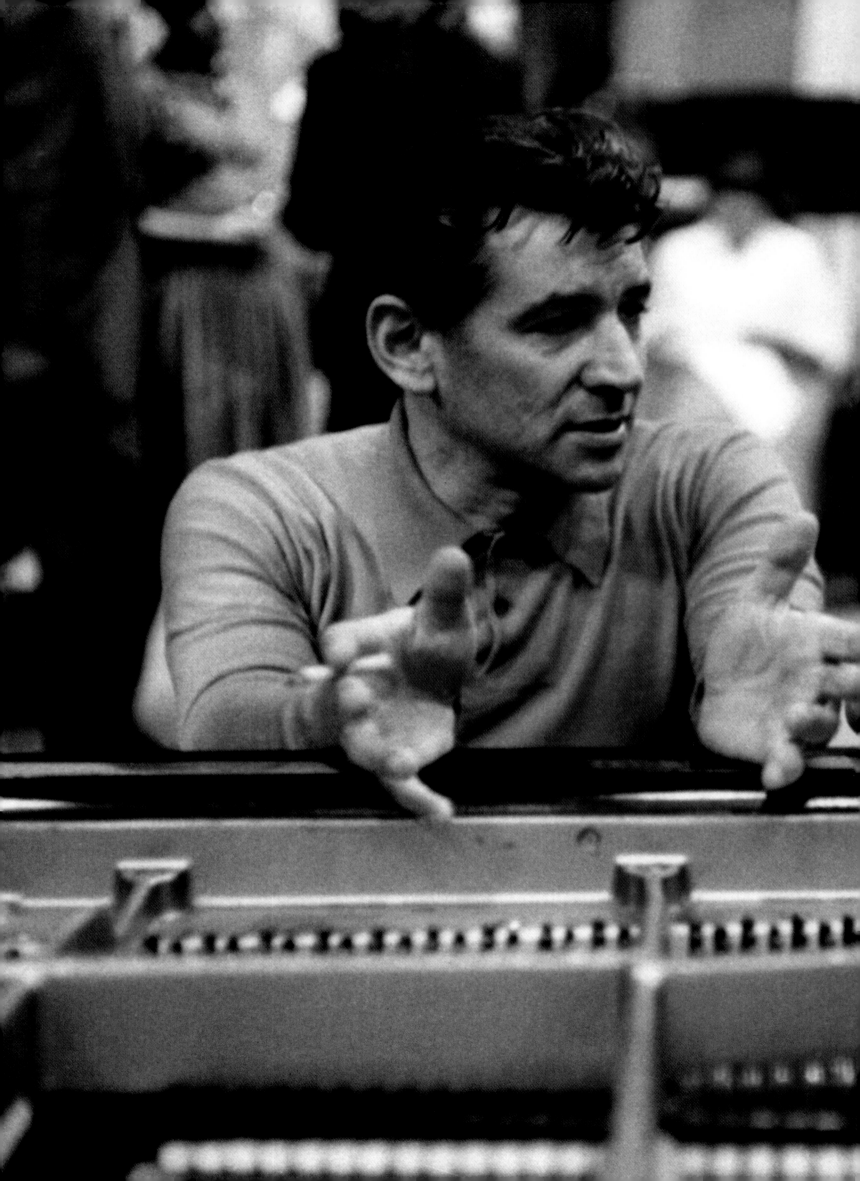

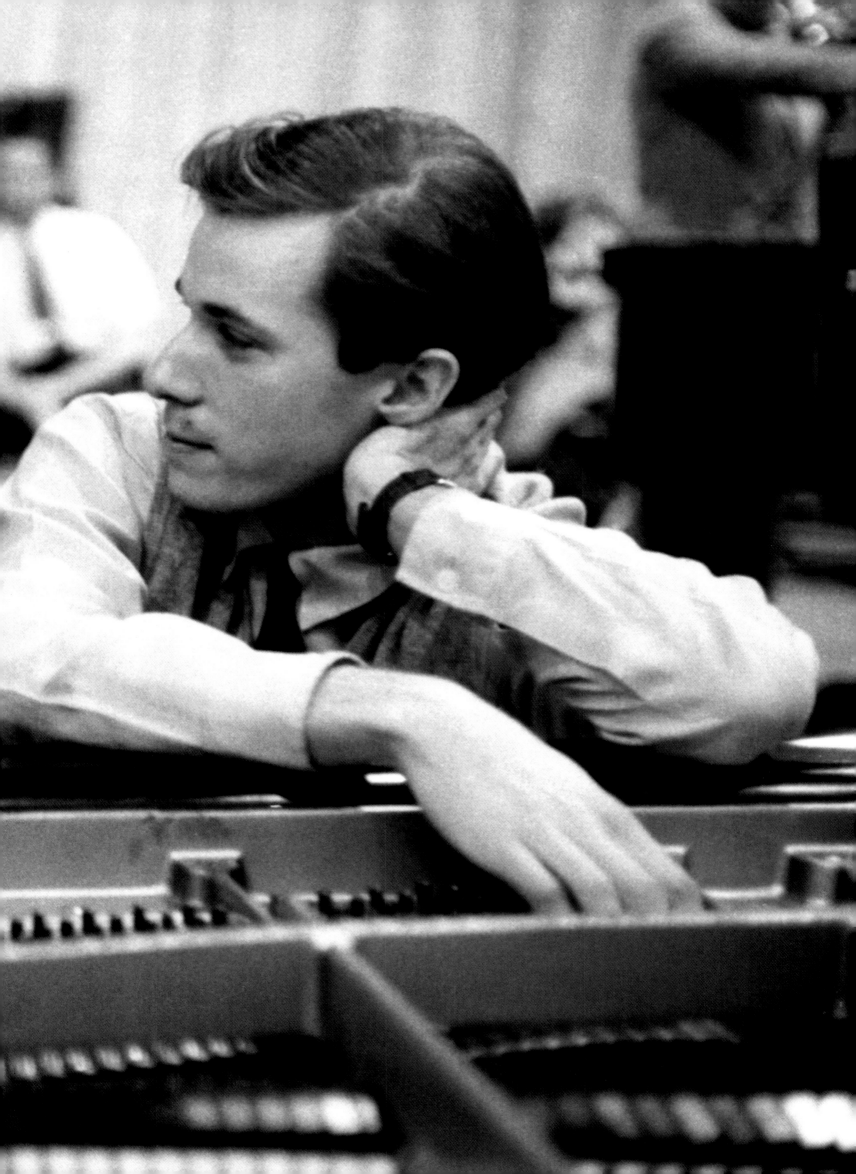

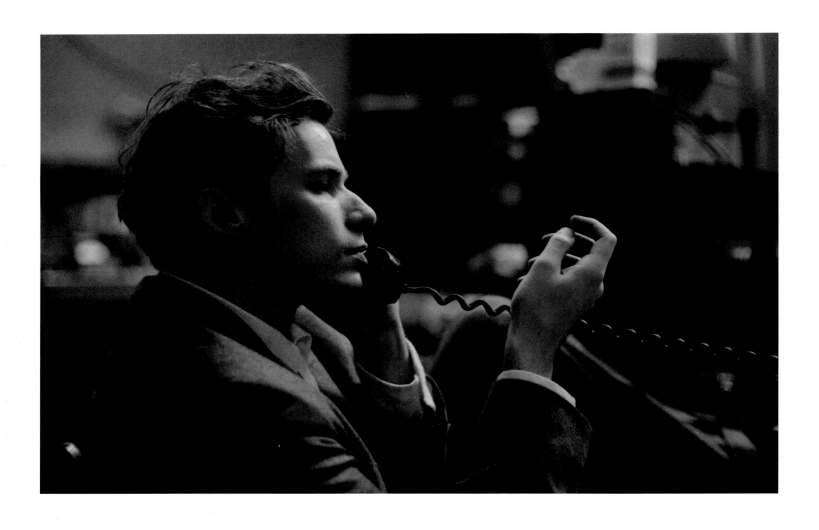

PAGE 63: Glenn Gould reading Beethoven, January 1958.
PAGES 64-65: Recording Bach concertos with Leonard
Bernstein, left, and the Columbia Symphony Orchestra, April 1957.
ABOVE & OPPOSITE: November 1957.

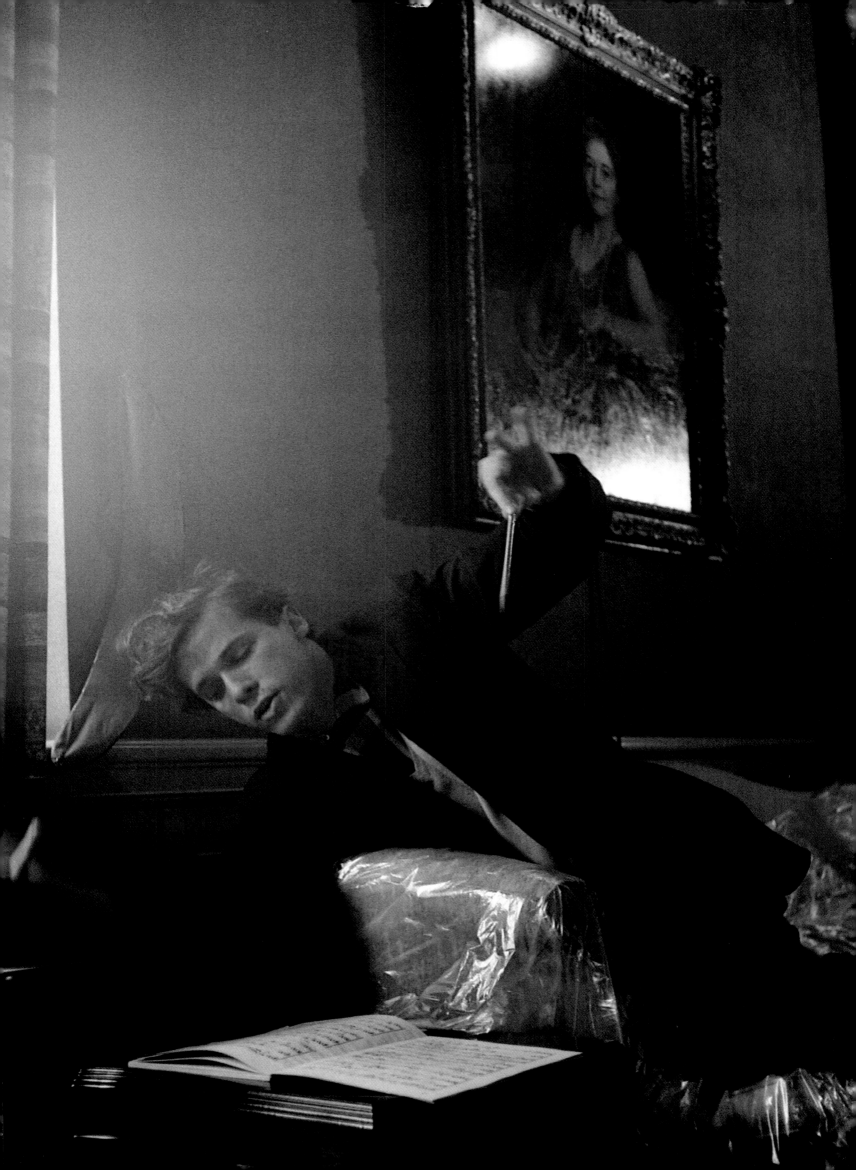

April 1957.

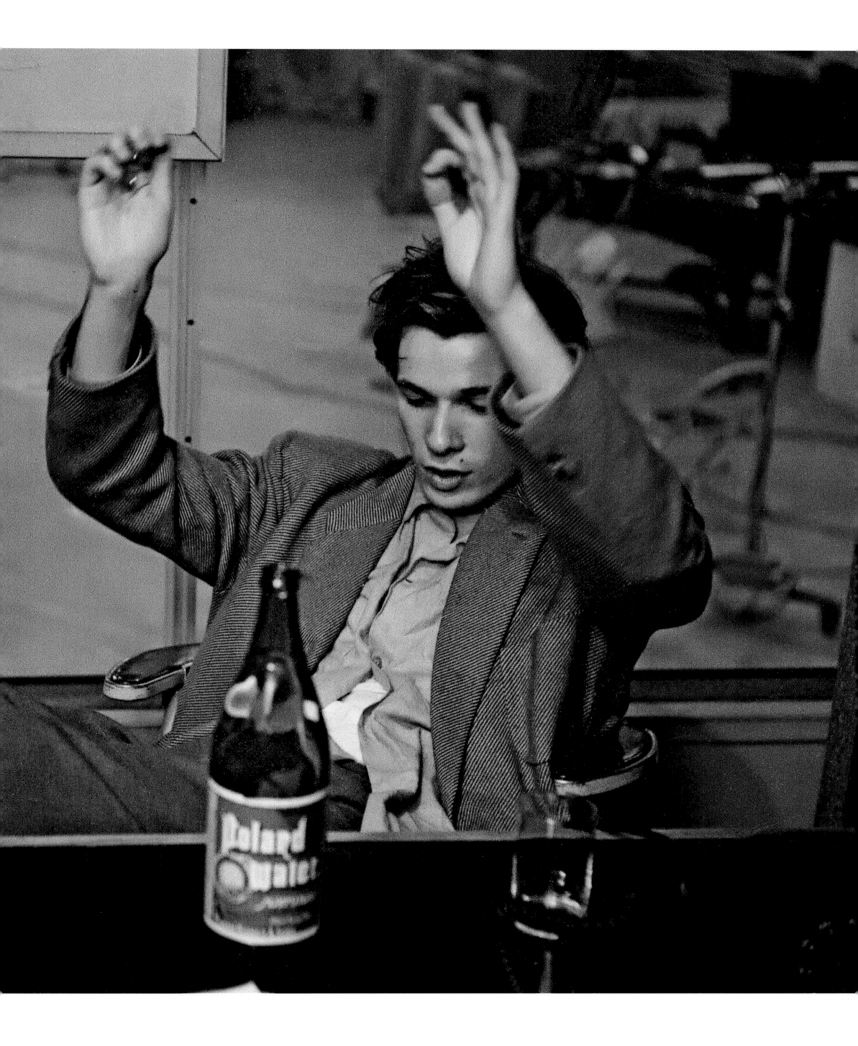

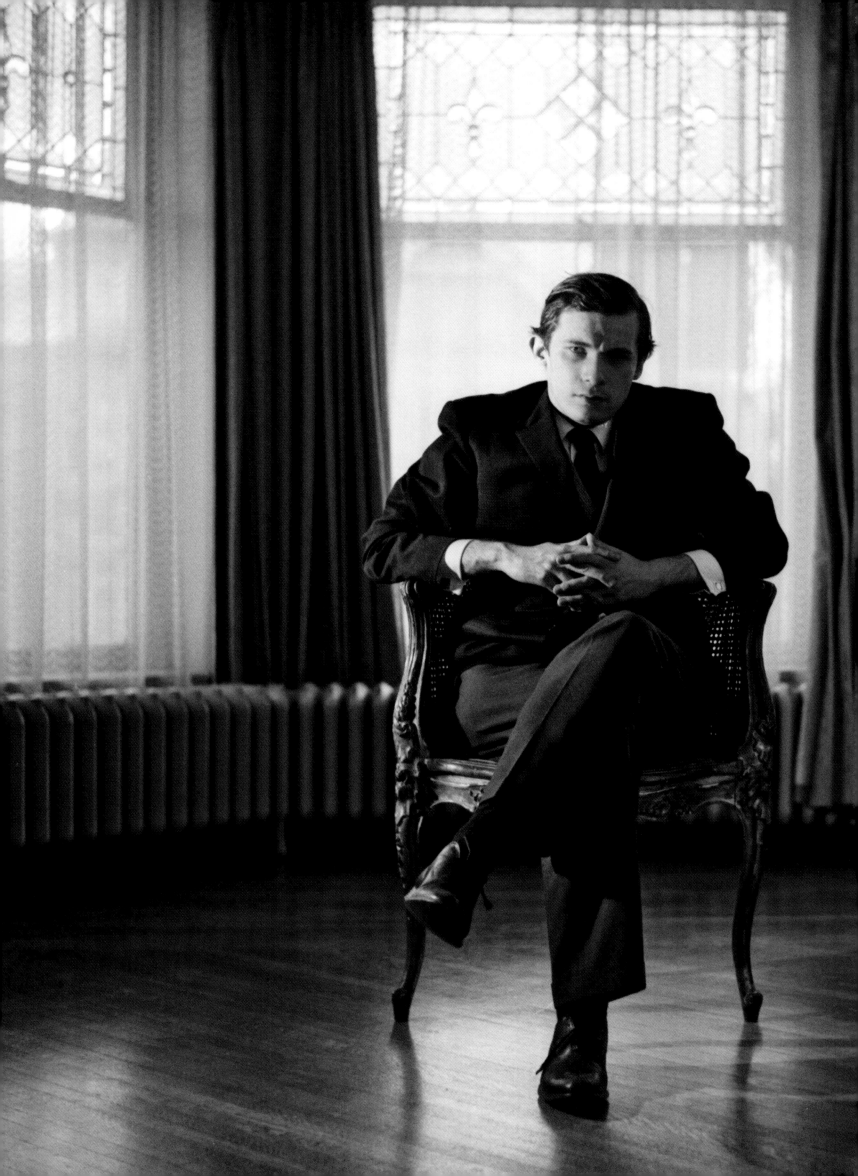

LEFT: Toronto, February 1961.
PAGES 72-73: Auditioning pianos at 30th Street Studios, April 1957.

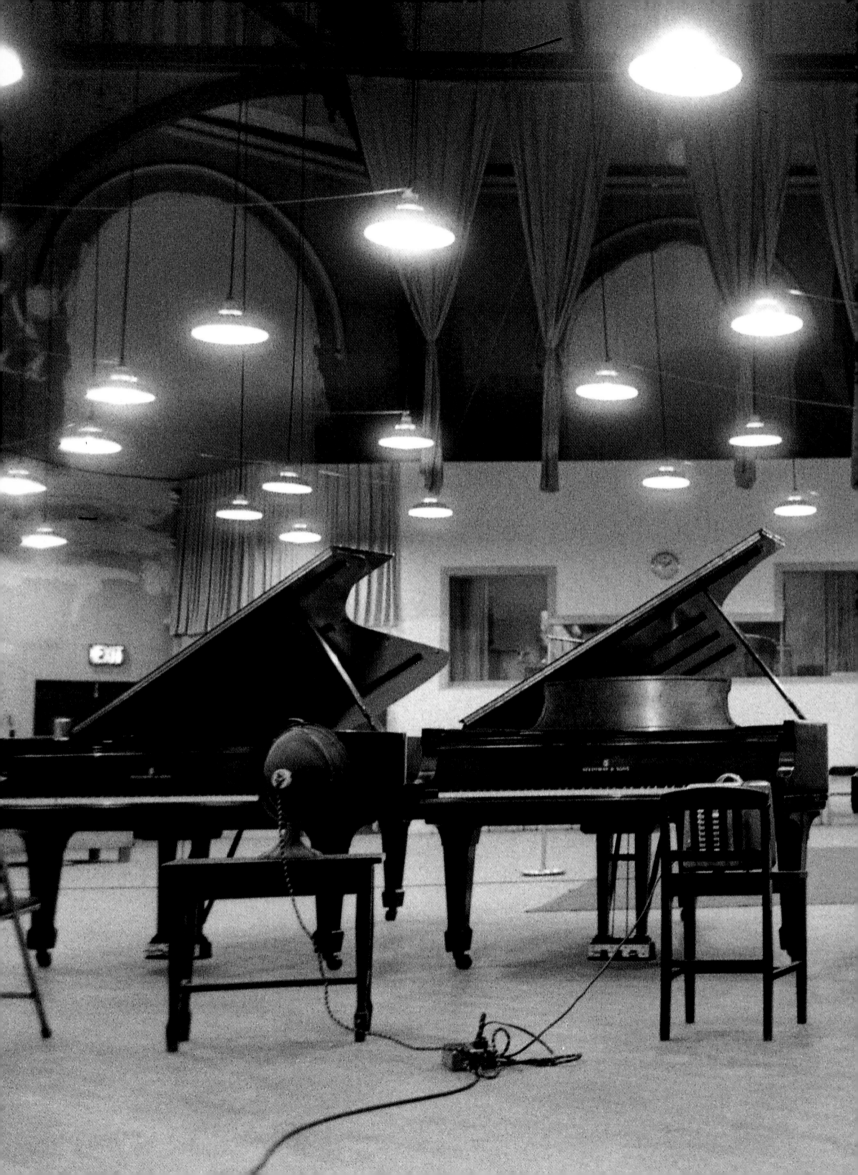

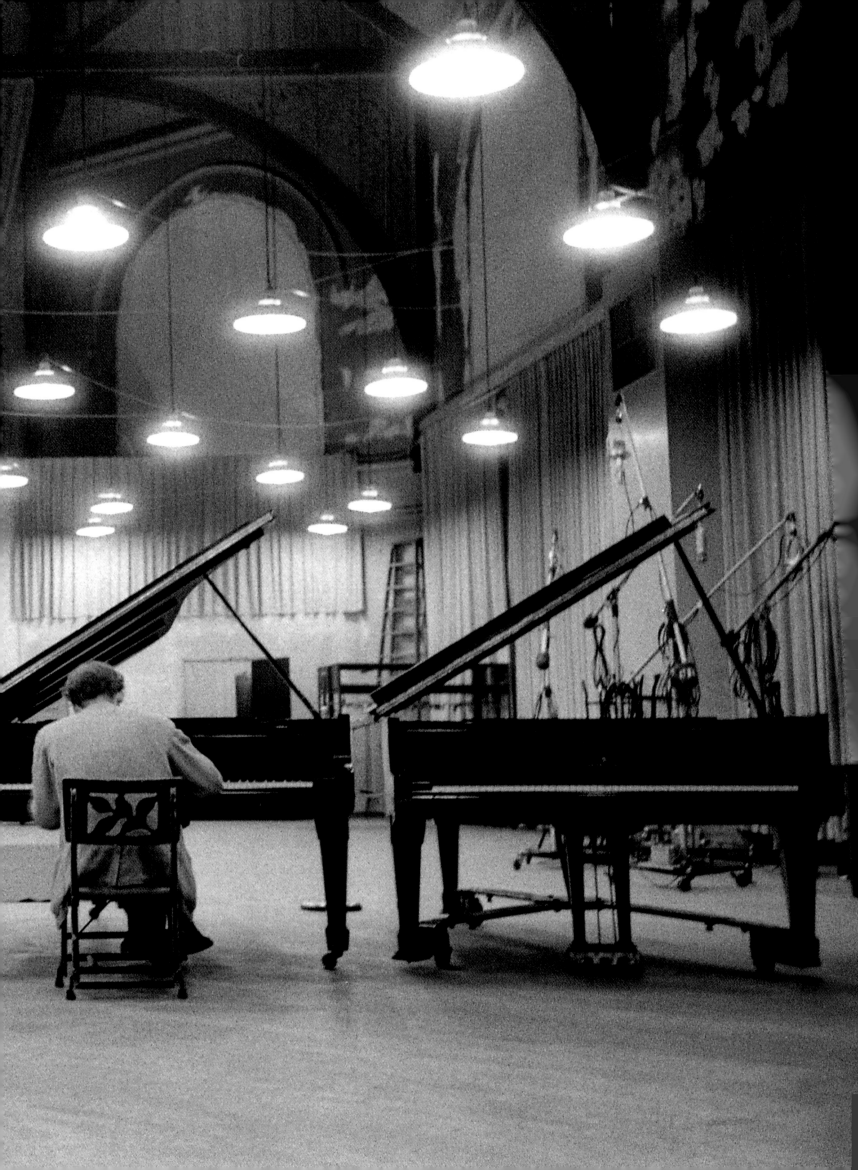

IGOR STRAVINSKY

THE RUSSIAN COMPOSER Igor Stravinsky was not one to be pinned down. He was a radical modernist and a knowing neoclassicist, a cosmopolitan expatriate and a deeply Russian spirit, a systematic thinker and a sophisticated joker, a composer who claimed to reject emotion in music and a creator of gorgeously visceral effects. He settled in the United States in 1939 and, working with Columbia Records, set about solidifying his own legacy. He conducted his own compositions, old and recent, preserving his interpretations for posterity. Beethoven couldn't do that.

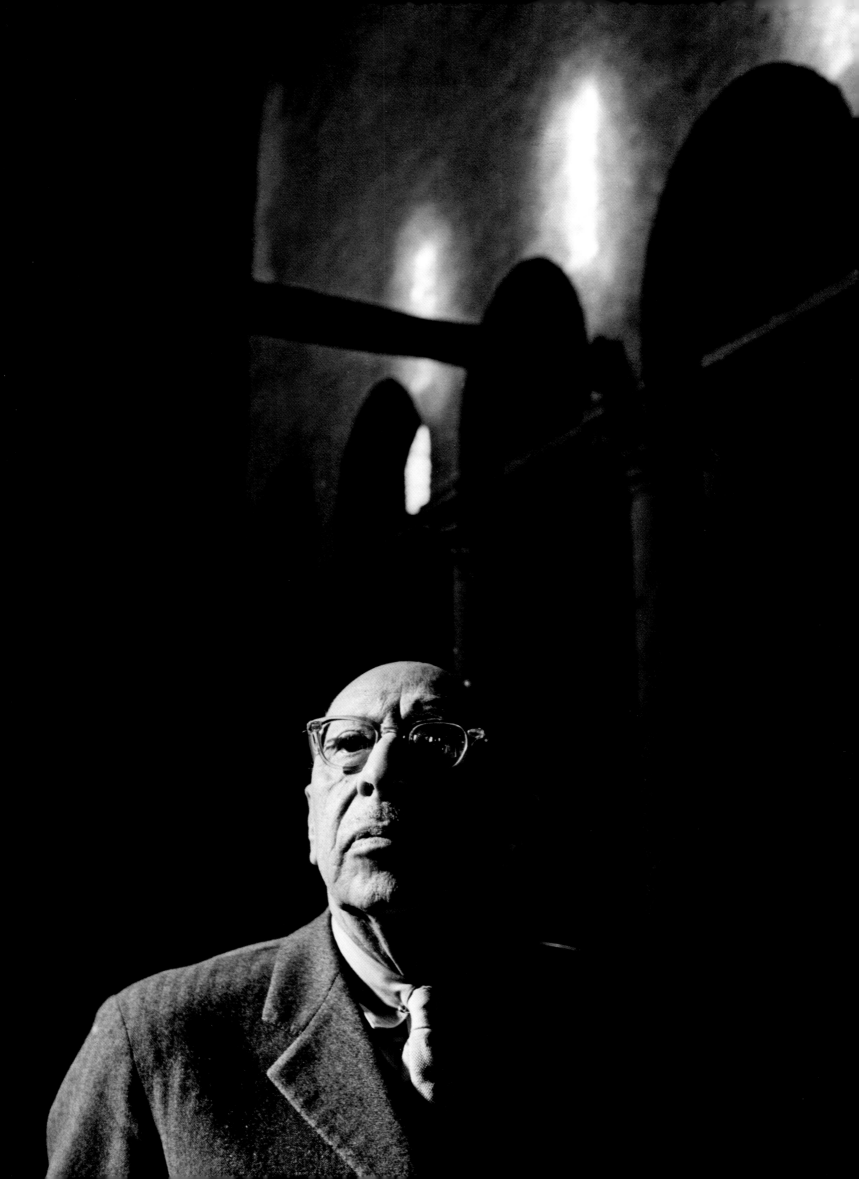

PAGE 75: Igor Stravinsky, Venice, Italy, September 1969.
ABOVE & OPPOSITE: Conducting *The Rite of Spring* at Carnegie Hall, January 1960.

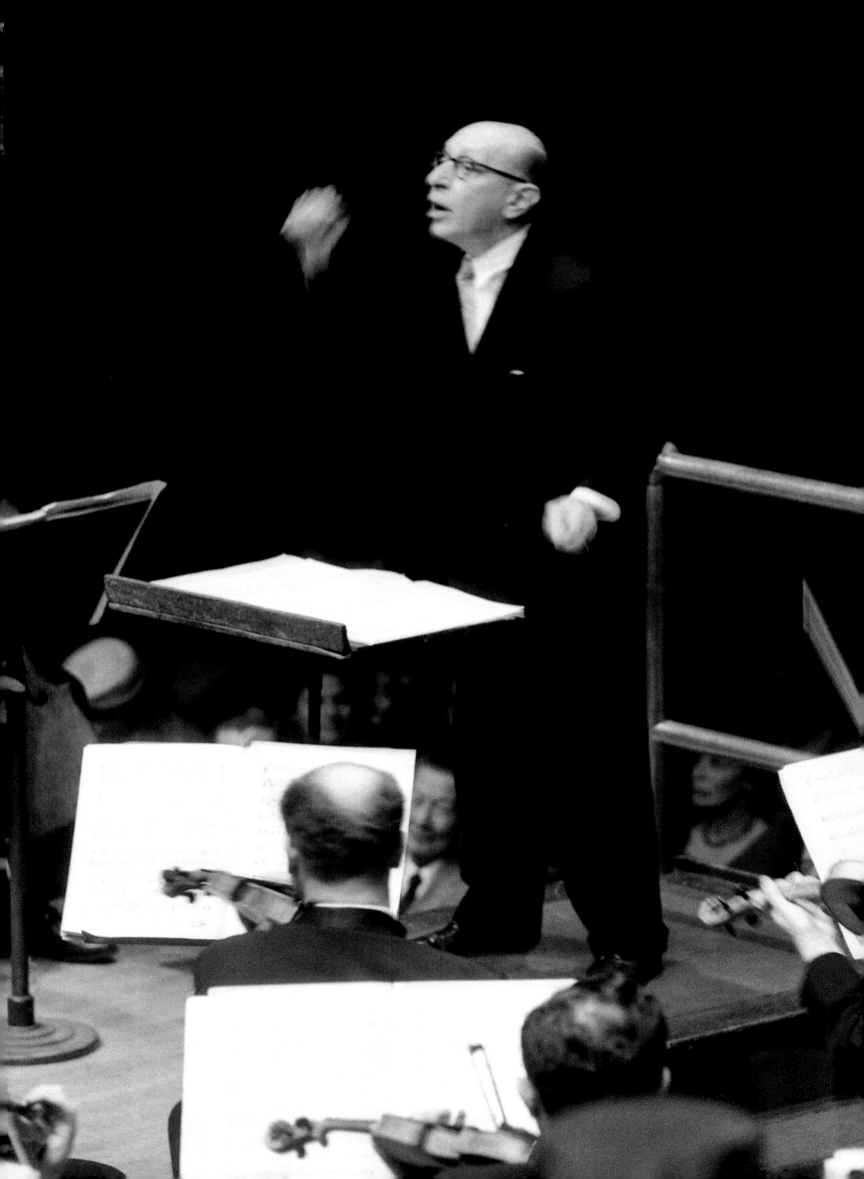

January 1959.

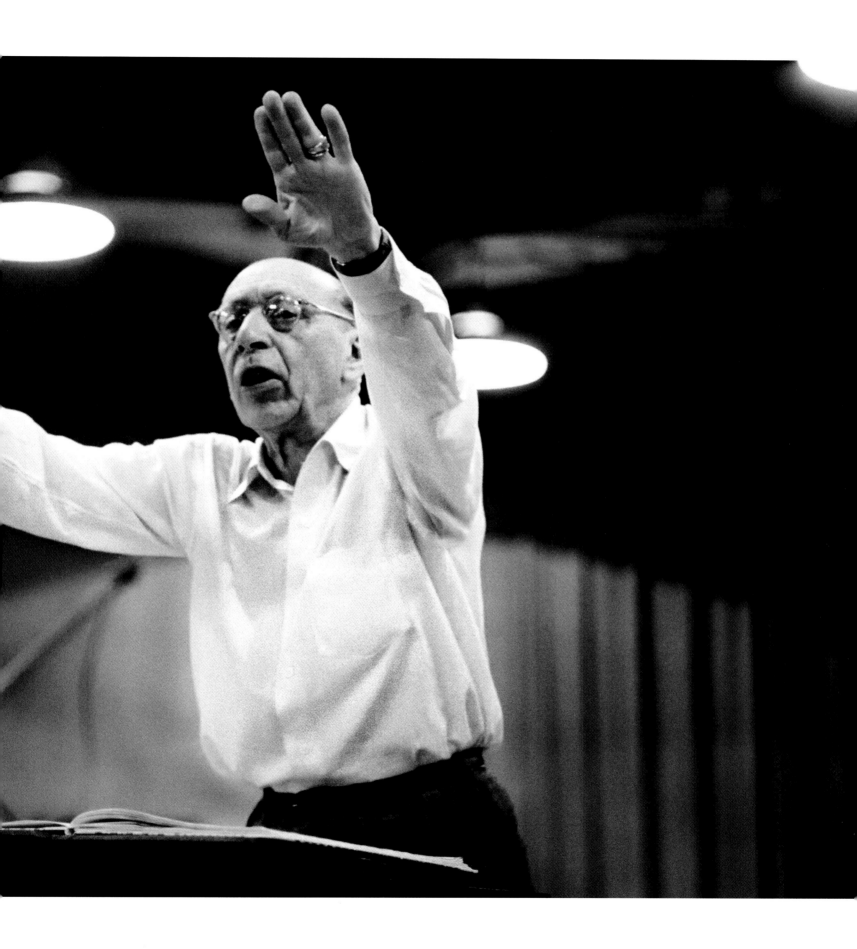

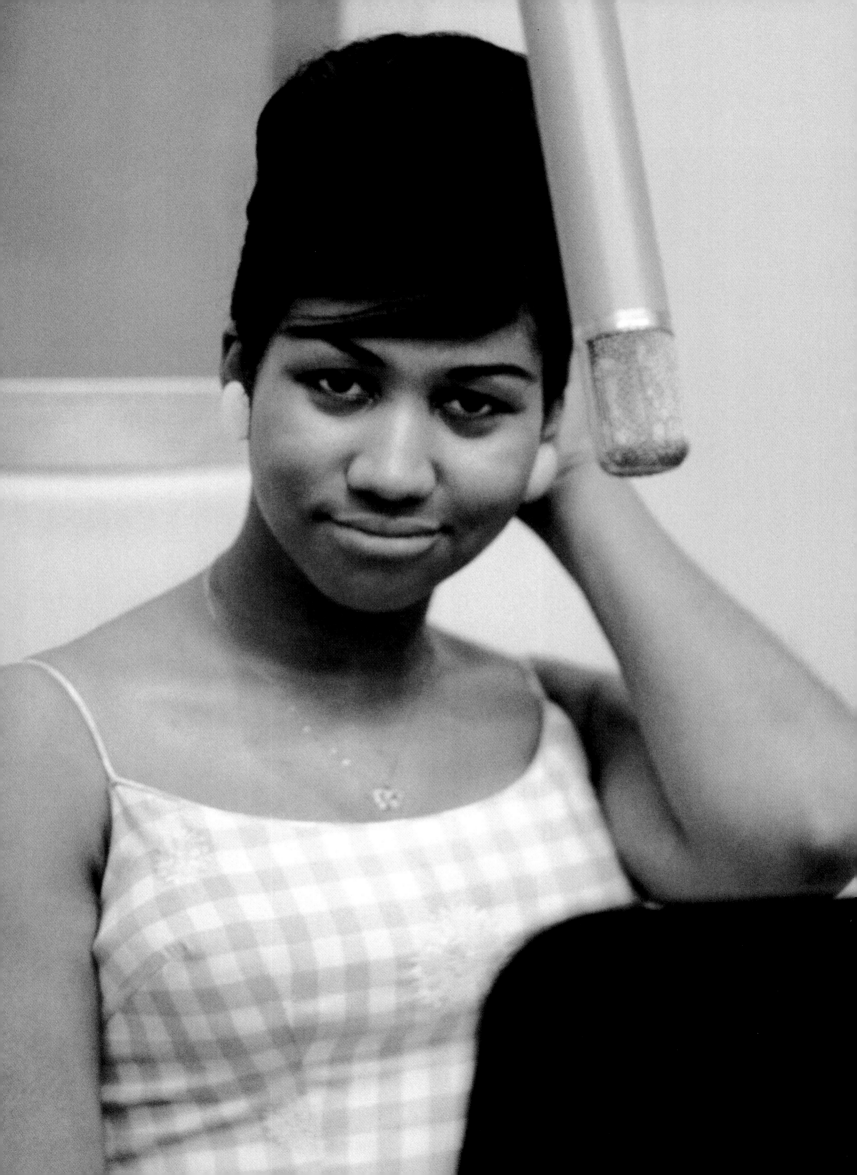

ARETHA FRANKLIN

THE WOMAN WHO WOULD BECOME the Queen of Soul was still finding her direction when she recorded for Columbia Records in the first half of the 1960s. Her magnificent voice was there from the start, with the fervor of gospel and the agility of jazz, but the material that would make her iconic was not yet in hand. She tried blues, jazz standards, show tunes, and girl-group hits, often singing up a storm but not gaining traction. The photos here are of a young, prodigiously gifted woman learning on the job.

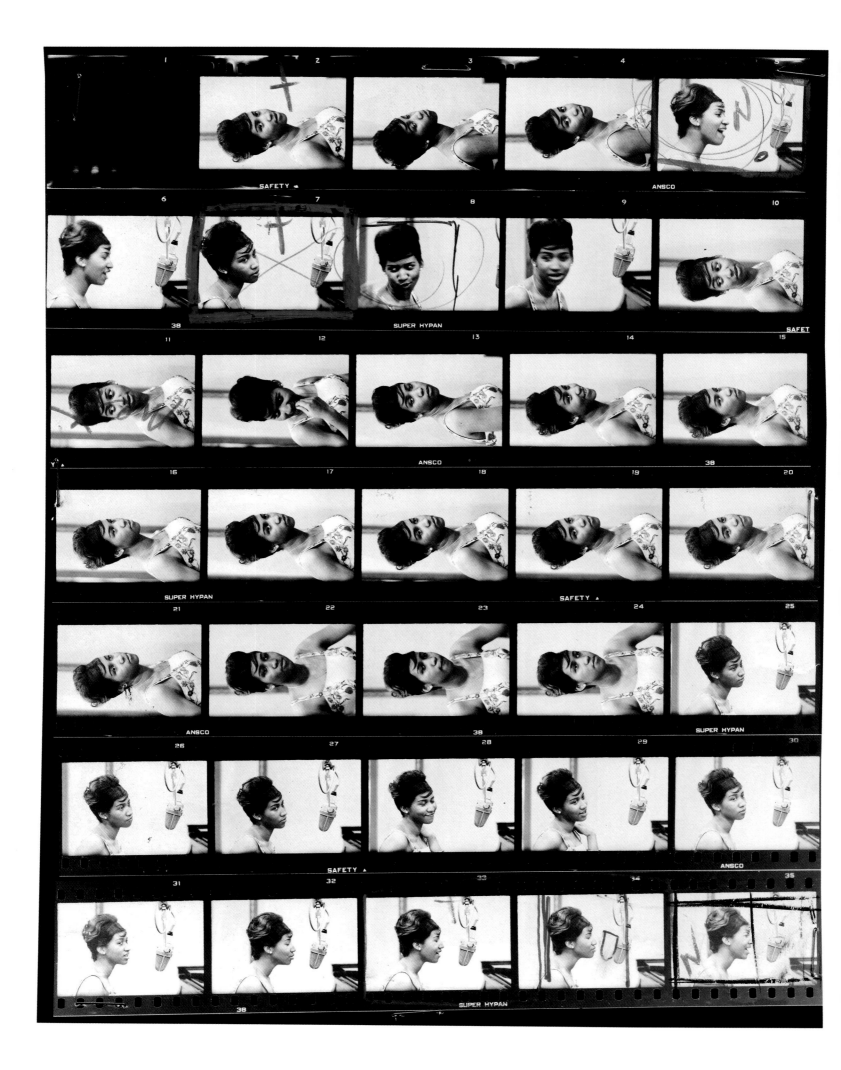

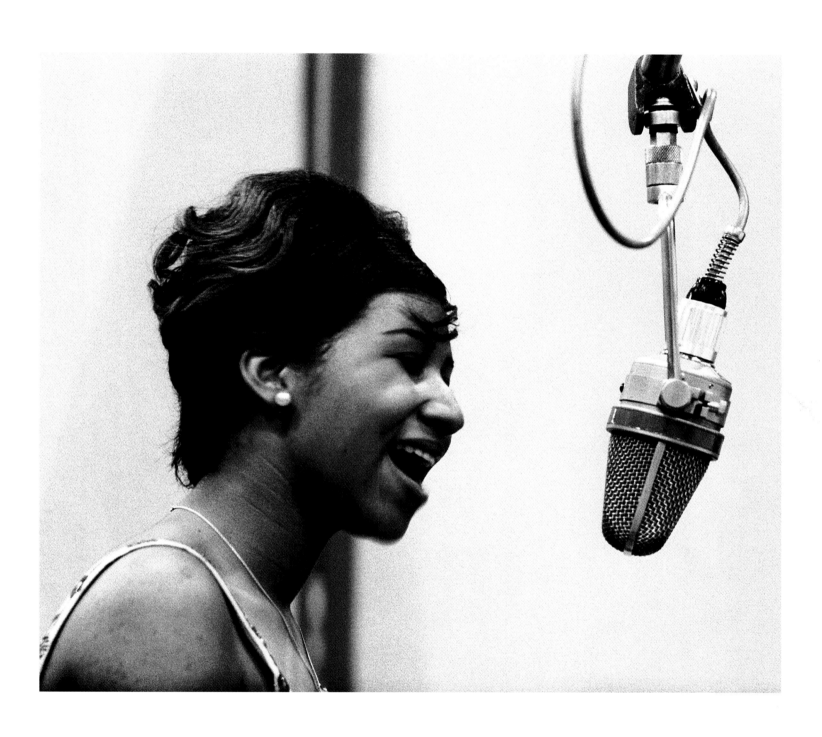

PAGE 80: Recording *The Electrifying Aretha Franklin*, New York, July 1961.
OPPOSITE, ABOVE & PAGES 84-85: Recording the first sides for Columbia Records, New York, August 1960.

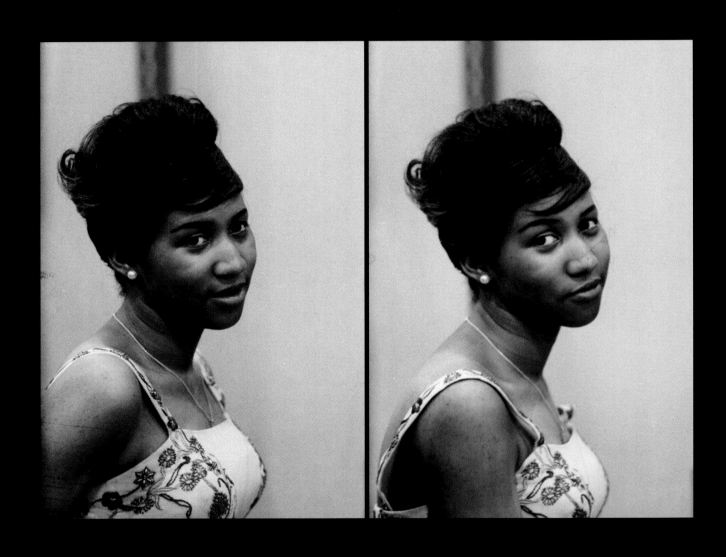

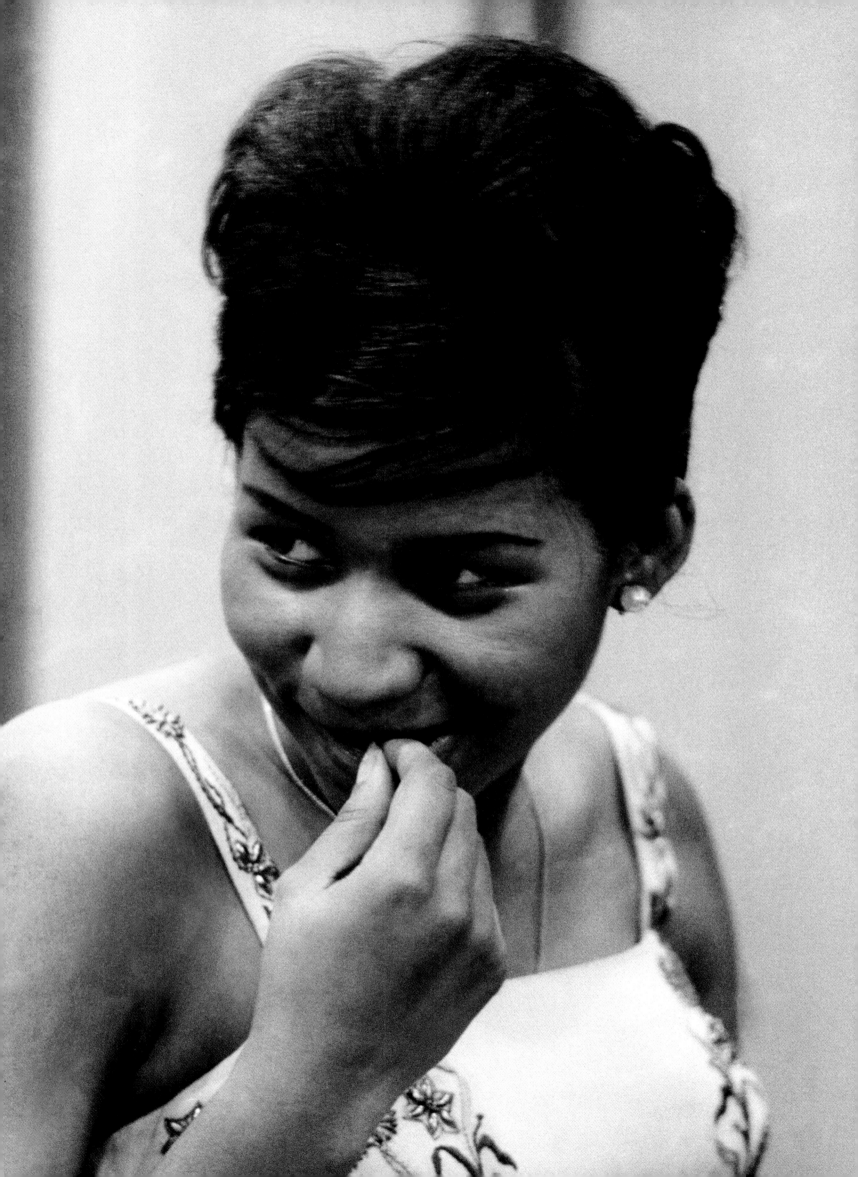

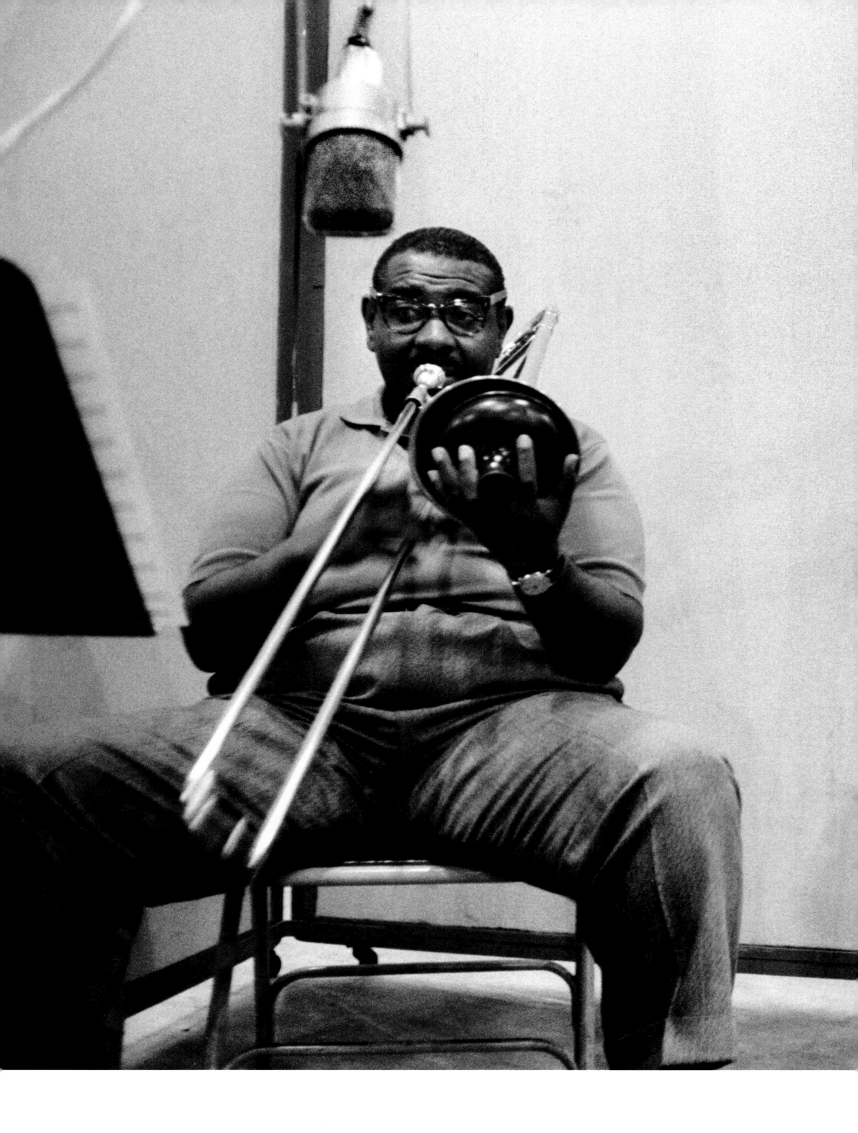

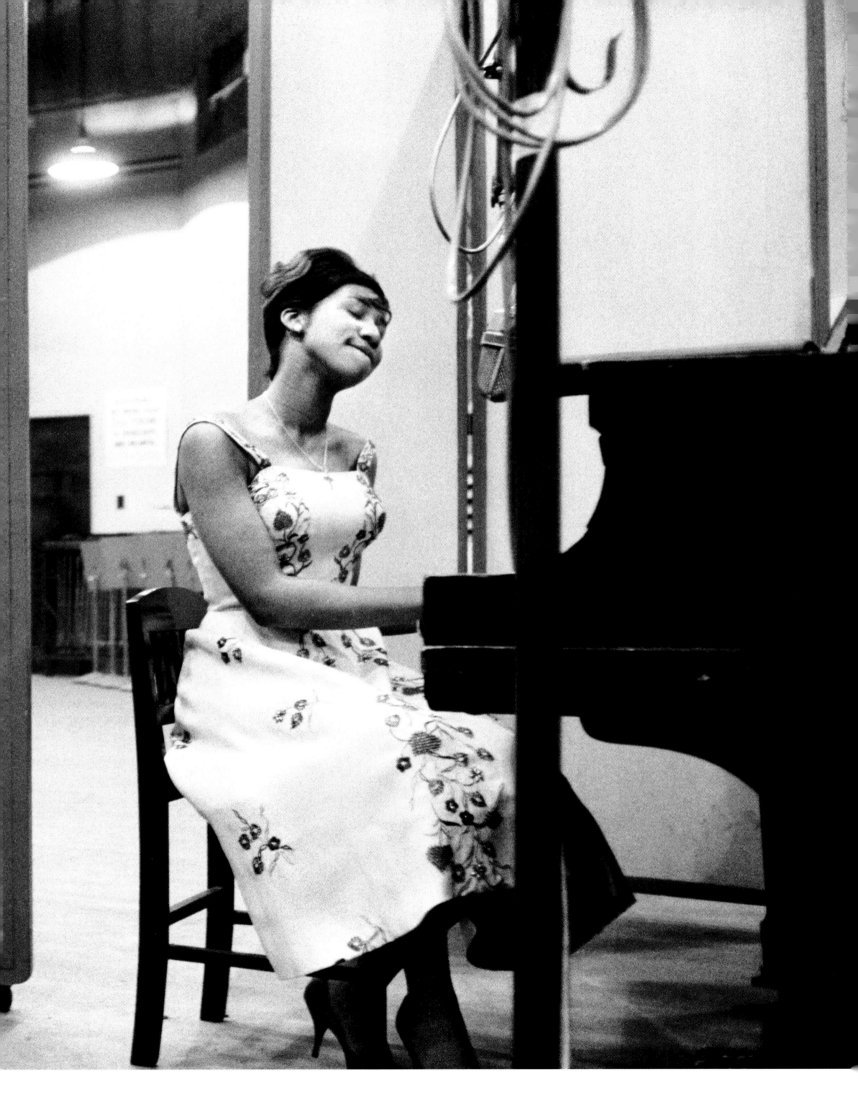

With trombonist Tyree Glenn, left.

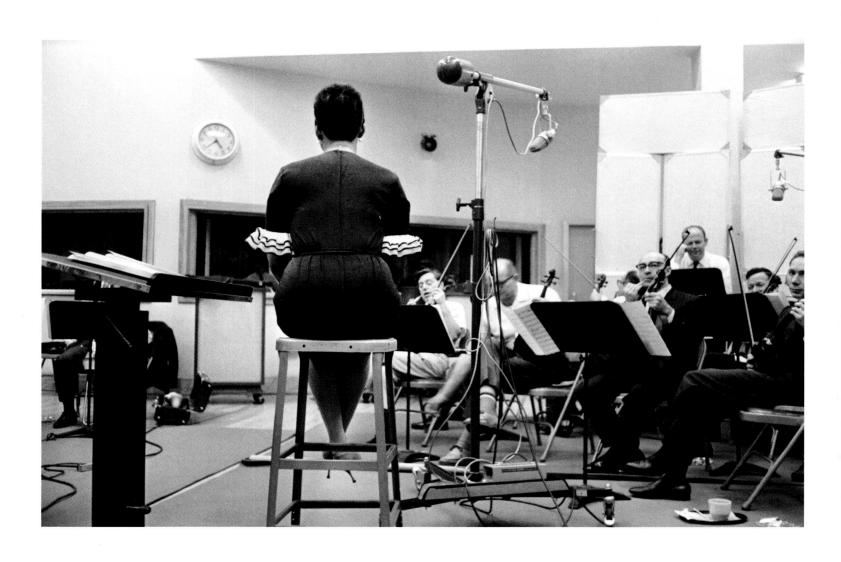

ABOVE & OPPOSITE: Recording *The Tender, the Moving,*
the Swinging Aretha Franklin, May 1962.
PAGE 90-91: Playback with producer John Hammond,
the Columbia A&R executive who also signed Billie Holiday,
Bob Dylan, and Bruce Springsteen, New York.

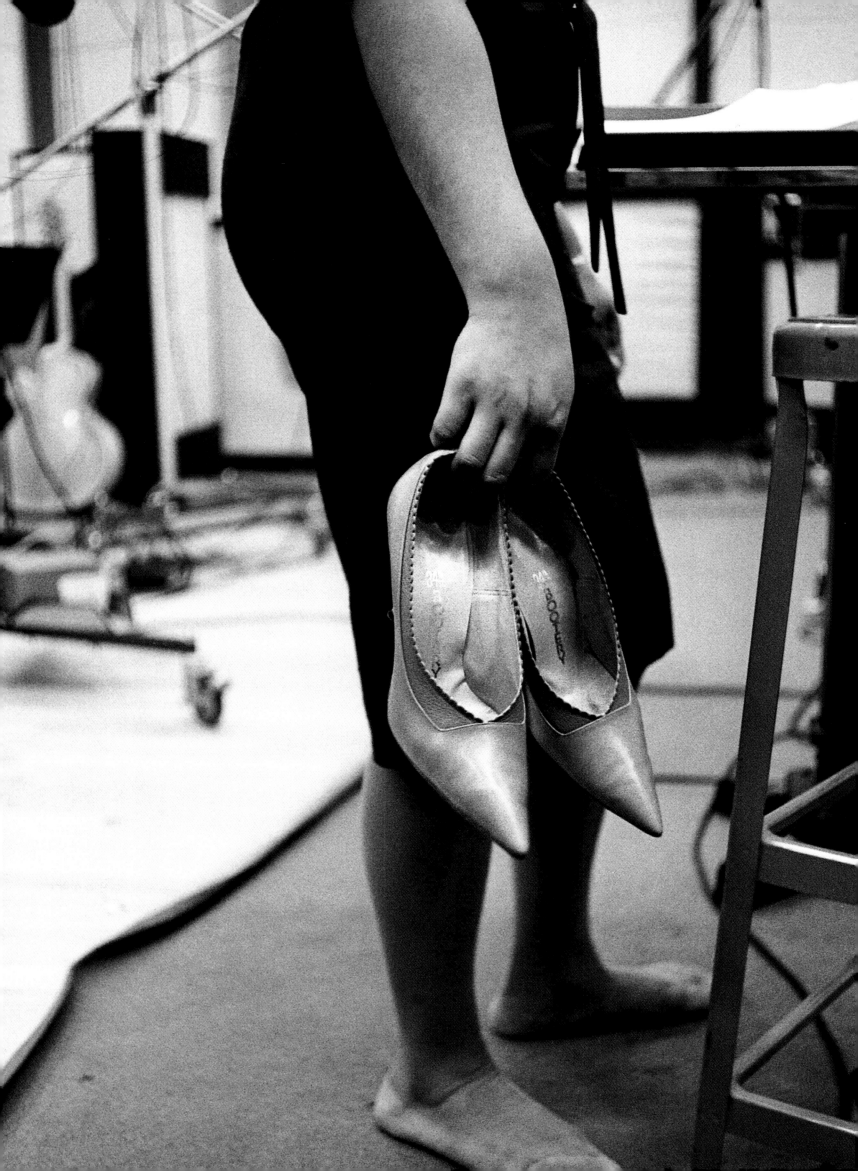

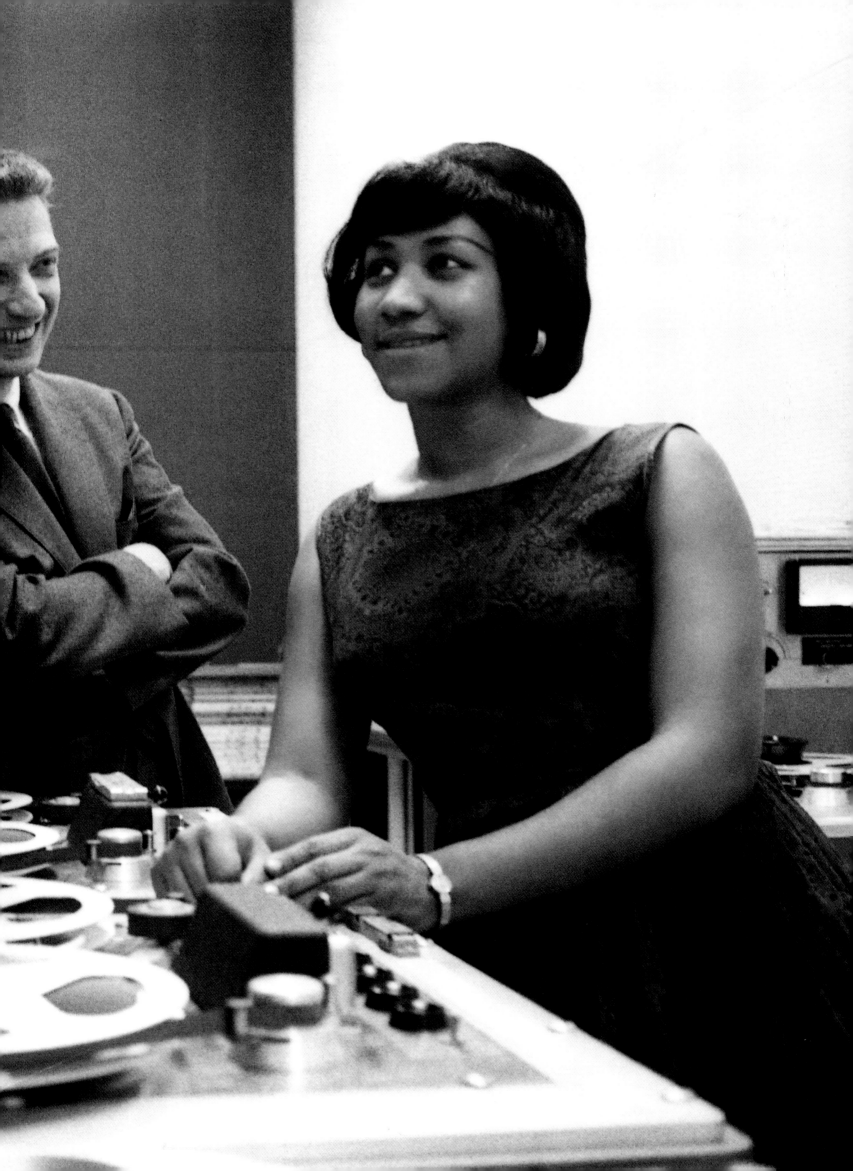

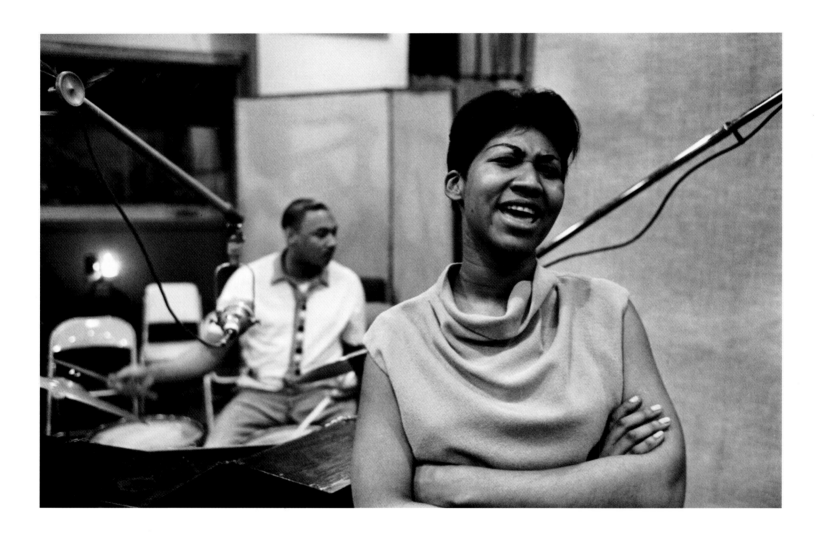

ABOVE & OPPOSITE: With drummer Hindel Butts, above left,
recording *Yeah!!! In Person with Her Quartet*, February 1965.

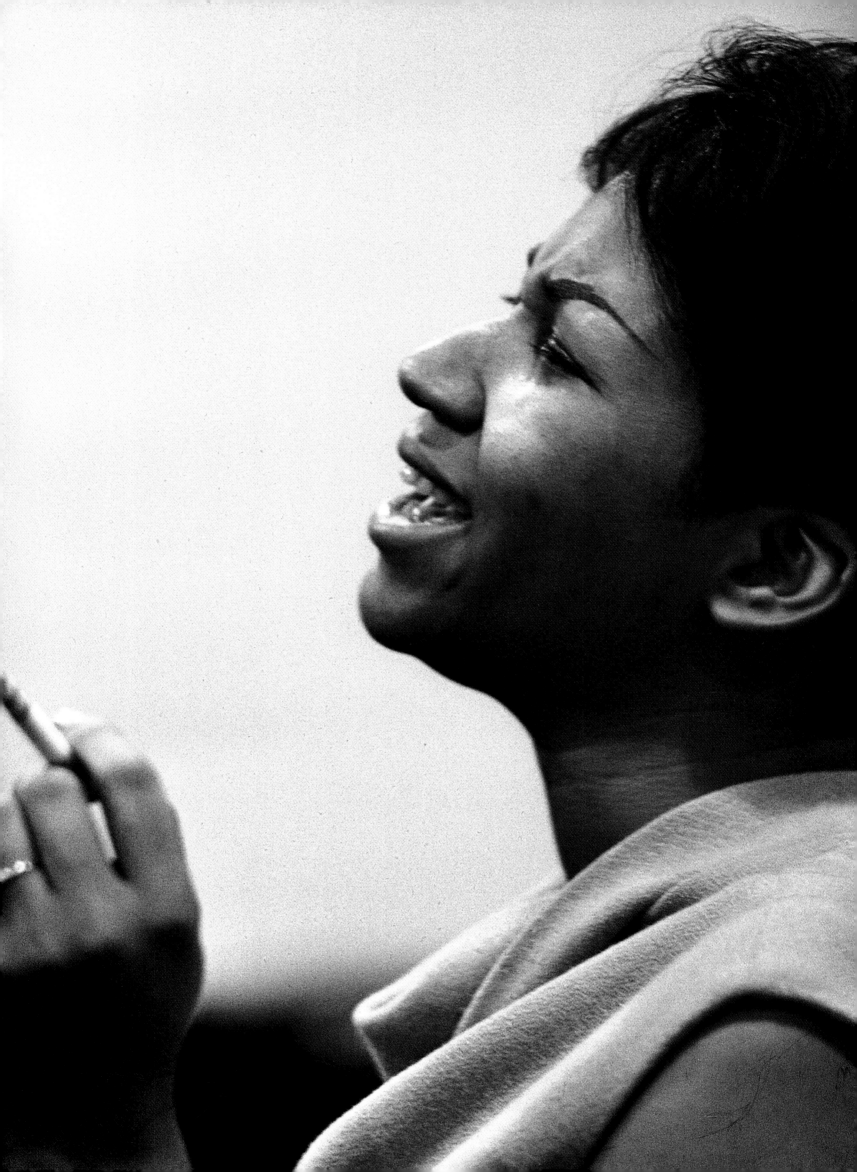

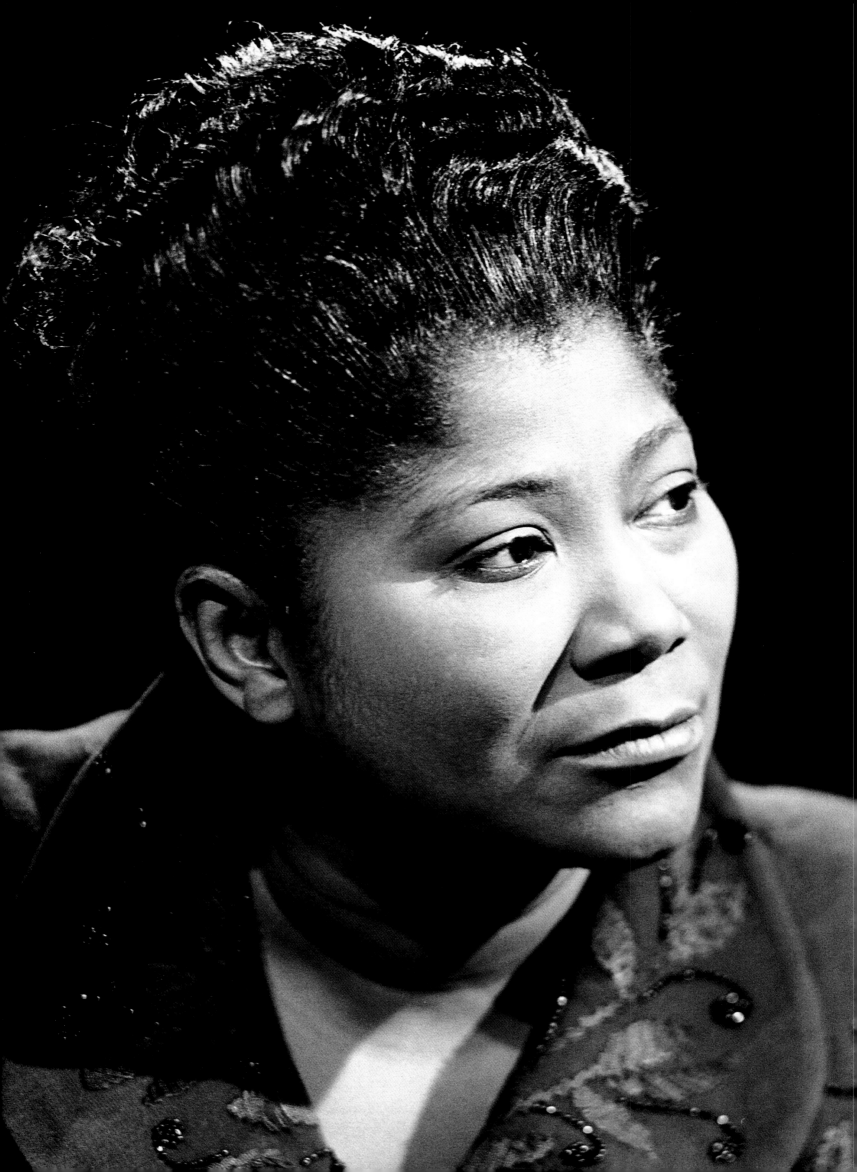

MAHALIA JACKSON

THE POWER OF MAHALIA JACKSON'S CONTRALTO, which could be humbly devout or flaunt its bluesy gusto, carried her from churches to Carnegie Hall to the 1963 March on Washington and beyond. Born in New Orleans and transplanted to Chicago in her teens, she bridged the traditions of slow, reverent spirituals and rocking, hand-clapping modern gospel—drawing early consternation from church elders before her decades of worldwide acclaim. She had plenty of chances to perform secular music; she never did.

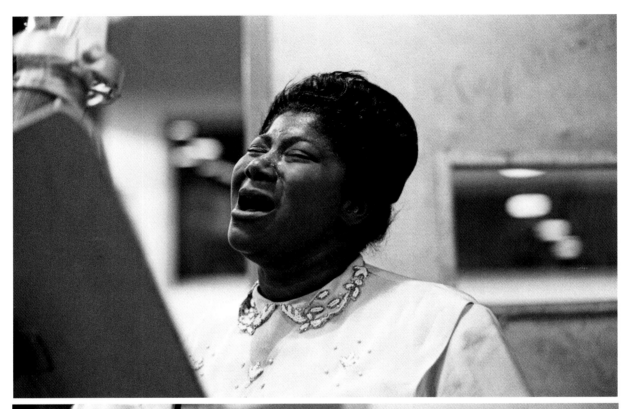

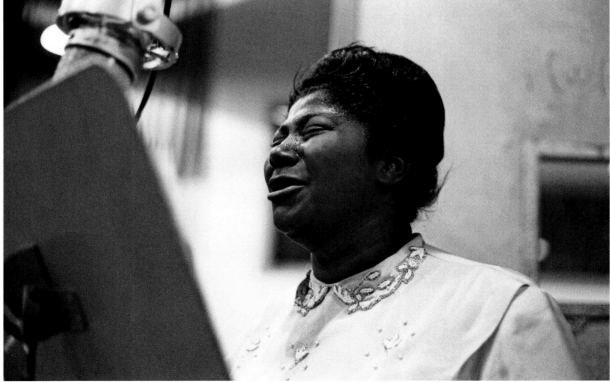

PAGE 94 & OPPOSITE: Bringing the spirit to the cameras and
the world, mid-1950s.
TOP & ABOVE: Recording spirituals in the studio, December 1958.
PAGES 98-99: Preaching to the choir at a Rotary International
convention, New York, June 1959.

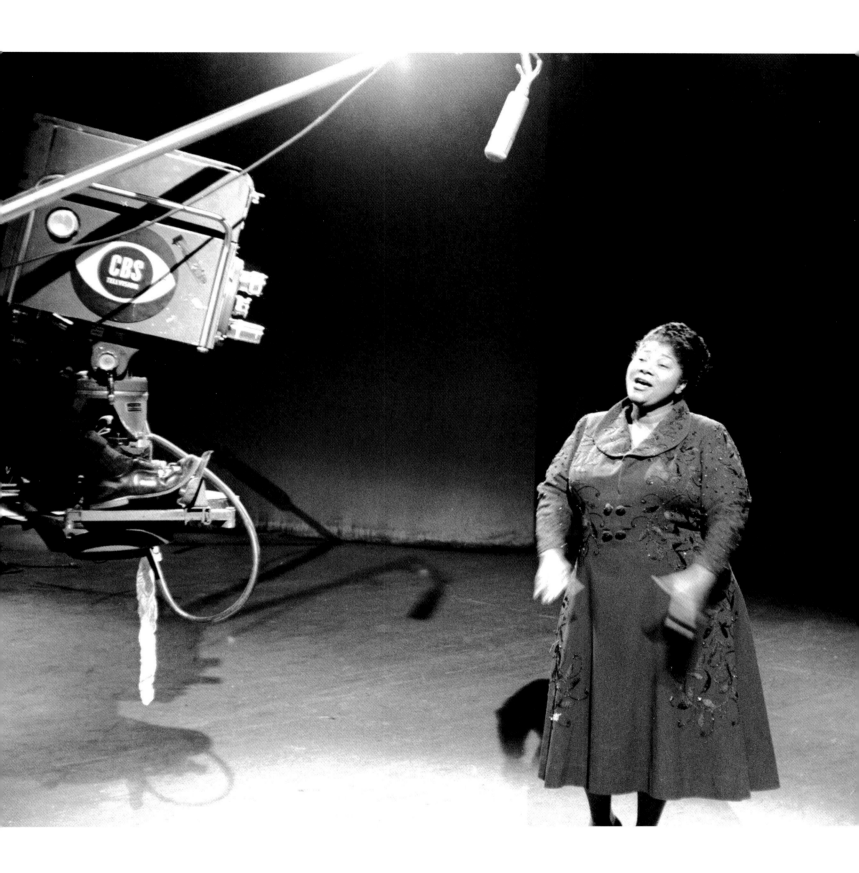

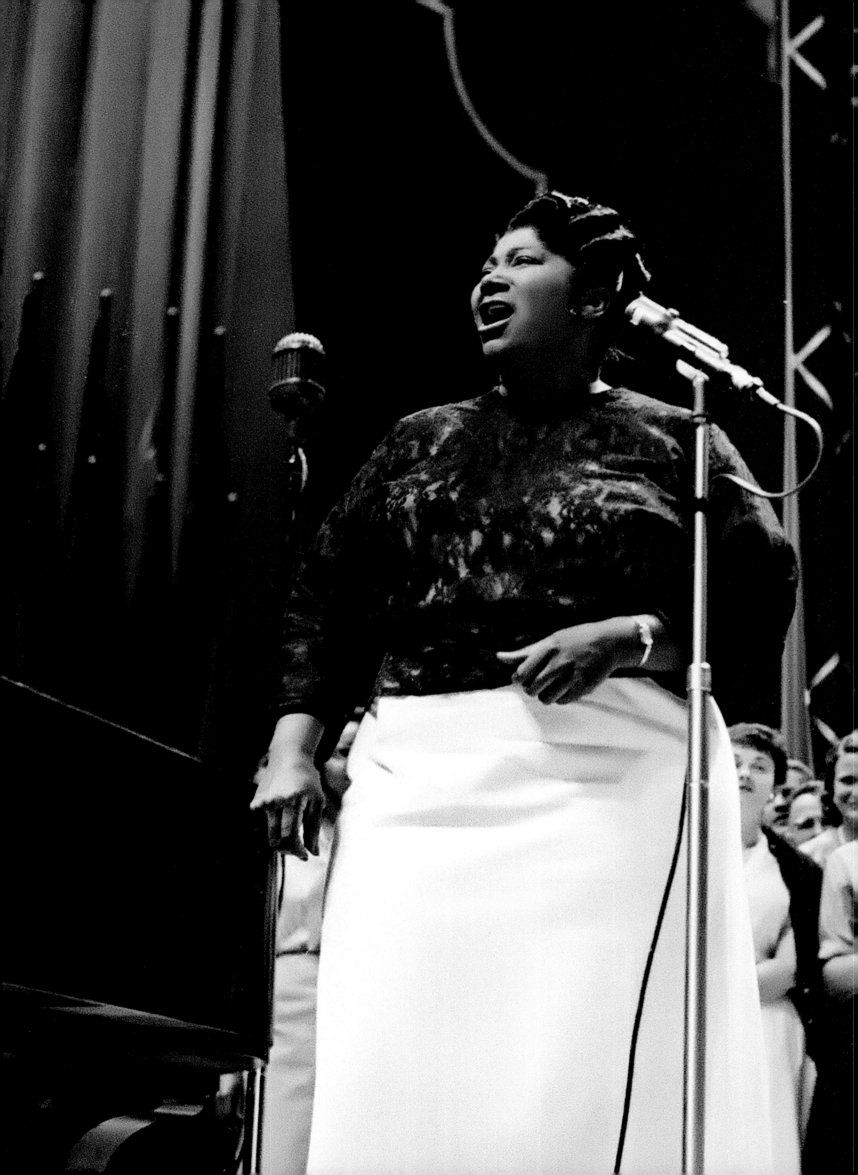

JOHNNY CASH

THE GRAVITAS OF JOHNNY CASH'S BARITONE was the sound of American-music integrity. His decades of recording led him from rockabilly through country, to collaborations with Bob Dylan and U2, and to final meditations on mortality. Early on, he chose to become the Man in Black, and performing in black clothes as a reminder, he sang of "the poor and the beaten down, living in the hopeless, hungry side of town."

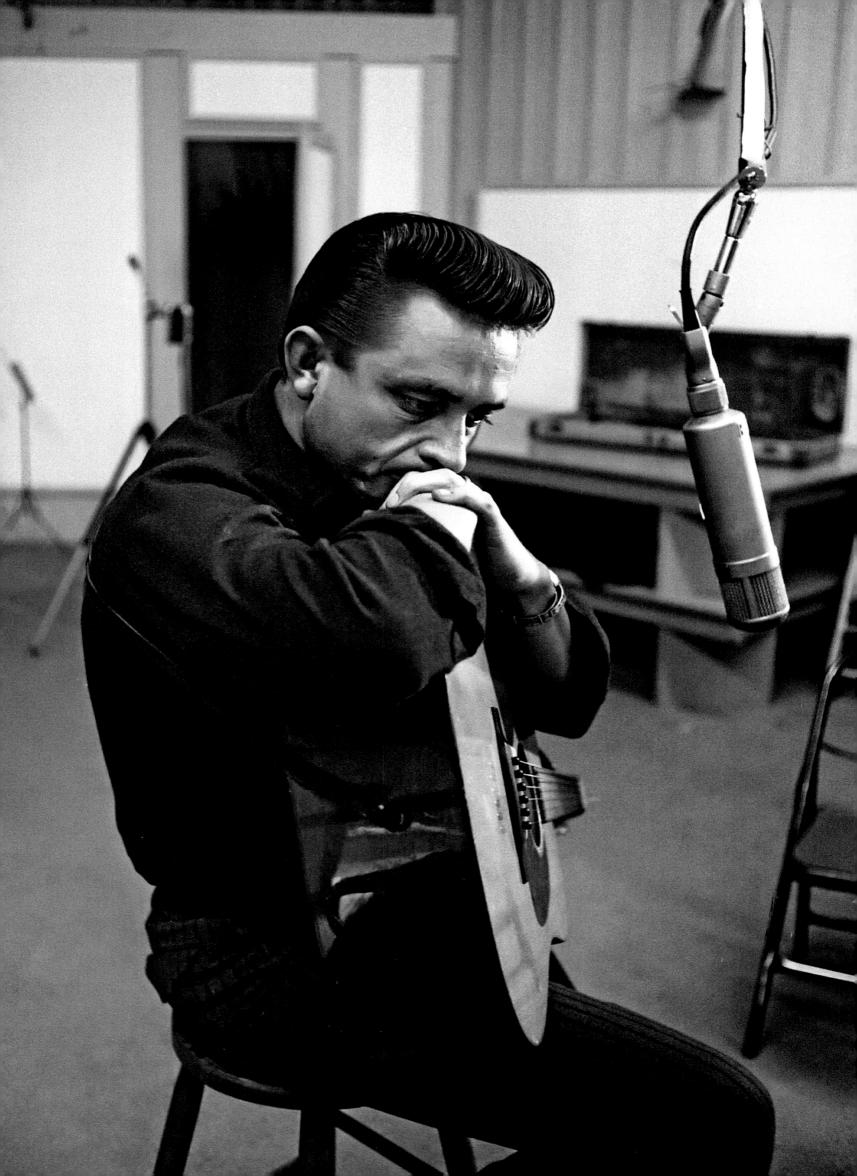

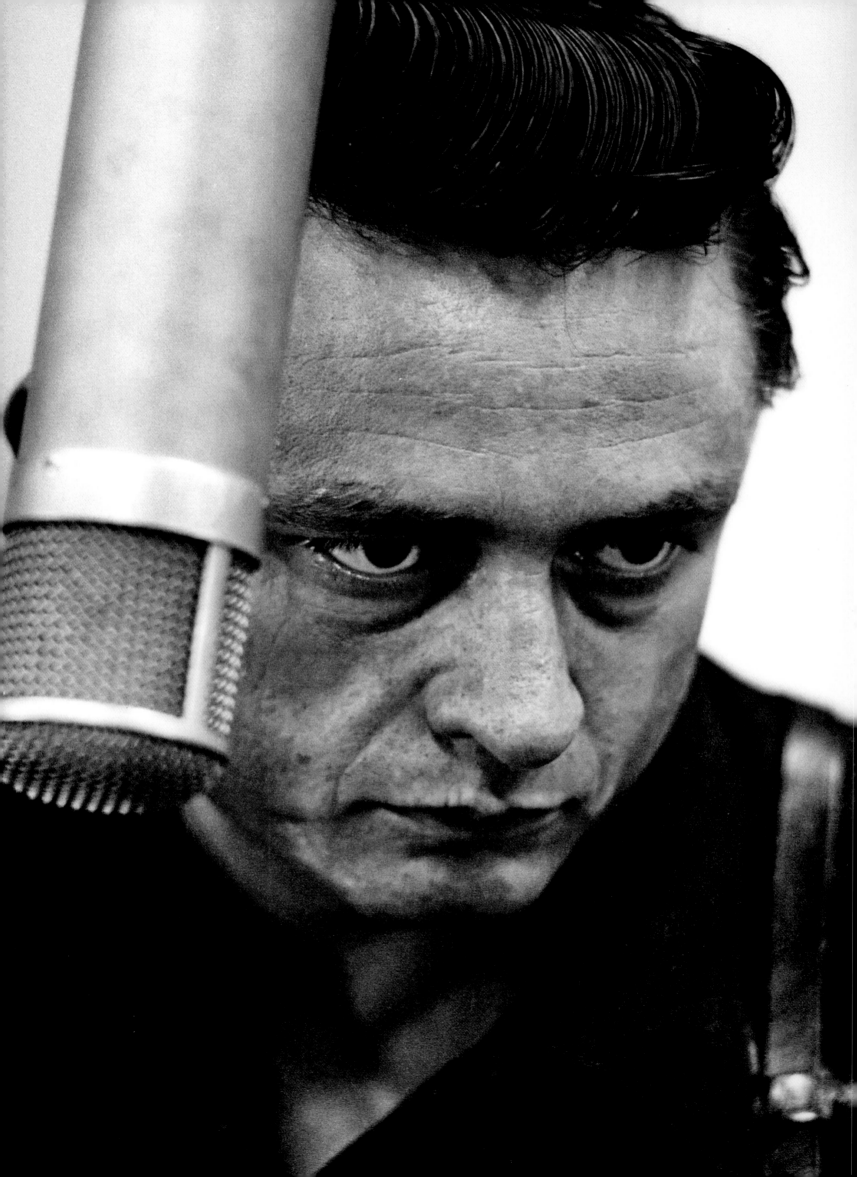

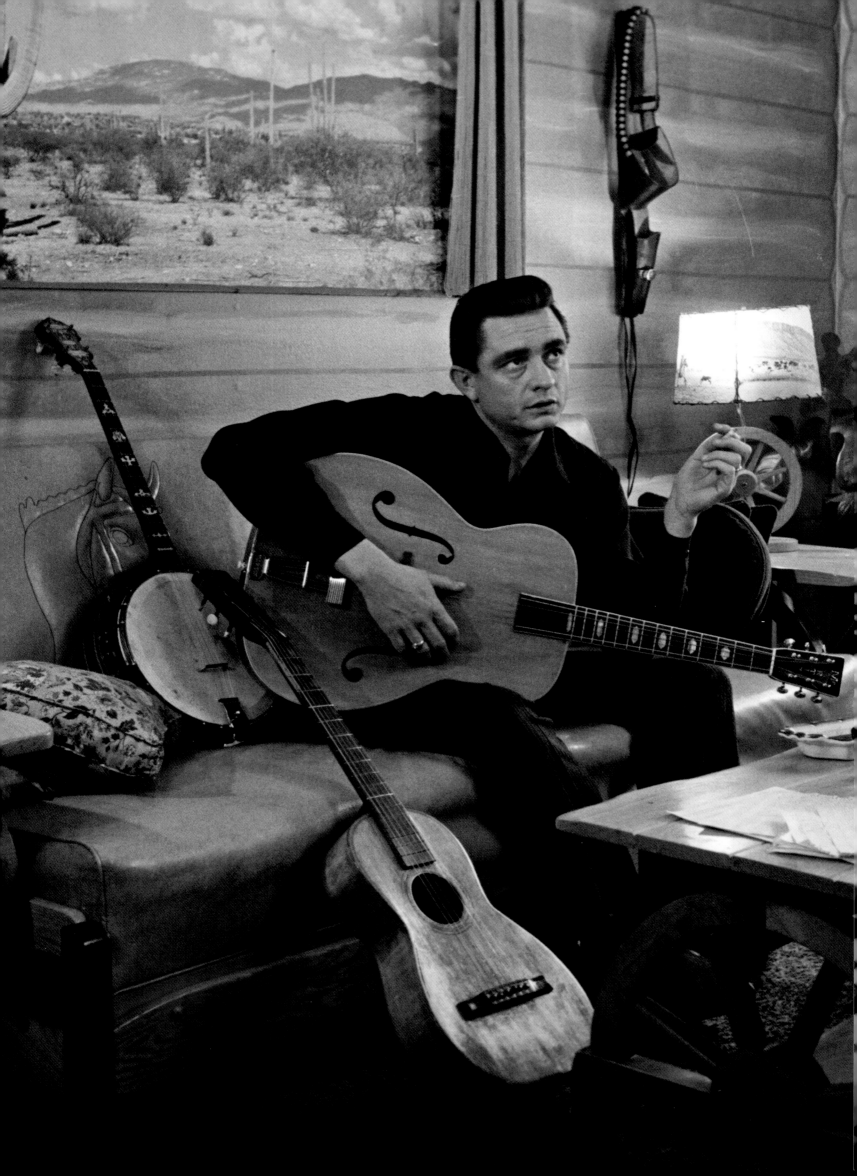

LEFT: At home in San Antonio, Texas, following his first show at California's San Quentin state prison, January 1960.
PAGES 106-107: Rehearsing and recording in Nashville with producer Don Law, in white shirt, October 1959.

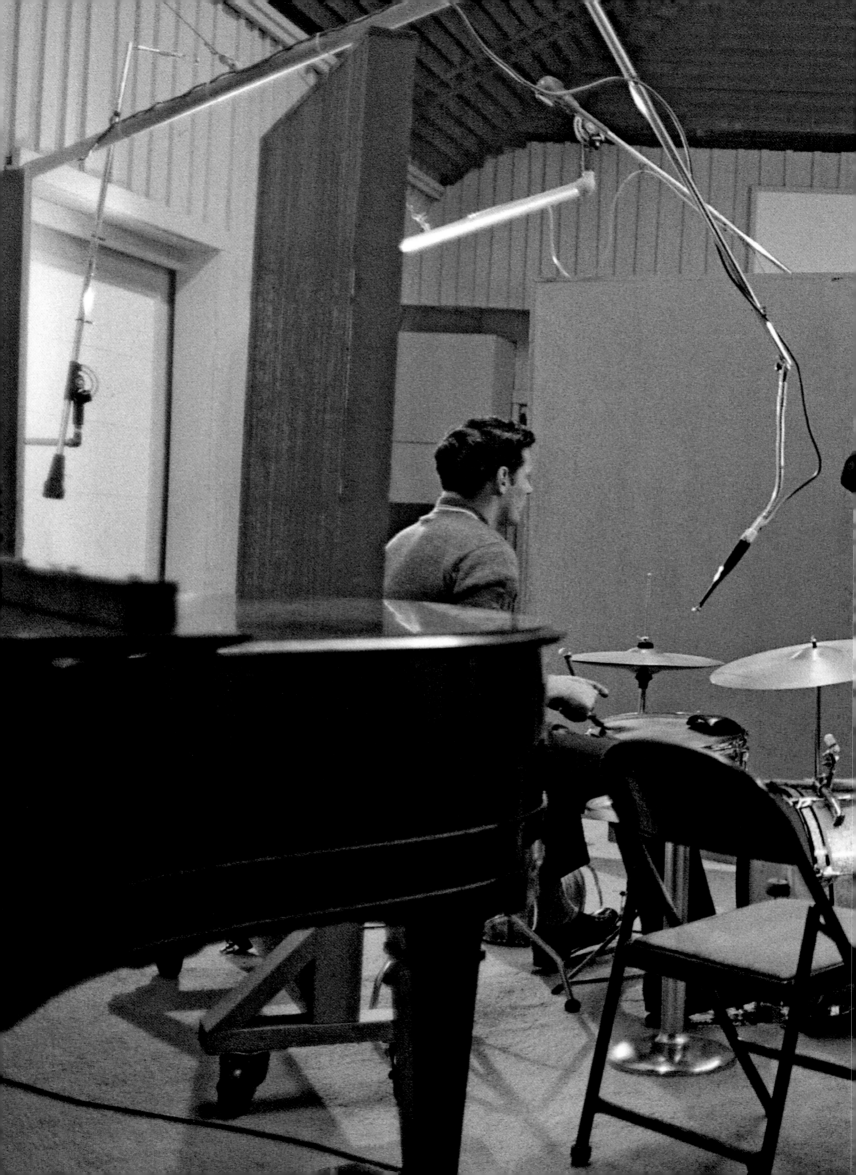

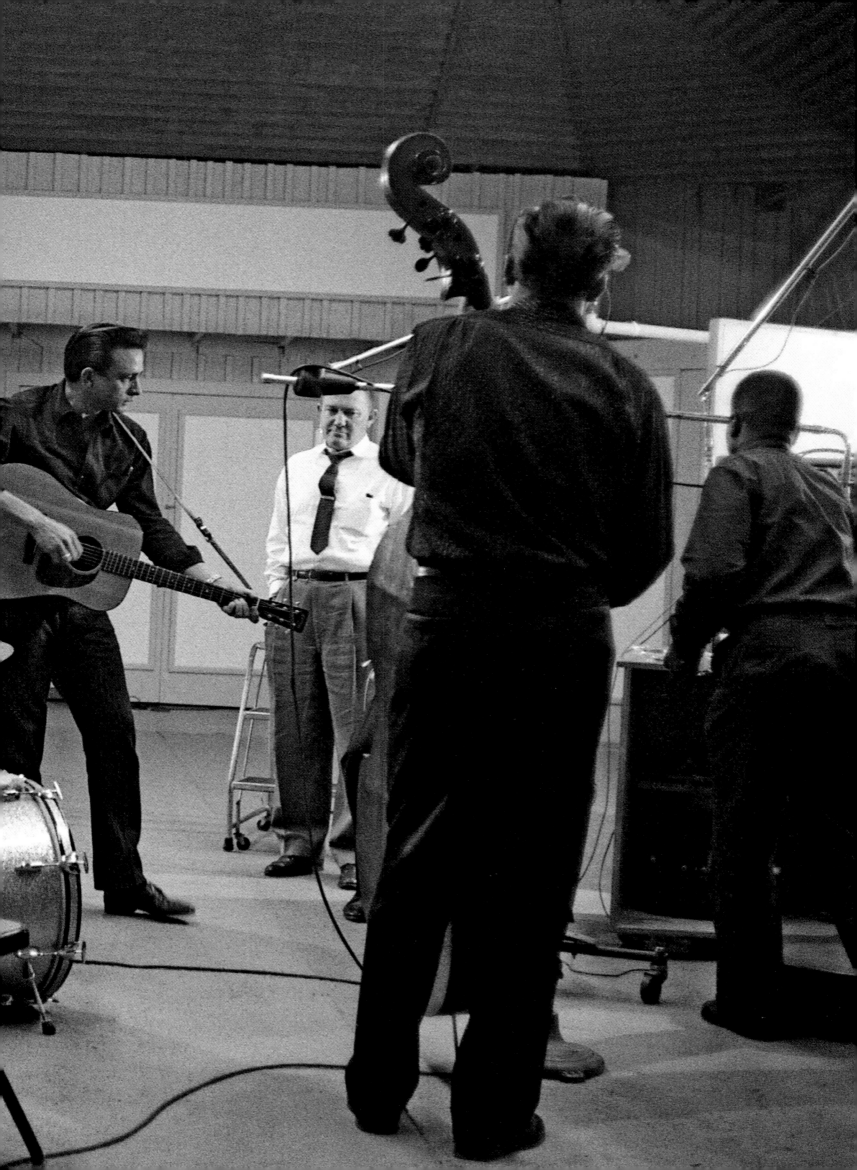

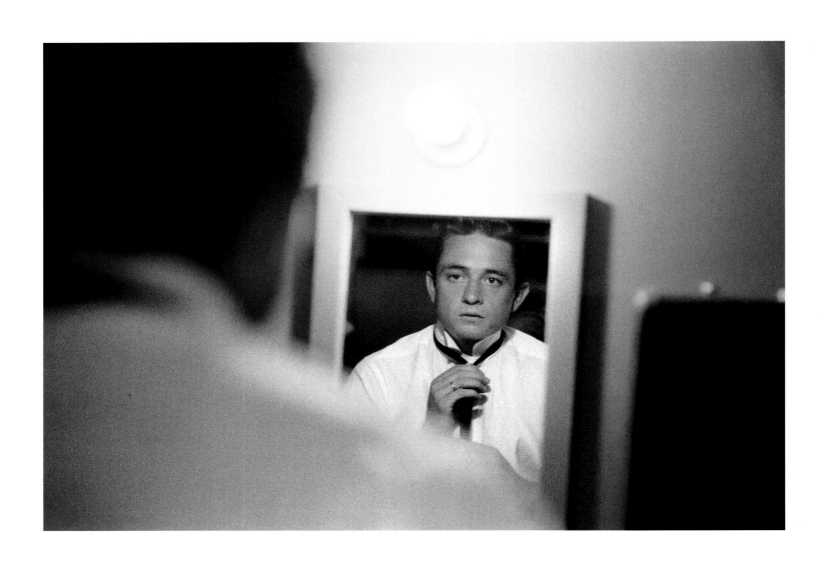

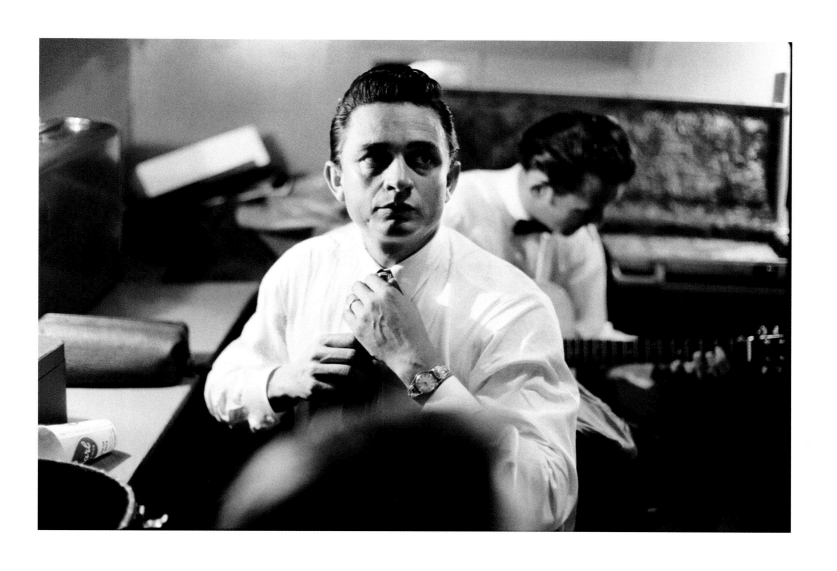

OPPOSITE & ABOVE: Backstage with guitarist Luther Perkins, above right, November 1960.

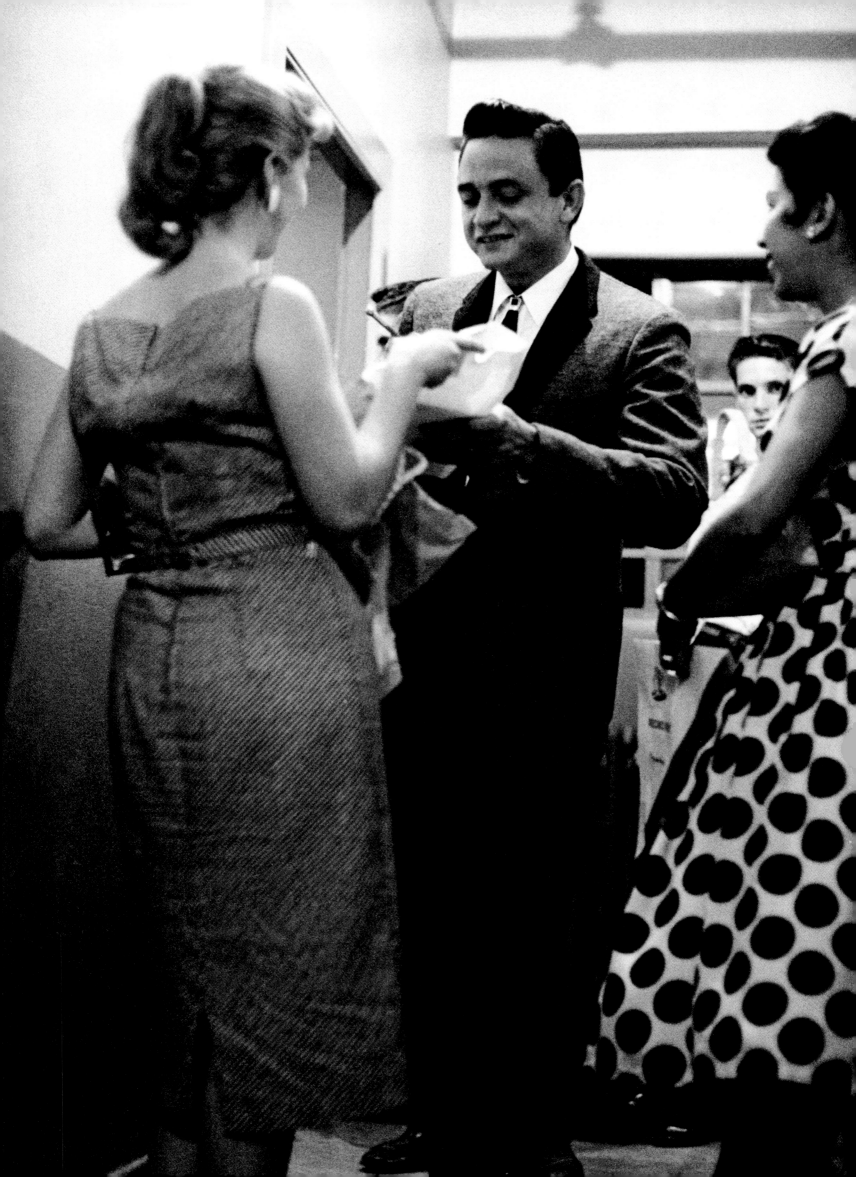

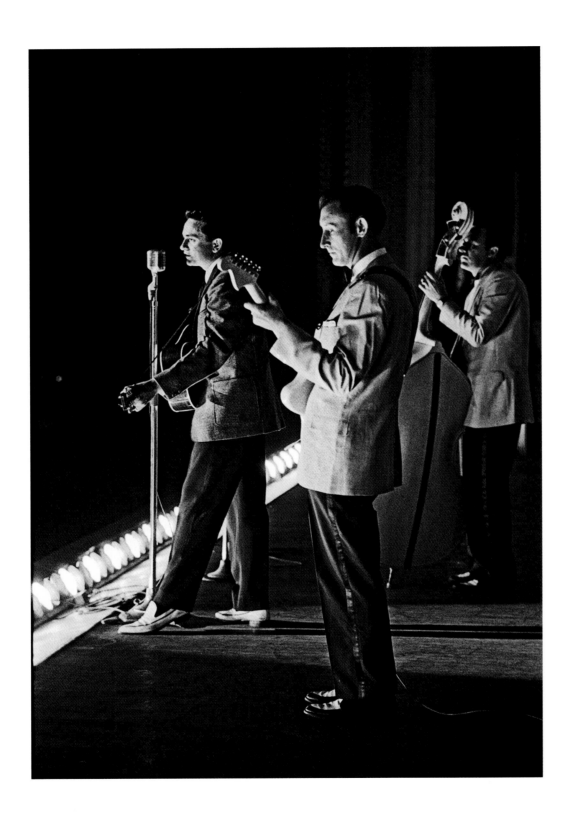

PAGE 110: Performing at the Columbia Sales Convention, July 1959.
PAGE 111: Signing autographs backstage, late 1950s.
ABOVE & OPPOSITE: Leading the Tennessee Three at the Grand Ole
Opry with Luther Perkins, center, and bassist Marshall Grant, right,
Nashville, November 1960.

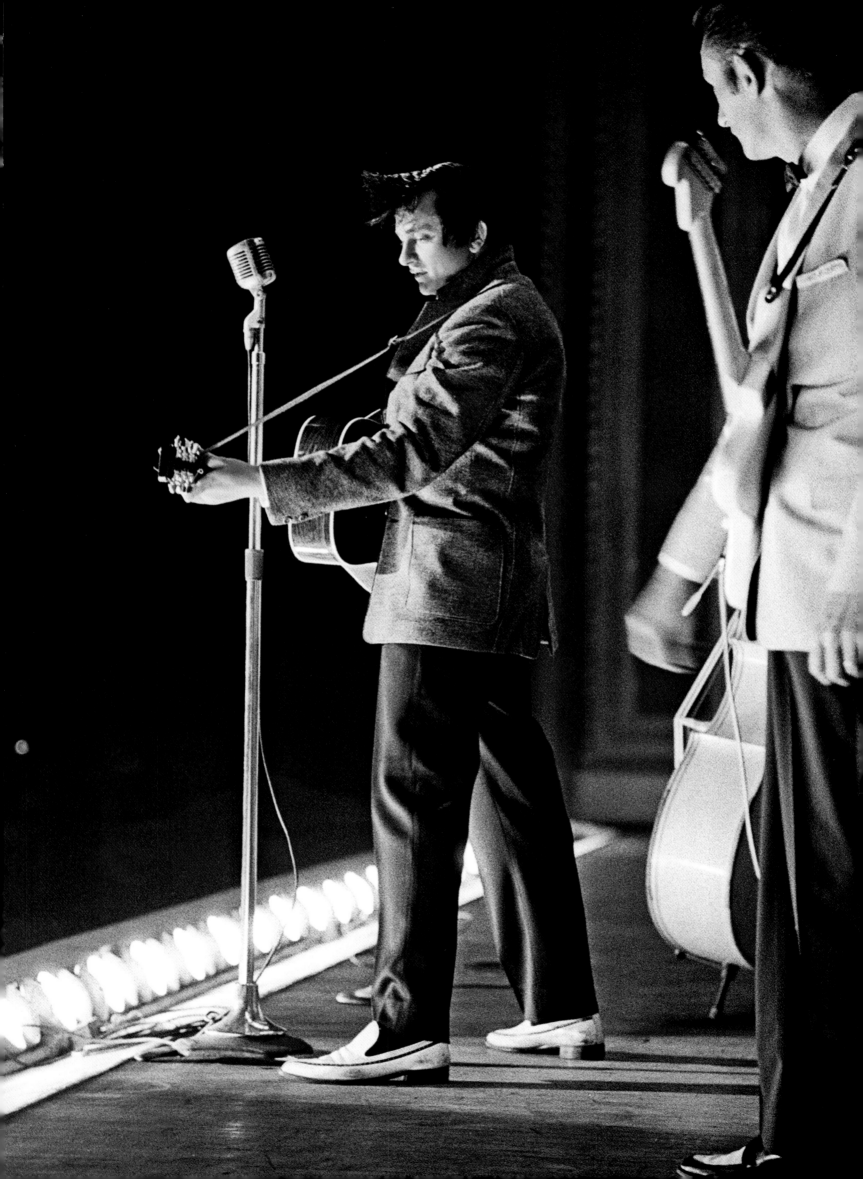

Introducing songs from *The Fabulous Johnny Cash* at a Nashville press party, February 1959.

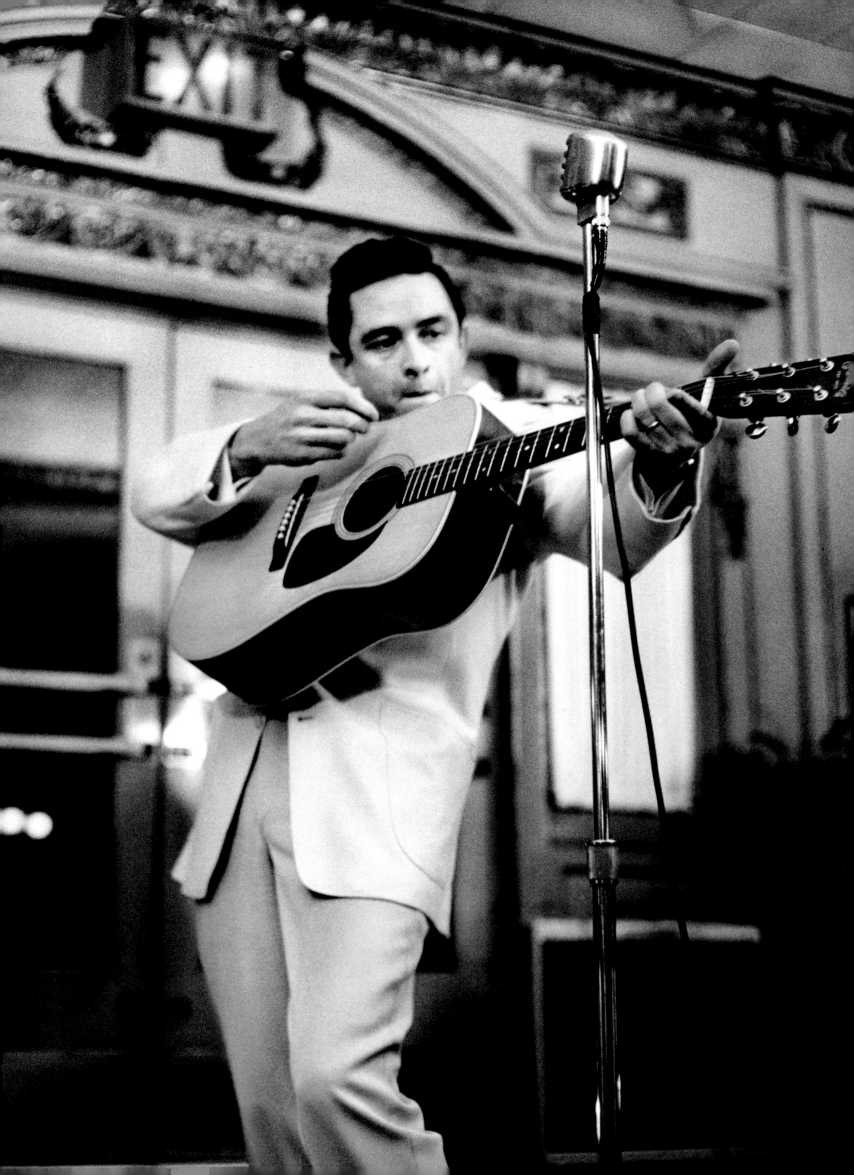

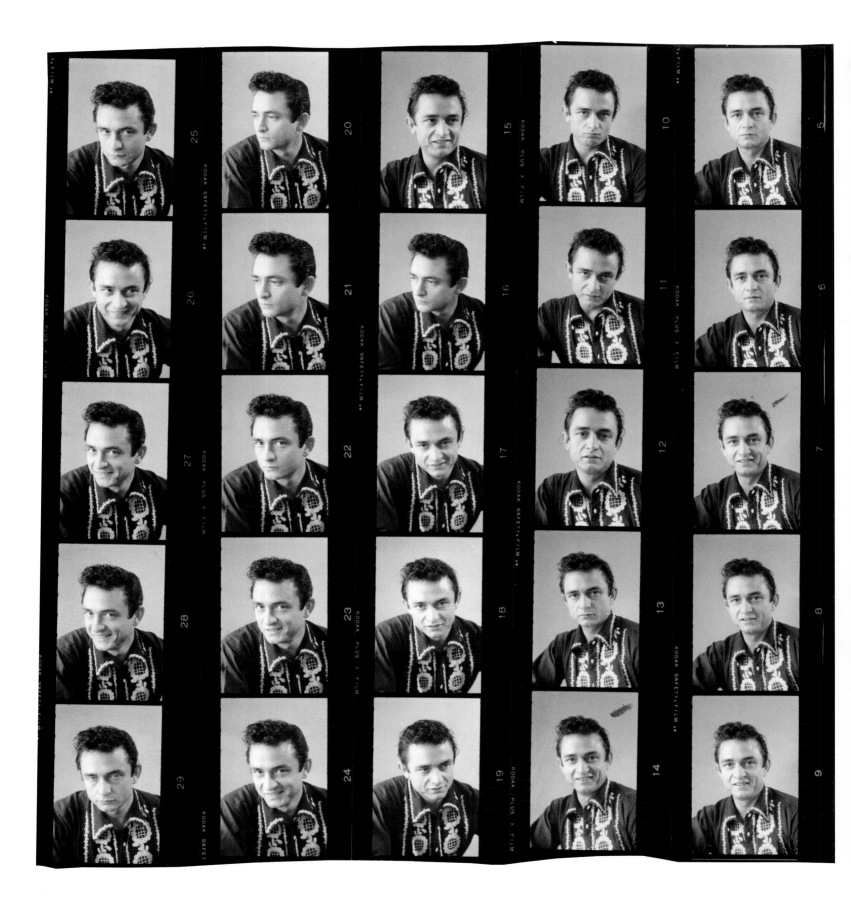

ABOVE: Film from a November 1957 shoot.
OPPOSITE: Becoming the Man in Black, July 1959.

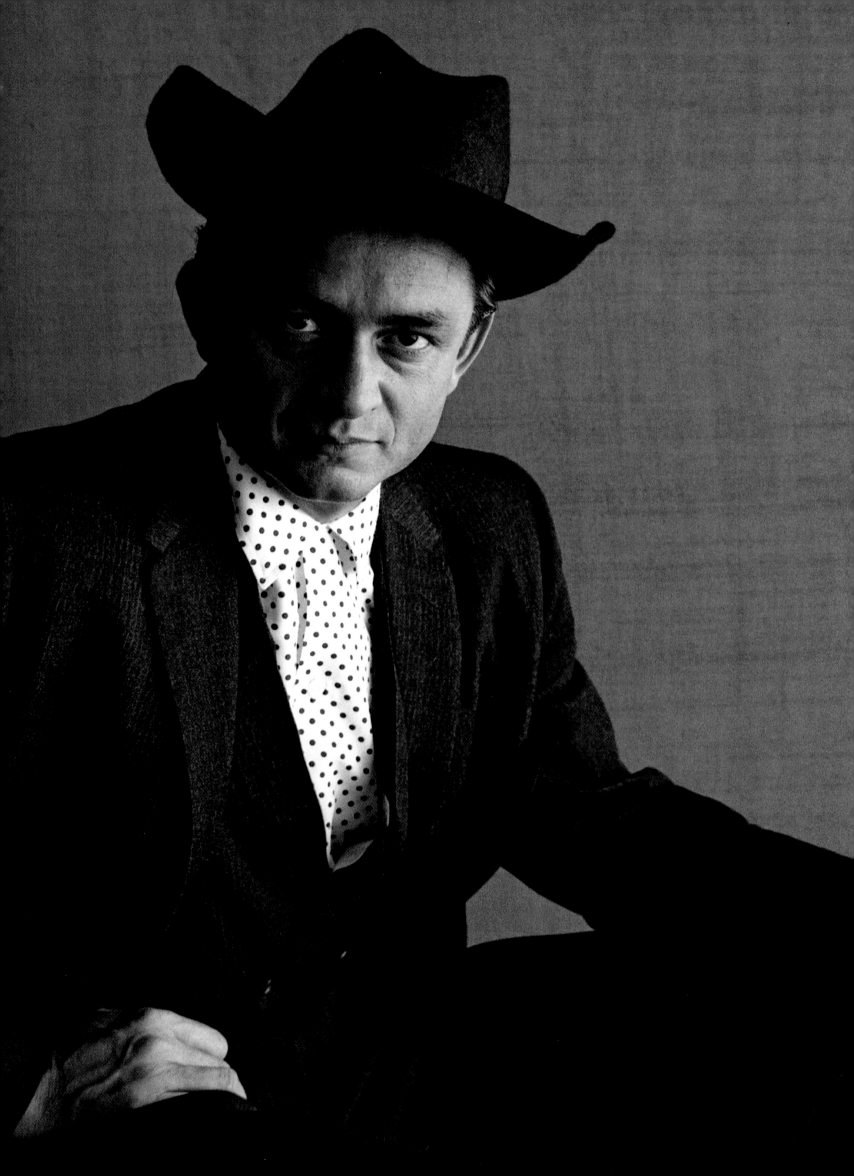

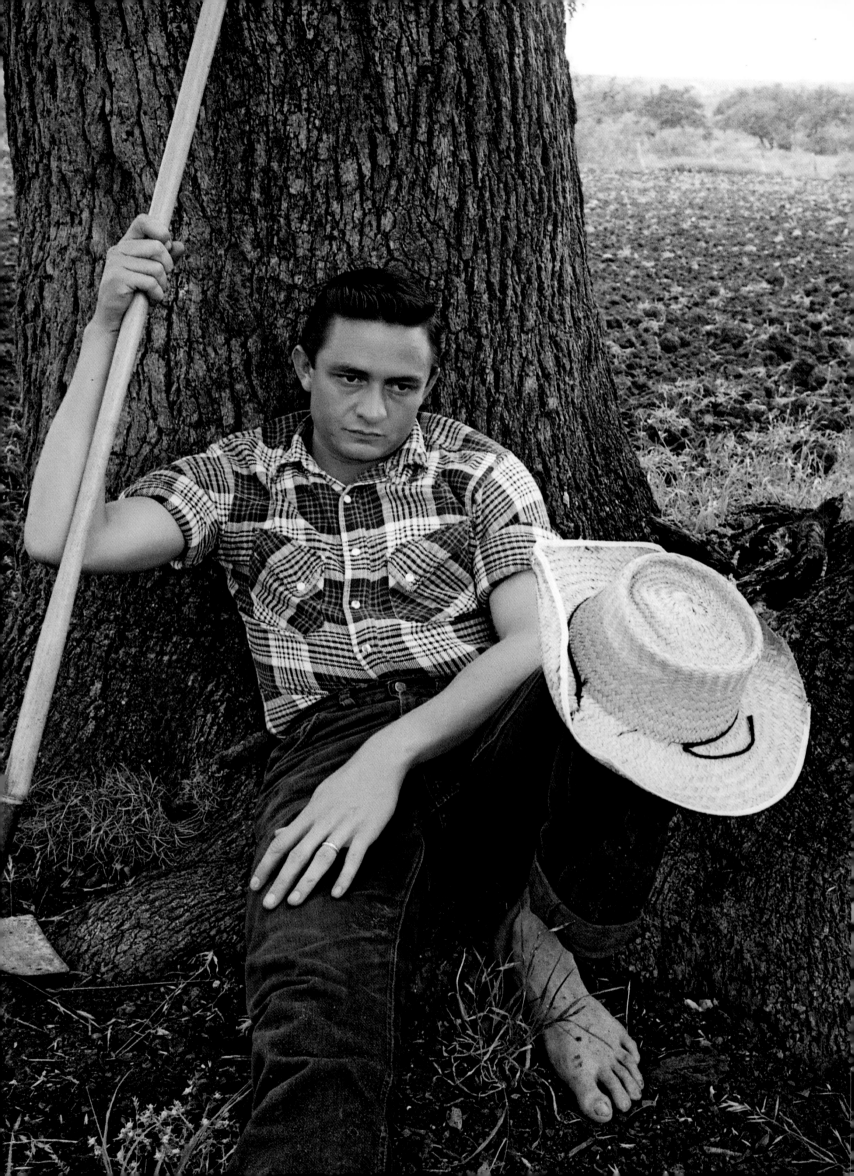

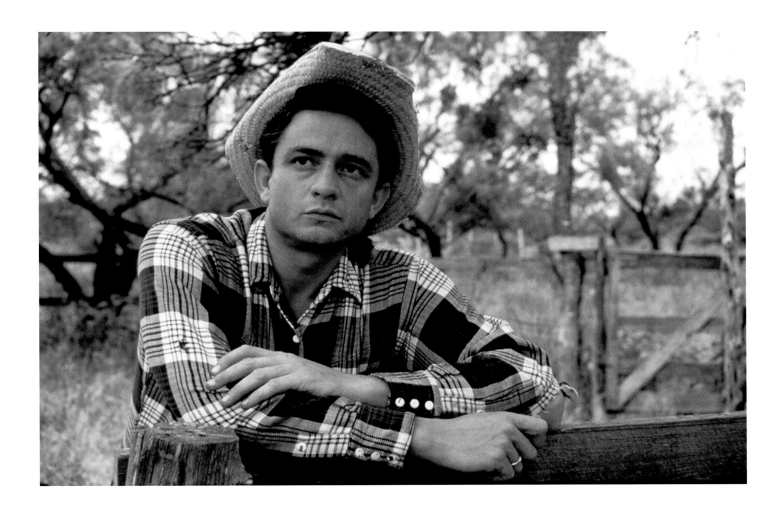

OPPOSITE, ABOVE & PAGES 120-121: On the family's twenty-acre farm, acquired during the Depression through President Franklin D. Roosevelt's New Deal program, Dyess, Arkansas, May 1959.

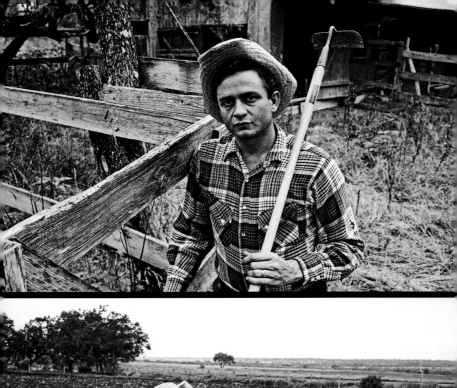
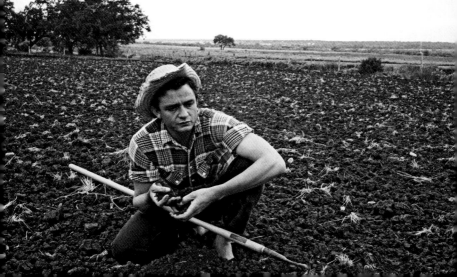

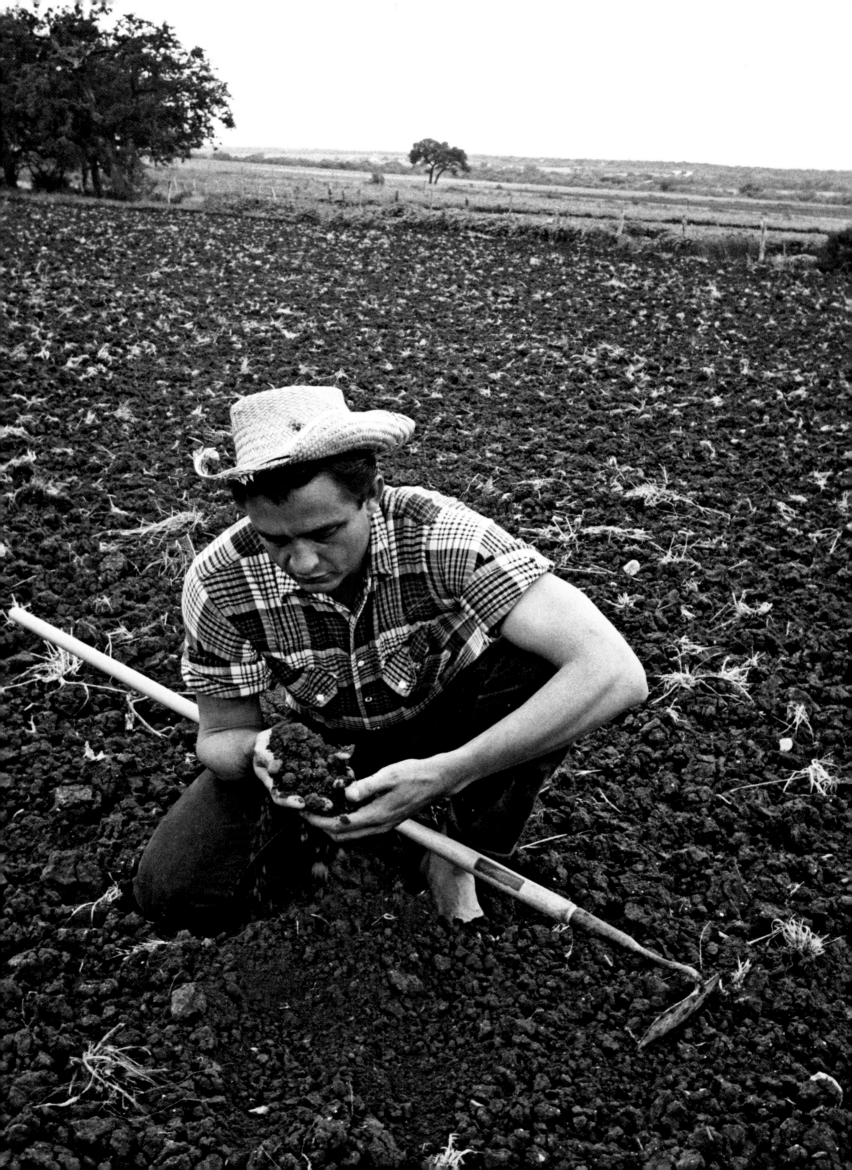

CASSIUS CLAY AND SAM COOKE

HANDSOME, ARTICULATE, WITTY, and shamelessly self-promoting, Cassius Clay—before he became Muhammad Ali—was the boxer whose celebrity extended far beyond the ring. More than an athlete, he was a symbol of black power, physical and cultural. Why not put him in a recording studio? Particularly when Clay could count on the musical assistance of his friend Sam Cooke, the great soul singer who infused pop love songs with churchy zeal. In March 1964, about a week after Clay won his first world championship, the fighter and the lover were in the studio together, recording a jovial song called "The Gang's All Here." That was their last project; Cooke died nine months later.

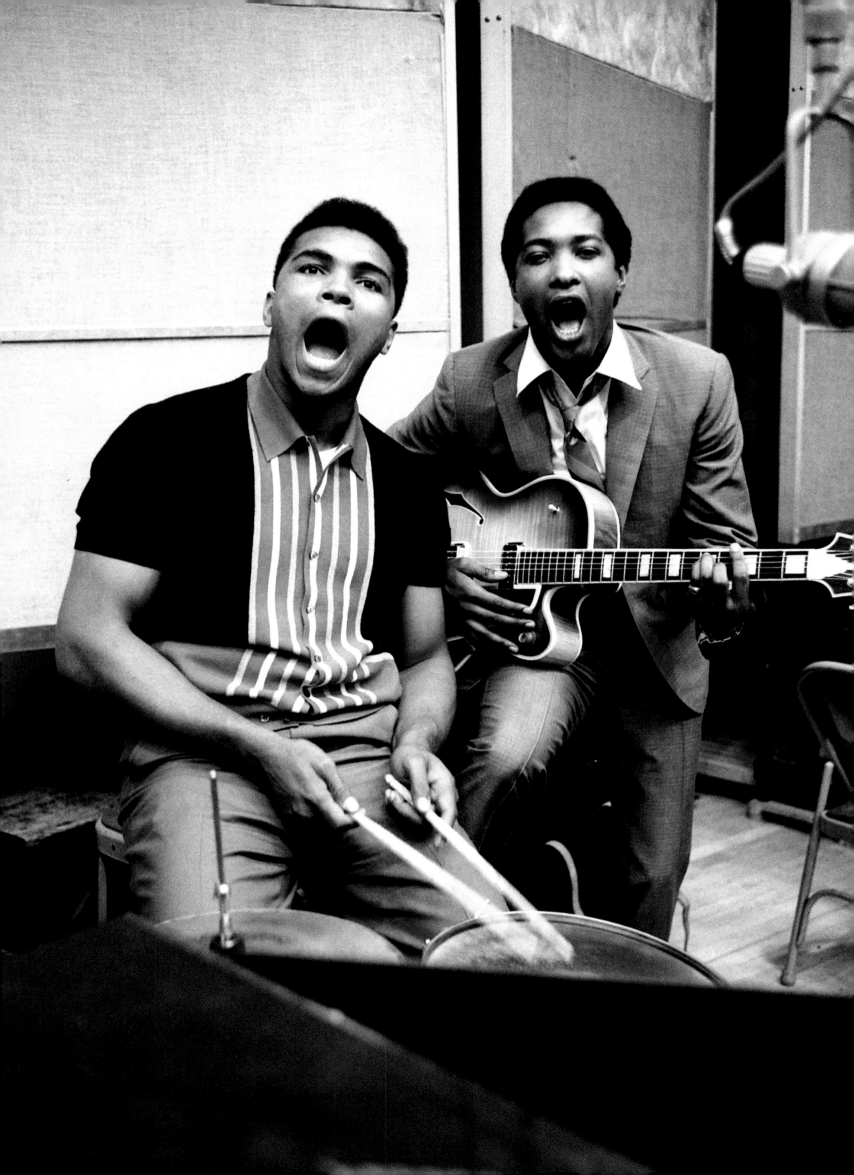

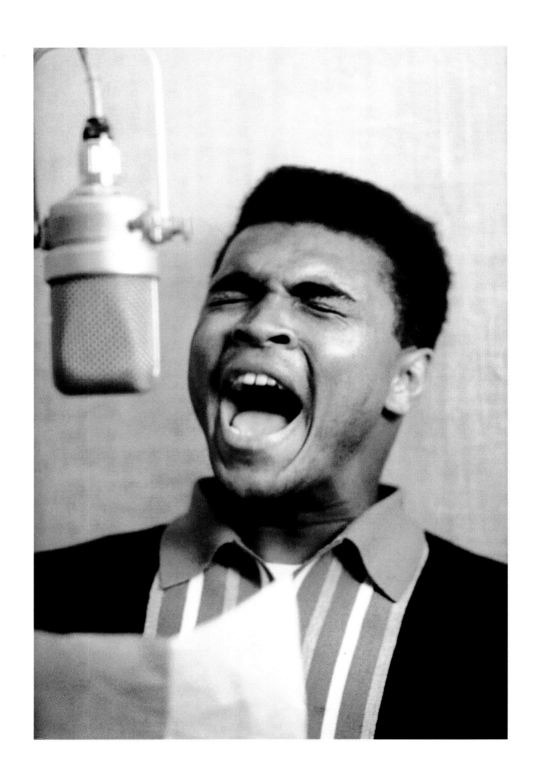

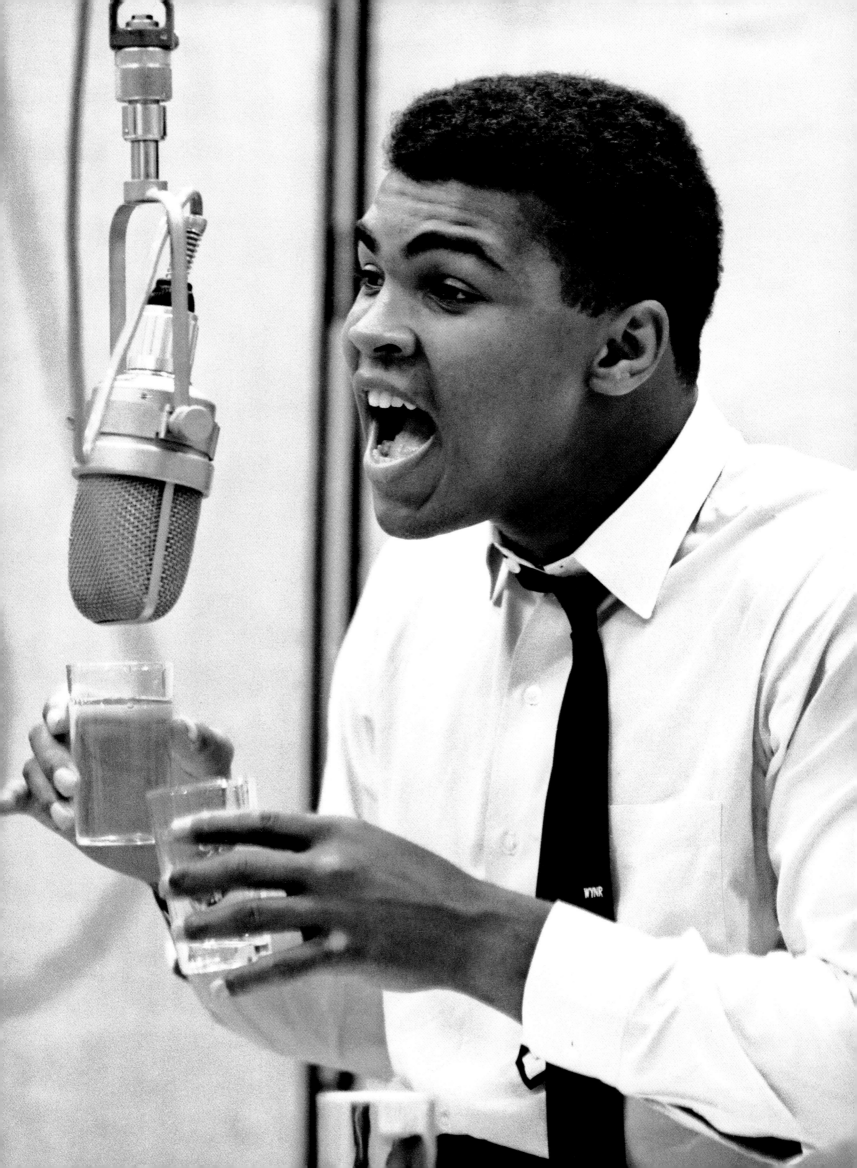

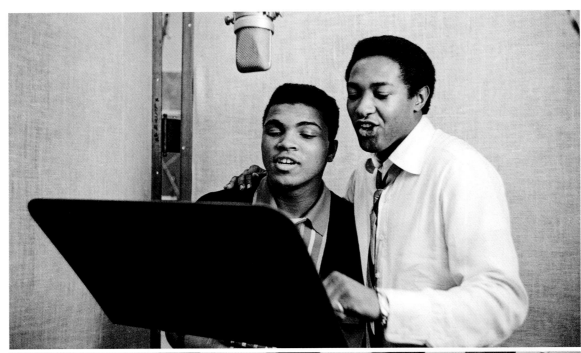

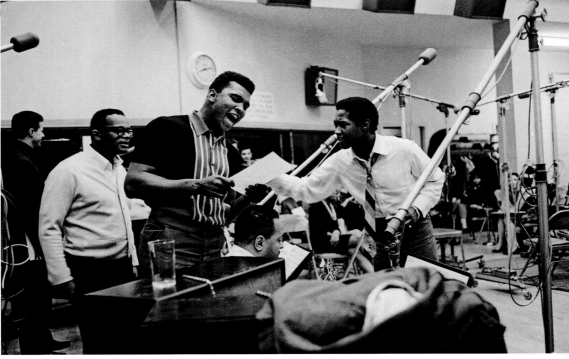

TOP & ABOVE: Cooke and Clay collaborate on "The Gang's All Here."
OPPOSITE: Background singers conducted by Horace Ott, left of music stand.

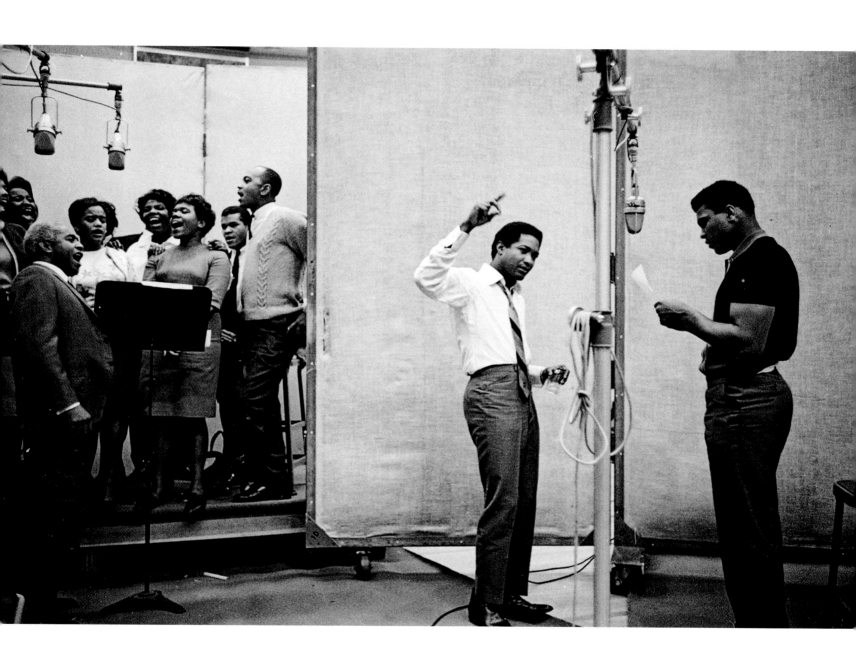

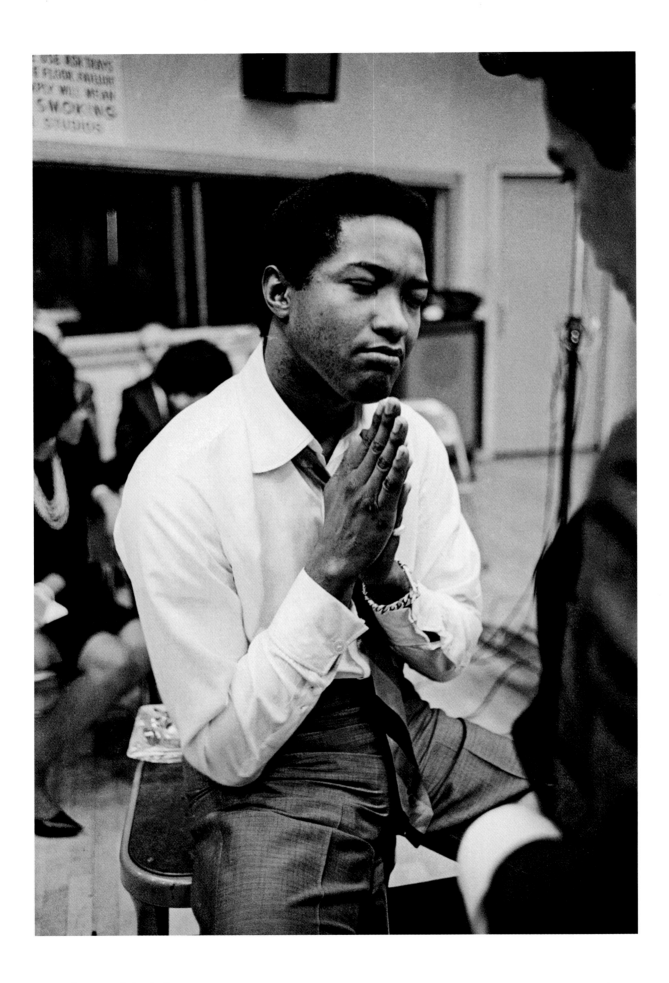

ABOVE: Sam Cooke pausing for inspiration.

OPPOSITE: The pair lay down a track.

PAGES 130-131: "The Greatest" on piano, New York, March 1964.

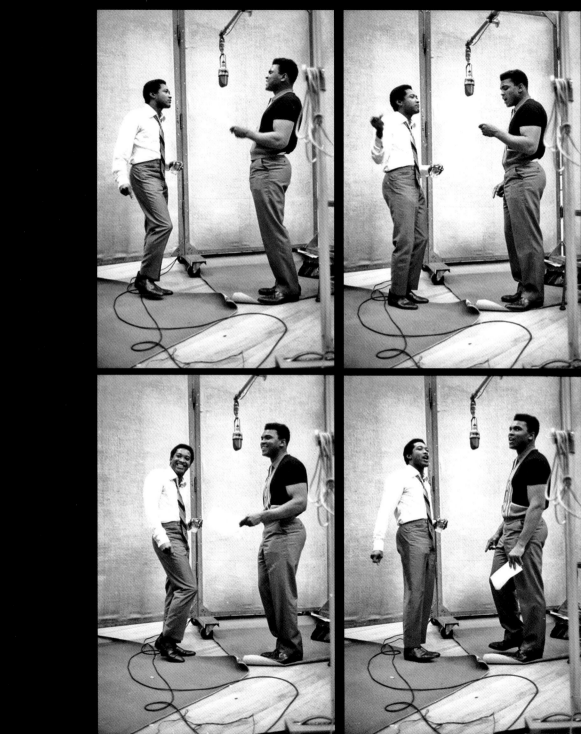

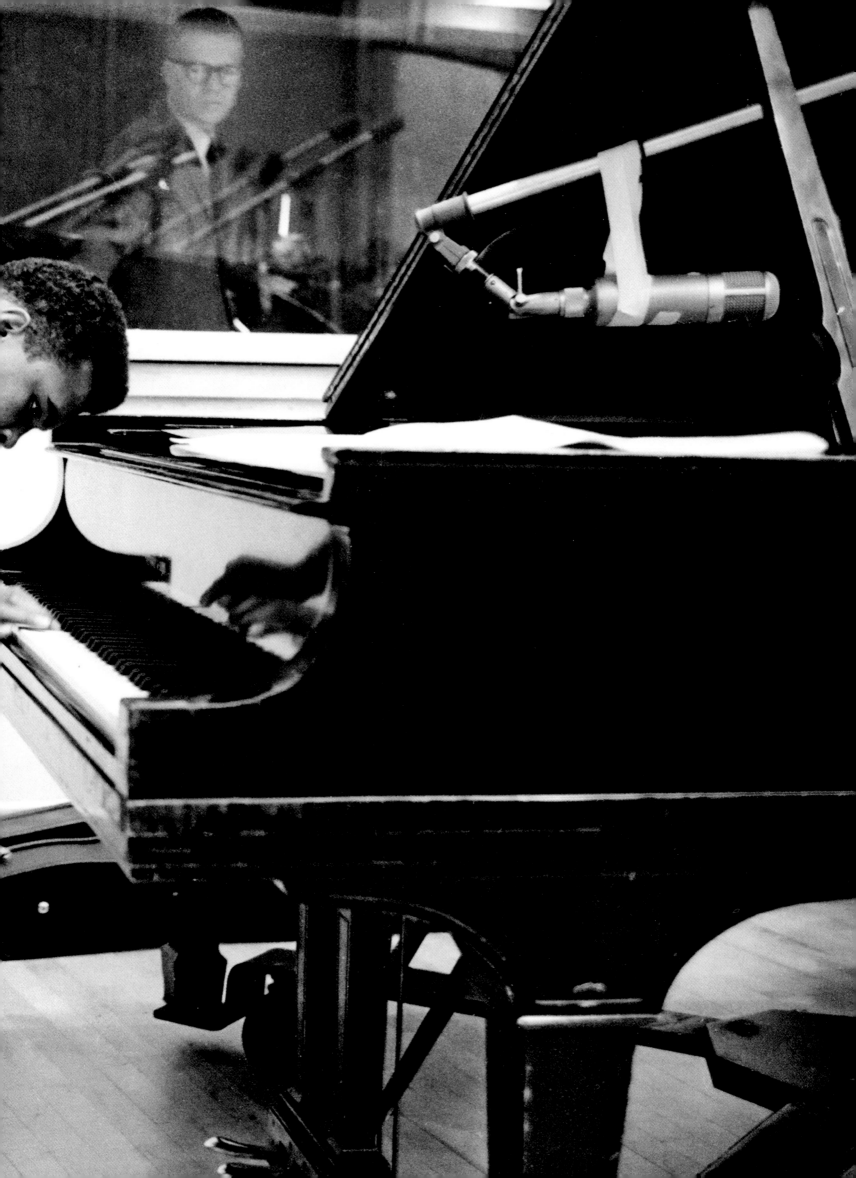

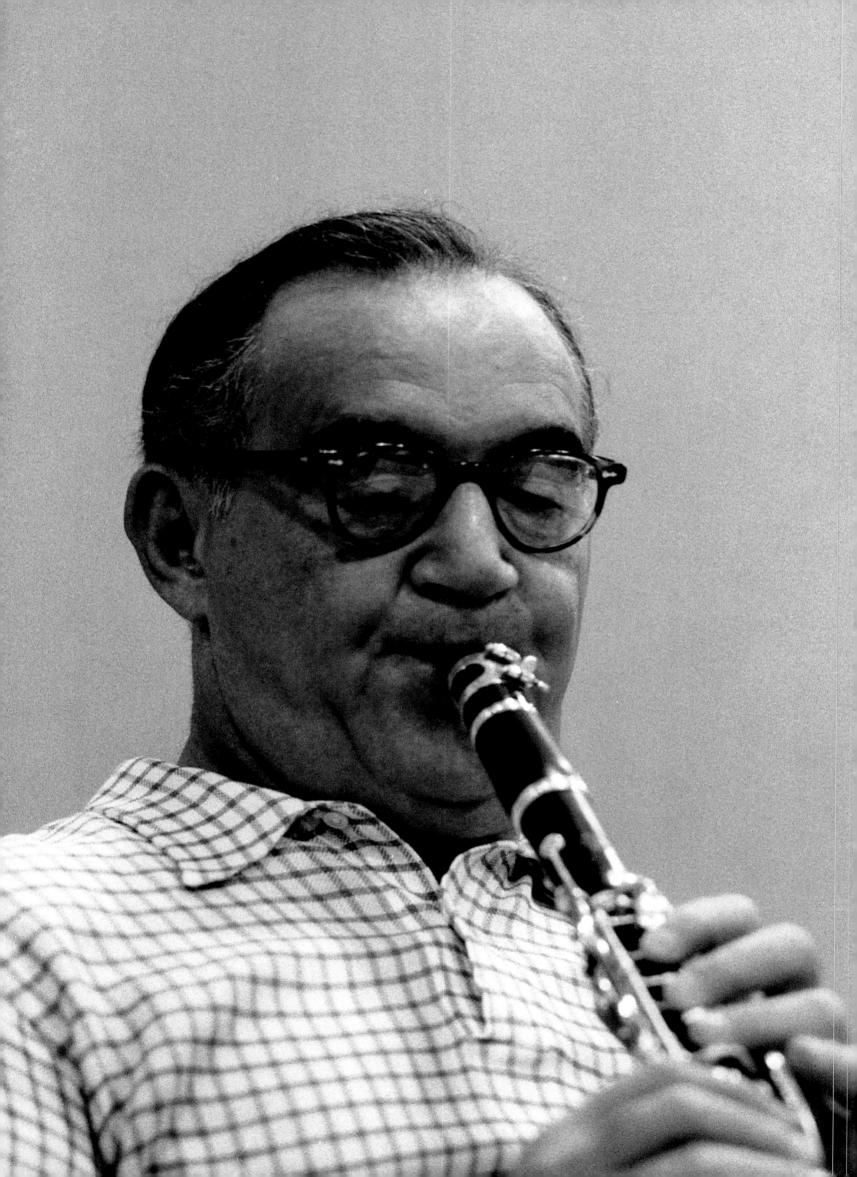

BENNY GOODMAN

THE CLARINETIST WHO LED one of the most popular bands of
the swing era, Benny Goodman had ambitions beyond the dance floor.
By the mid-1930s, Goodman had mass audiences jitterbugging to the hot-
test arrangements he could get (often by Fletcher Henderson), topped
by his own curlicued solos. But he also formed small groups that were
proudly integrated in an era of segregation, featuring musicians like
Lionel Hampton, Teddy Wilson, and the pioneering electric guitarist
Charlie Christian. In 1938, Goodman's band played the first jazz concert
at Carnegie Hall. And while swing would always be his staple, Goodman
also commissioned and recorded contemporary classical music for clarinet
from composers including Aaron Copland and Béla Bartók.

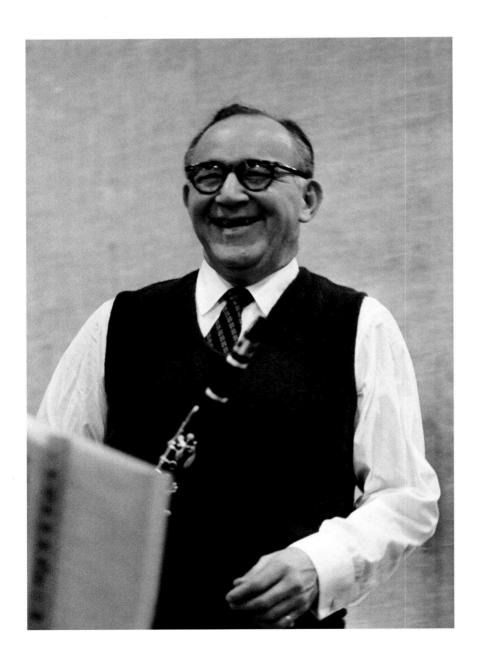

PAGE 132: Benjamin David "Benny" Goodman, August 1960.
ABOVE: February 1958.
OPPOSITE: Recording *Concerto for Clarinet and String Orchestra*
with Aaron Copland, left, New York, November 1950.

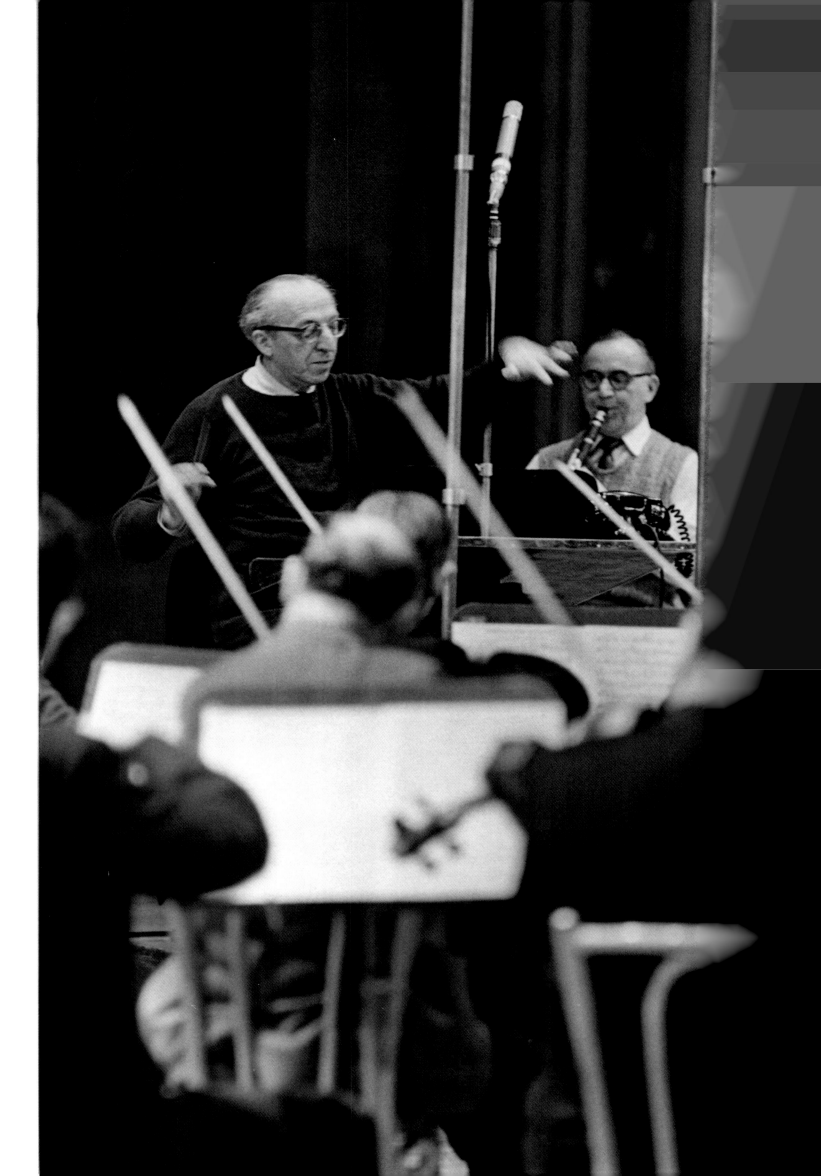

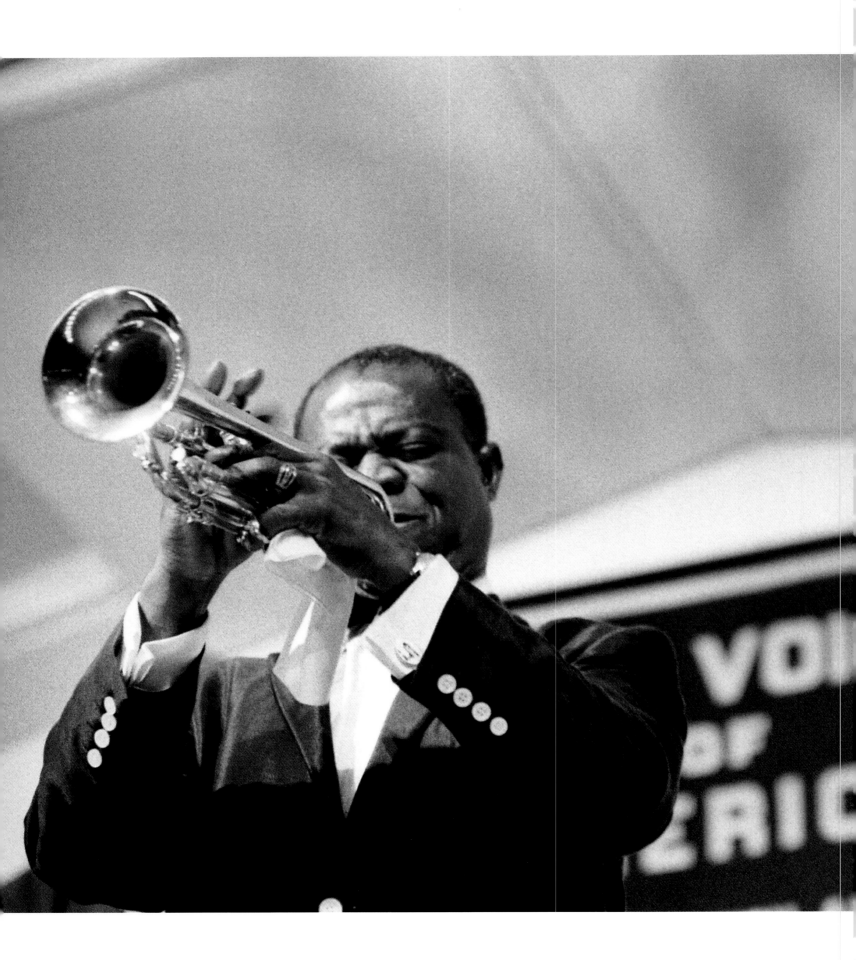

LOUIS ARMSTRONG

EVEN ON TECHNOLOGICALLY PRIMITIVE early recordings, the buoyant, sassy, exultant tone of Louis Armstrong's trumpet immediately leaped out of the improvisational tangle of the New Orleans jazz that he both defined and transfigured. There was his voice, too, savoring every bit of rasp and gravel to laugh off the blues and swing as if nothing could be easier. Armstrong's recordings in the mid-1920s with his Hot Five and Hot Seven, and his 1928 duets with Earl "Fatha" Hines, held the makings of all jazz in their wake: the ascendance of the soloist, the rhythmic and harmonic daring, the scat-singing, the sheer joyful risk. Armstrong smiled through the next decades as a groundbreaker in movies and on radio, as a worldwide ambassador for jazz, as a quiet and then outspoken voice against segregation, as a hit-maker who could challenge the Beatles (with "Hello, Dolly!"), and, always, as an entertainer who left audiences cheering for exceptional art.

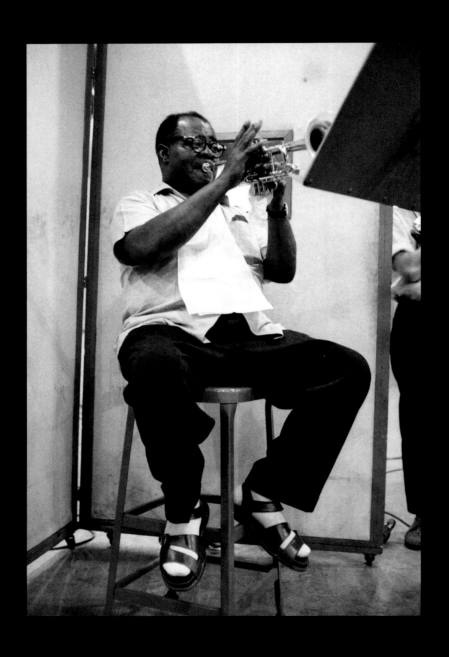

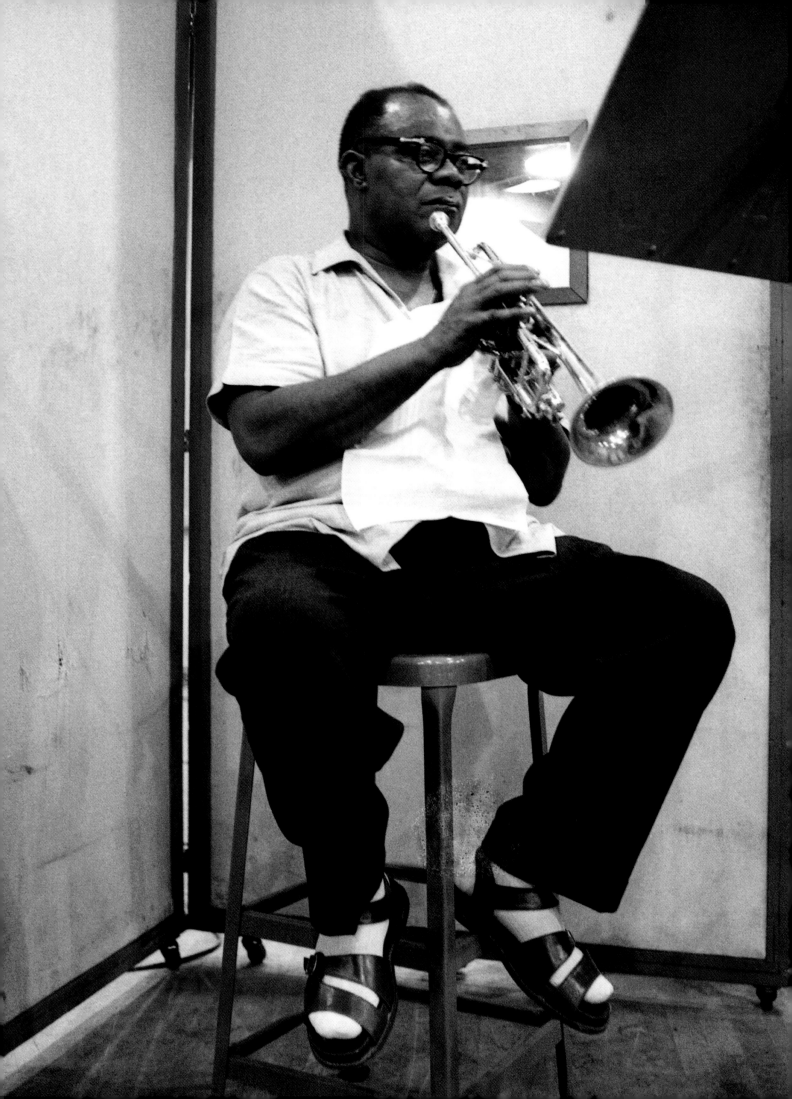

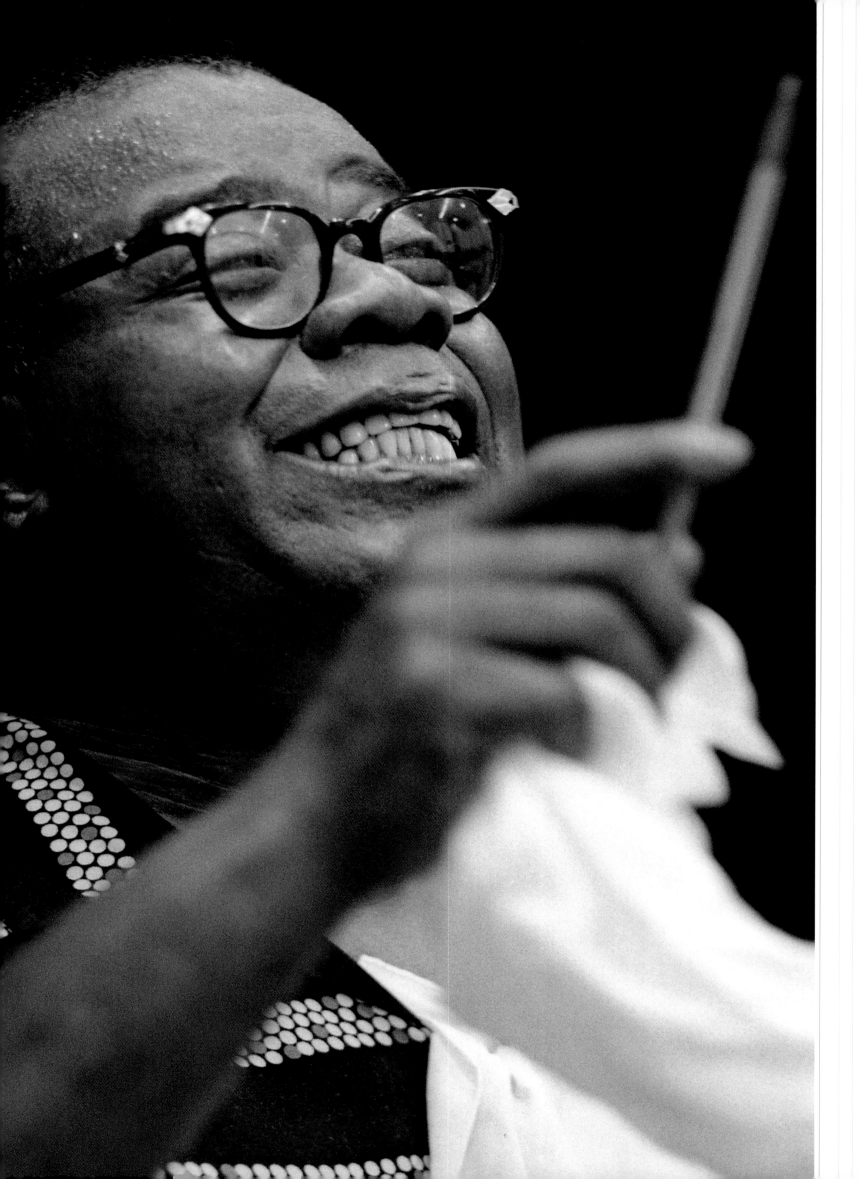

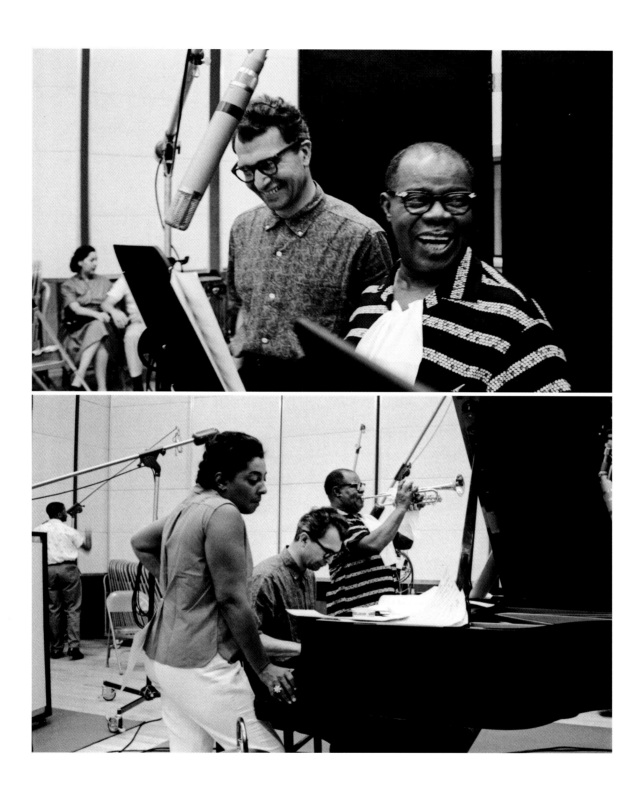

OPPOSITE, TOP & ABOVE: Sessions with pianist Dave Brubeck, top left, and singer Carmen McCrae, above left, New York, September 1960.

MILES DAVIS

IF MILES DAVIS HAD JUST BEEN A TRUMPET PLAYER, he still would have been amply celebrated. His tone and phrasing were unmistakable, from the aching delicacy of his ballads to his jabs, smears, and declarations in uptempo tunes. His sense of harmony, and how far it could be stretched and twisted, was unimpeachable. But of course he was far more: the bop coconspirator, the composer of durable tunes, the talent scout who enlisted John Coltrane, Cannonball Adderley, Herbie Hancock, Wayne Shorter, Bill Evans, John McLaughlin, and far too many more to mention, and the bandleader who could define a new course for jazz with each new lineup. A restless explorer—and a snappy dresser, too.

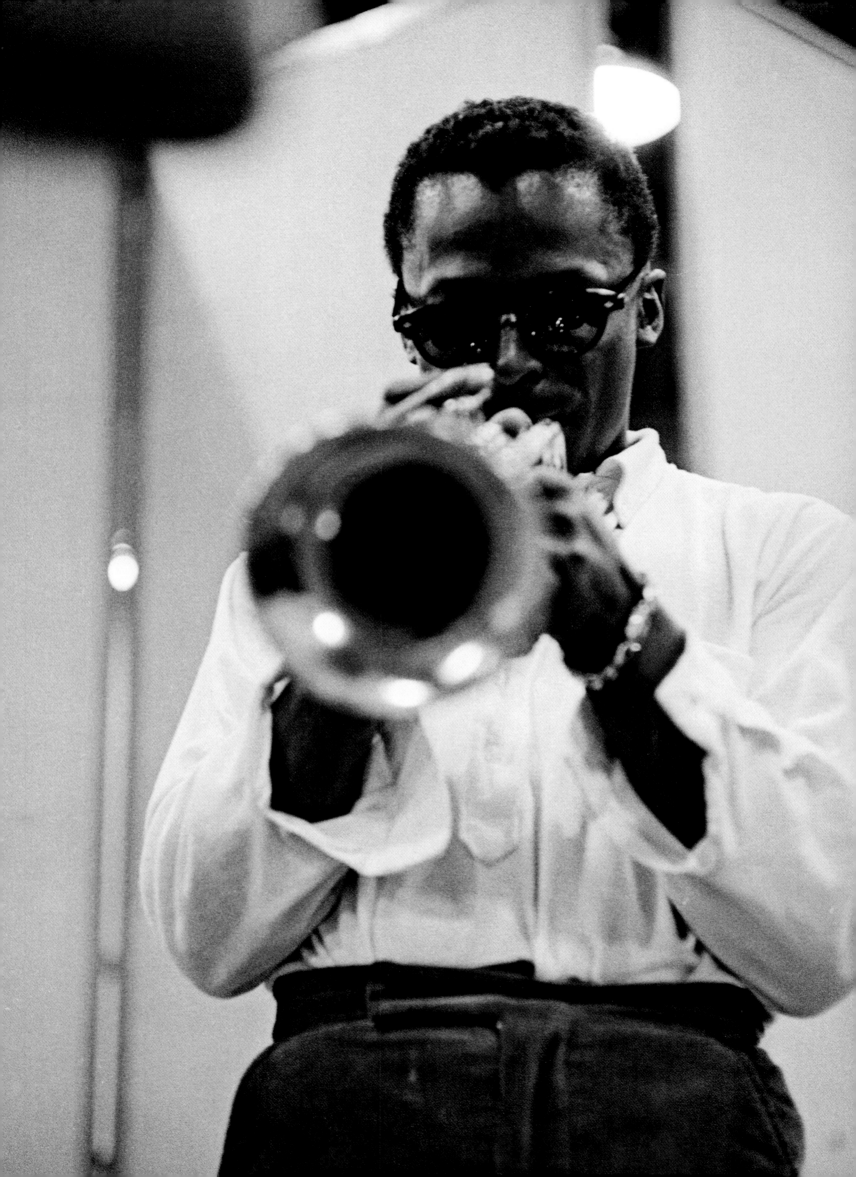

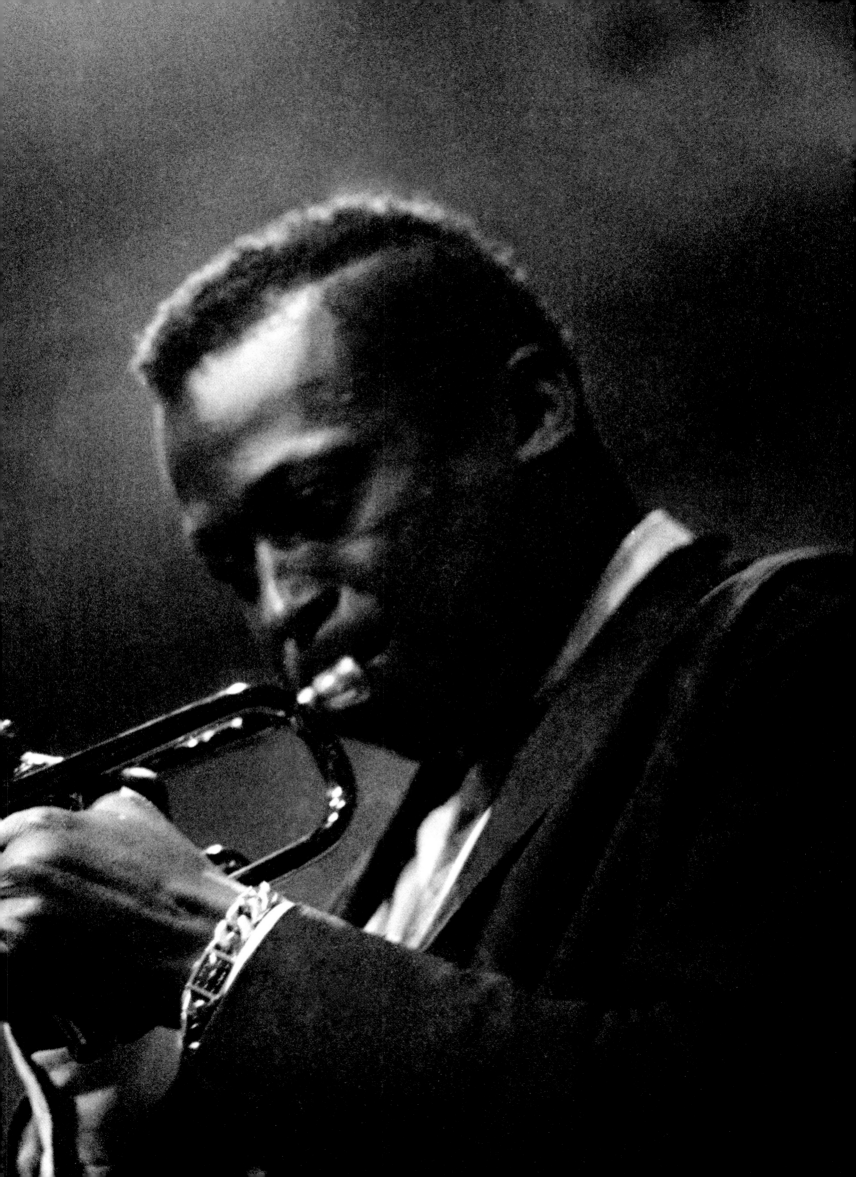

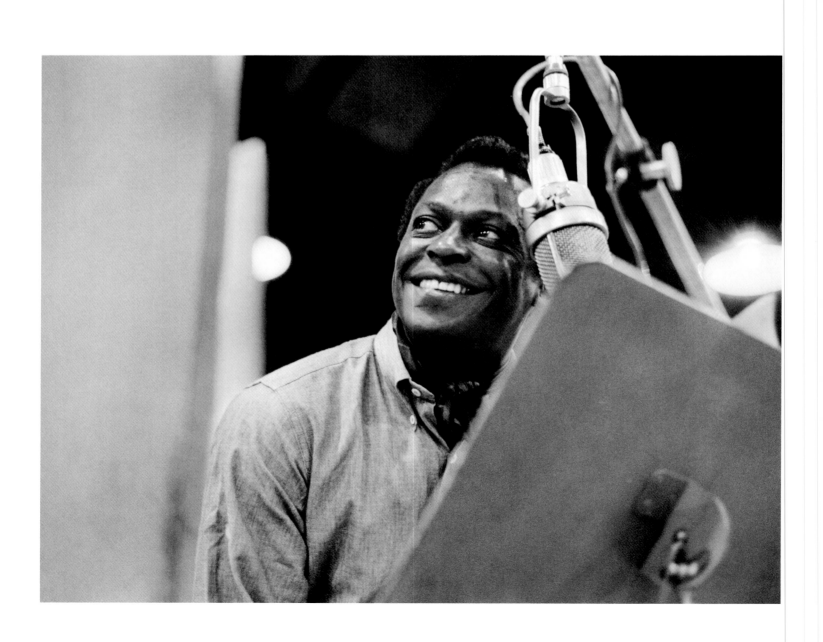

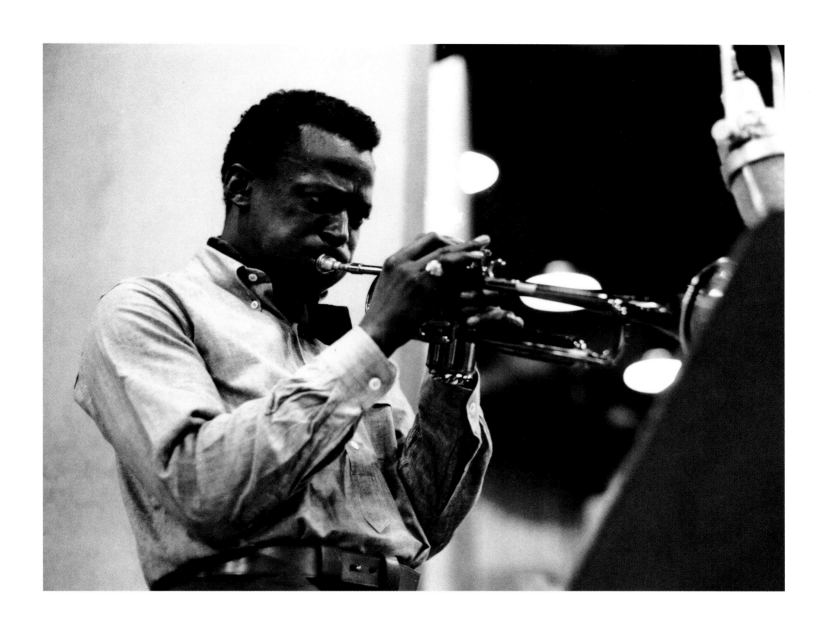

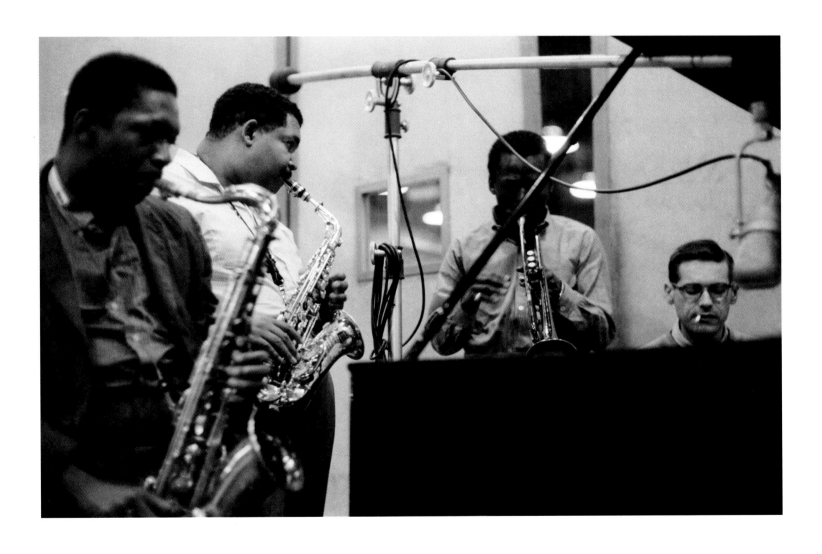

OPPOSITE & ABOVE: At the historic 1959 recording session for *Kind of Blue* with (above from left to right) John Coltrane, Cannonball Adderley, and Bill Evans.

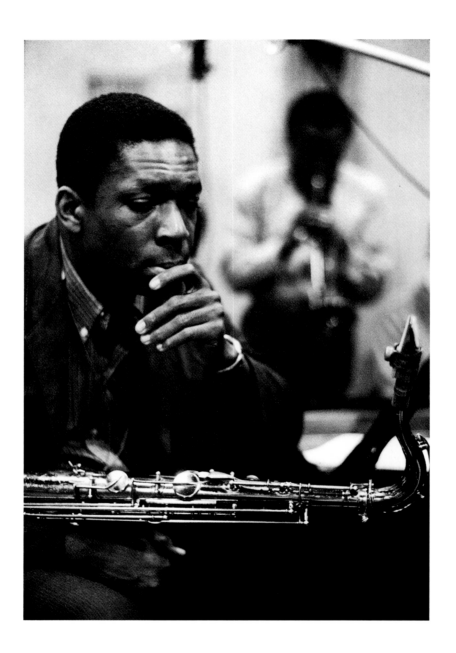

ABOVE & OPPOSITE: With saxophonist John Coltrane, left.

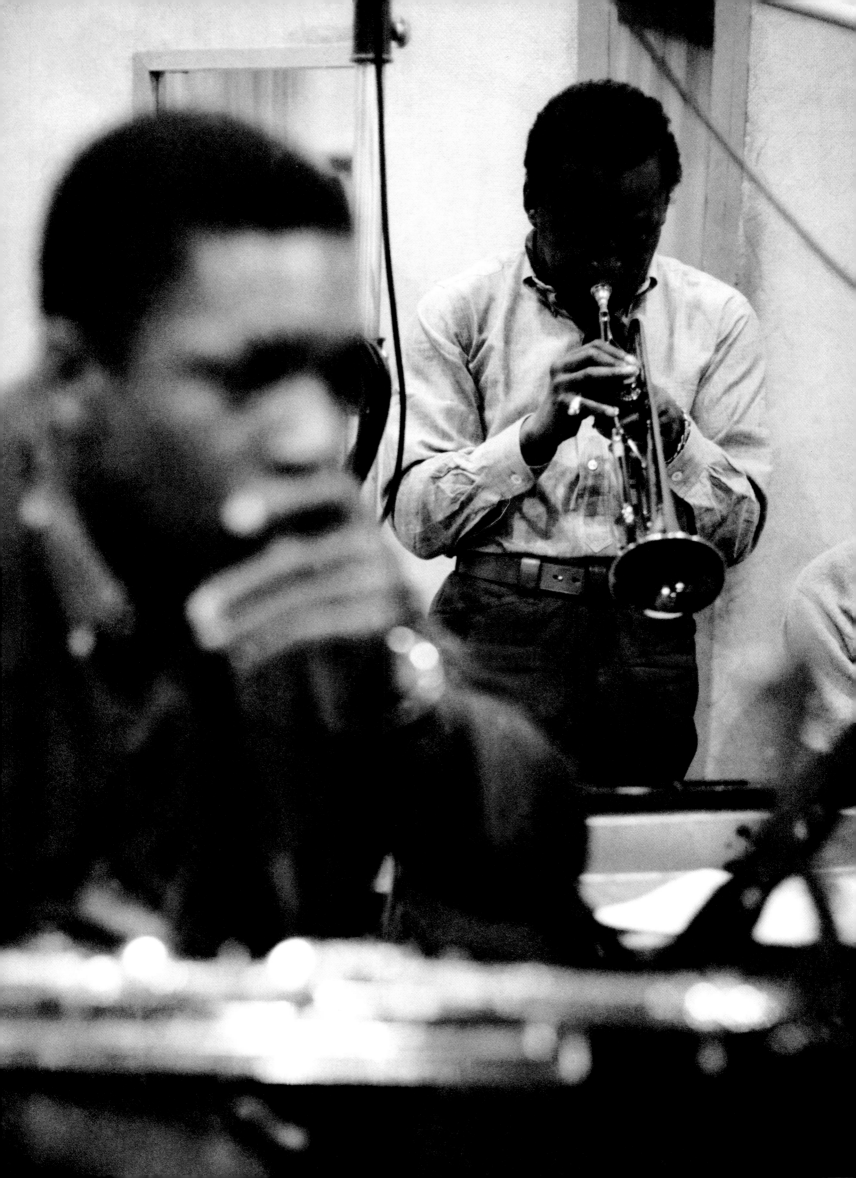

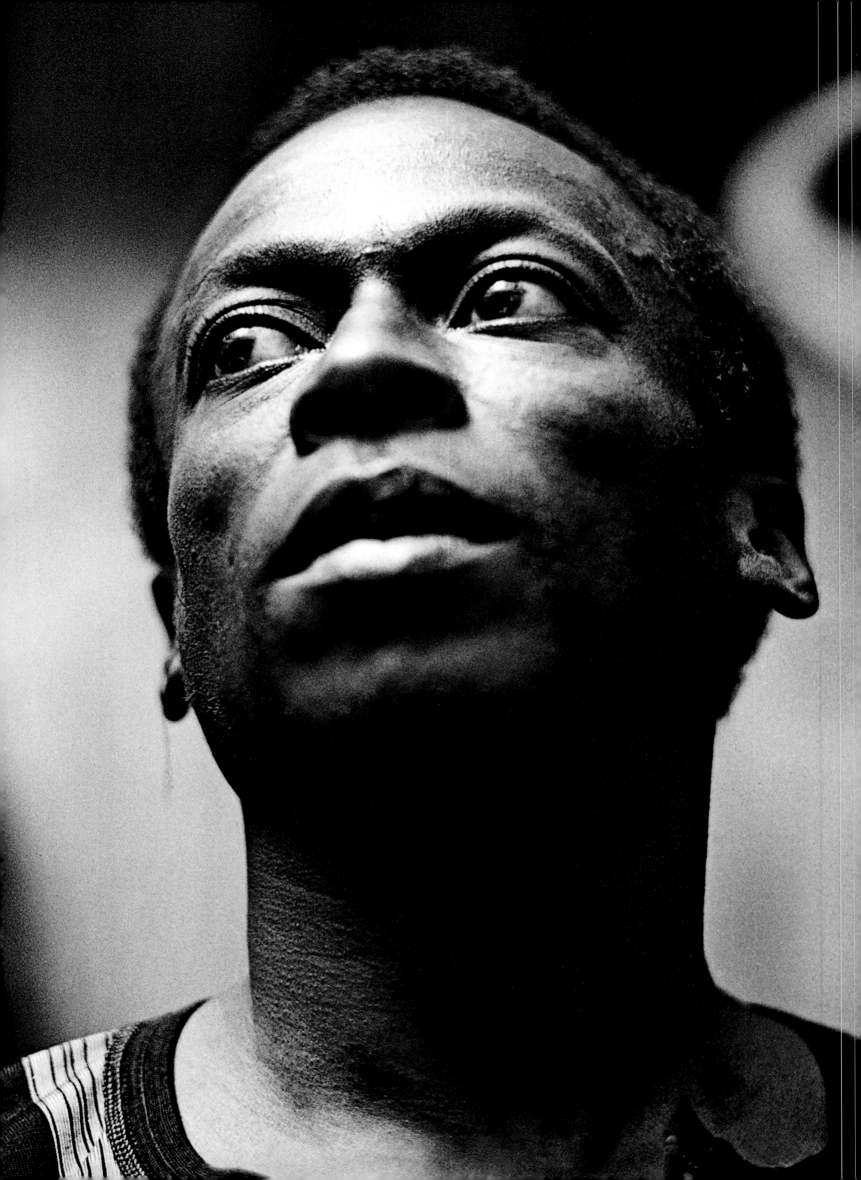

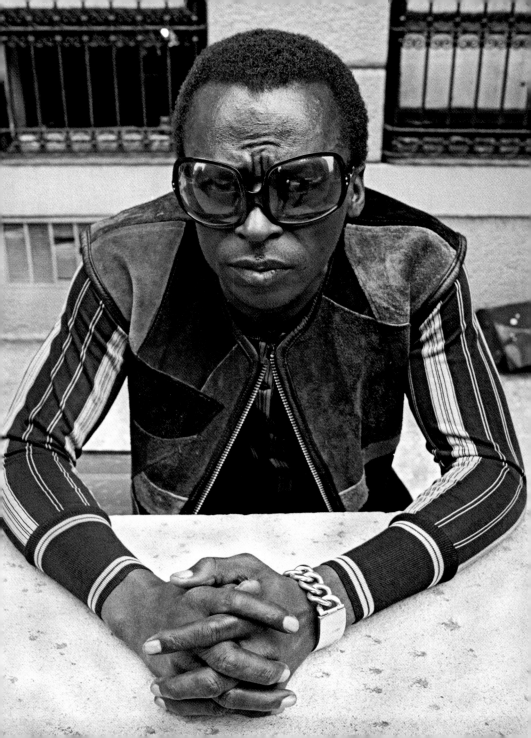

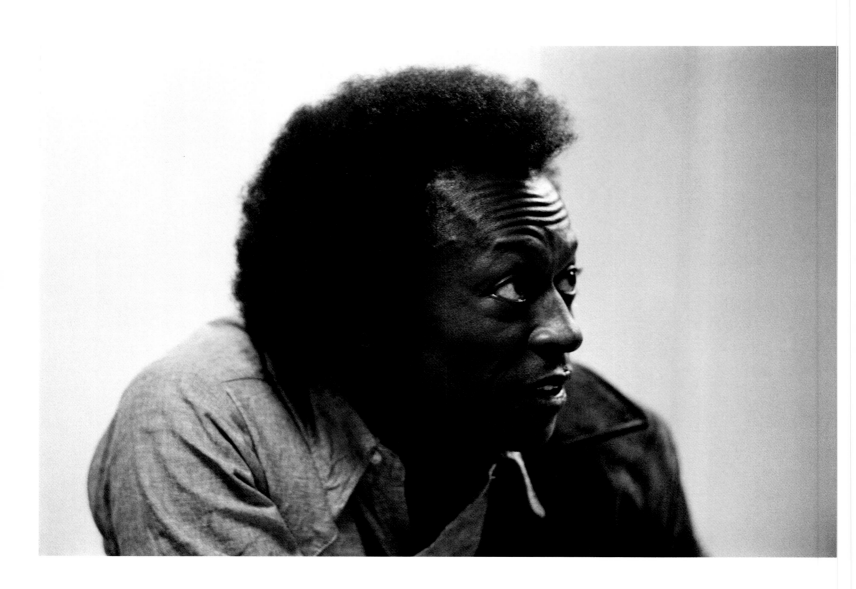

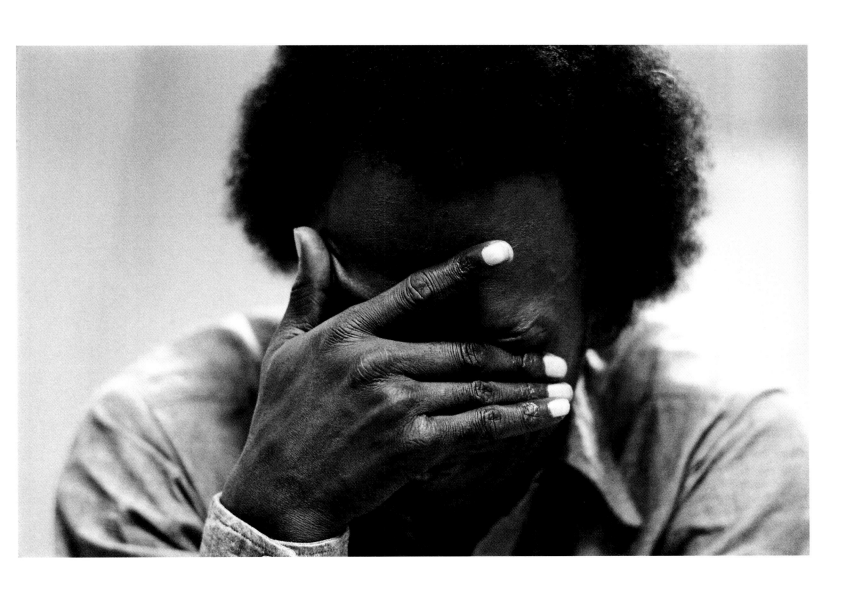

OPPOSITE & ABOVE: When the double album, *Live-Evil*—
in concert and in the studio—was released, New York, November 1971.

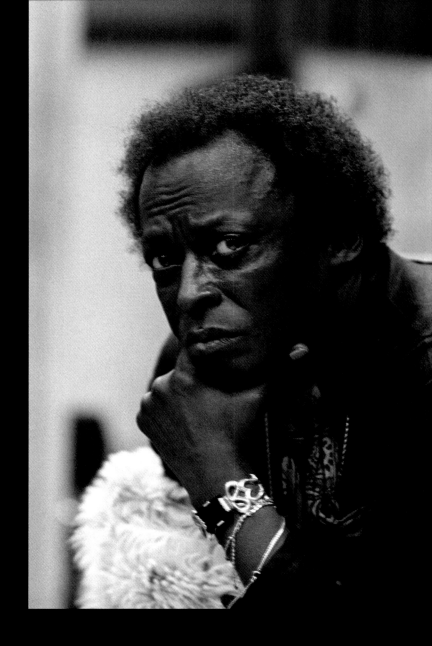

ABOVE & OPPOSITE: Returning to the studio after a long absence, New York, March 1978.

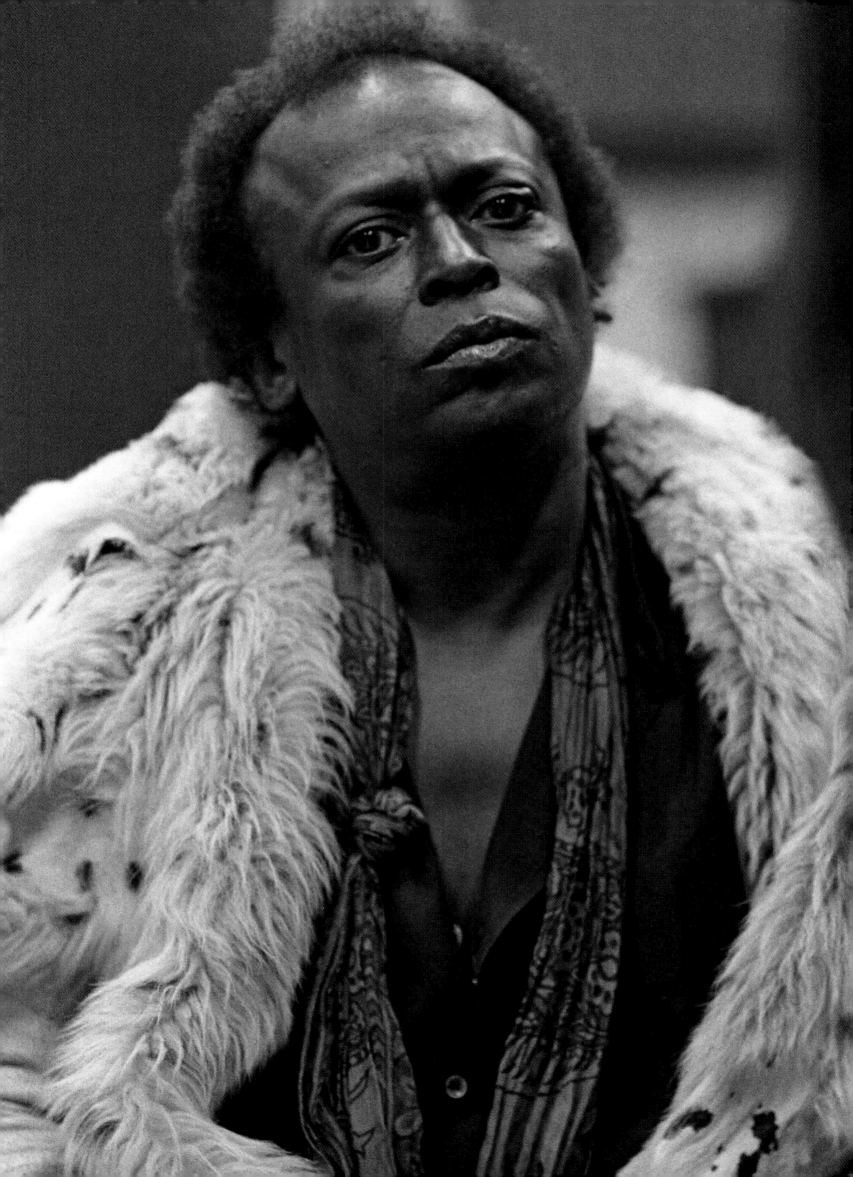

BILLIE HOLIDAY

BILLIE HOLIDAY'S GREATNESS is inseparable from tragedy. Her signature songs—"God Bless the Child," "Lover Man," "Strange Fruit," "Don't Explain," "Good Morning Heartache"—were tales of betrayal, loss, and worse, and her long decline through addictions and abusive relationships has been well chronicled. But her music endures independent of the backstory. Holiday's voice brought endless subtleties to every line: a teasingly seductive swing, ever-improvisational melodic turns, and a tone that could be sultry or wounded, kittenish or caustic. She brought singers the freedom of horn players and reminded horn players that their lines could sing. The tragedy is that her life never reflected such grace.

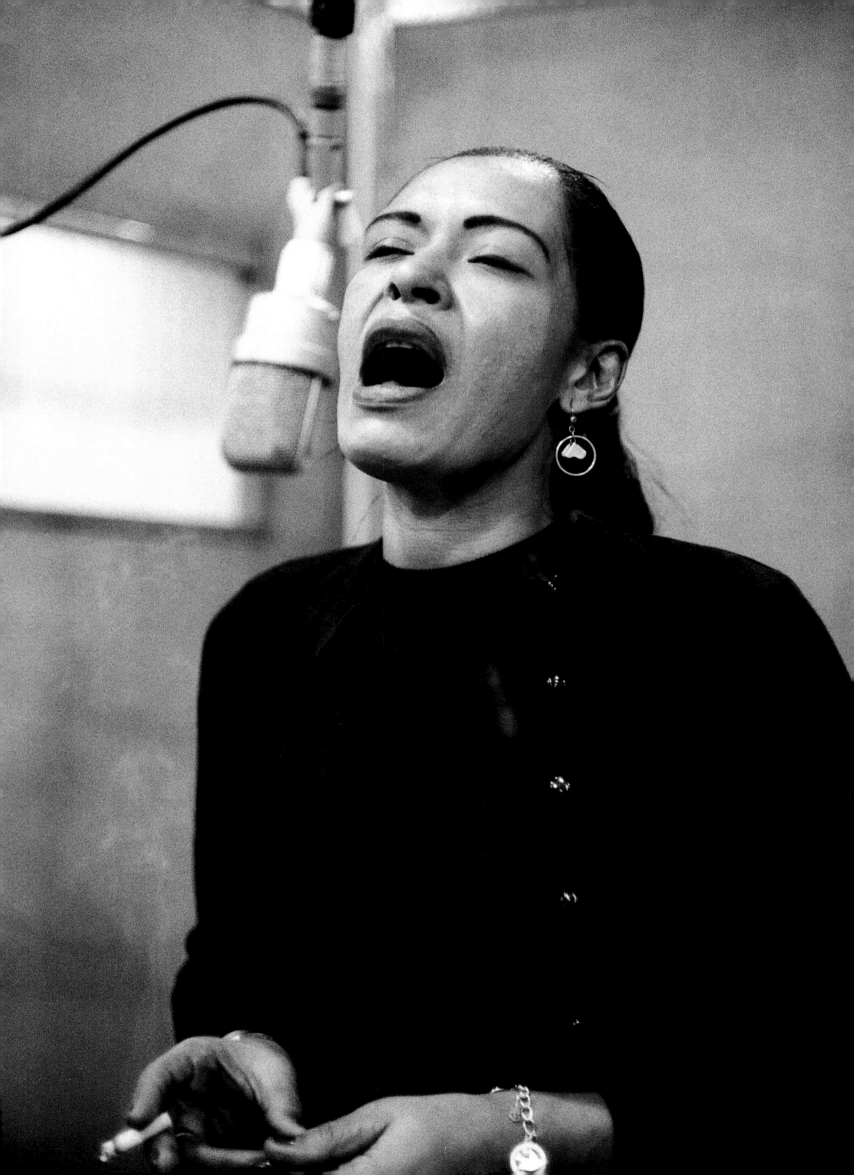

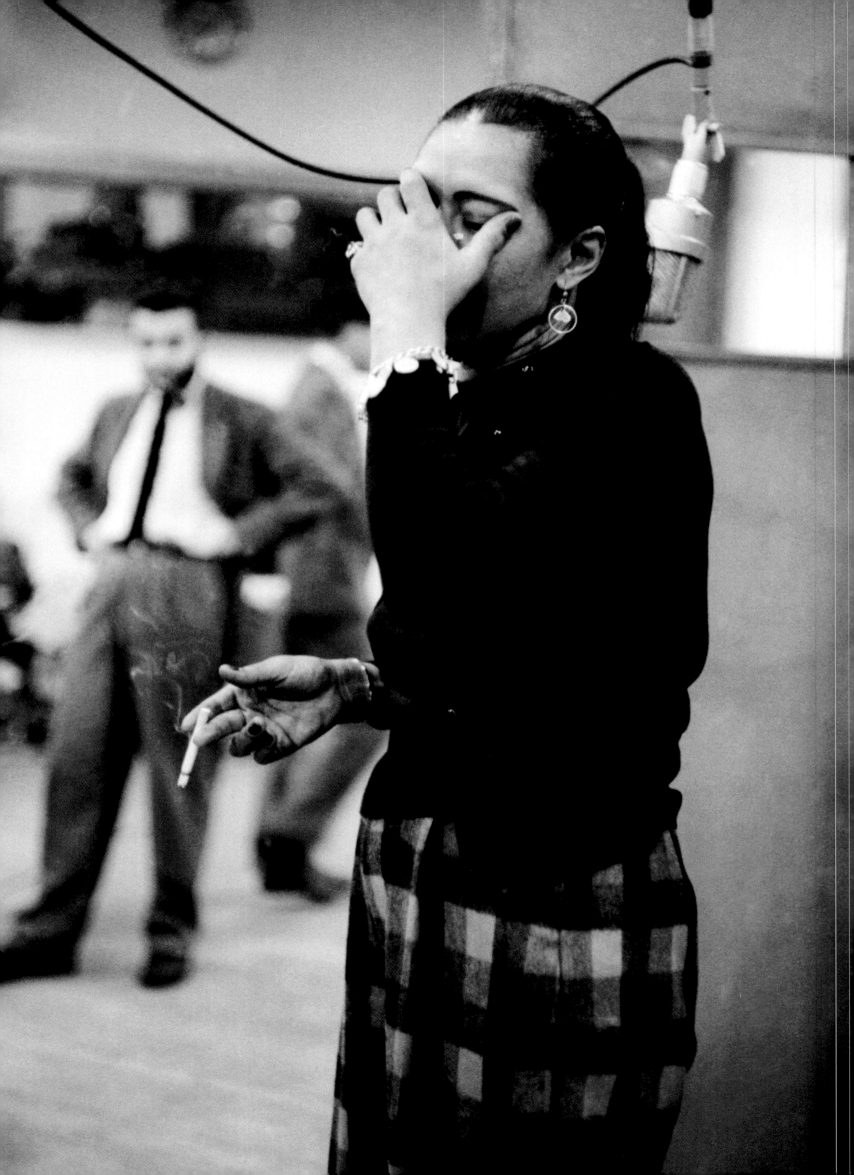

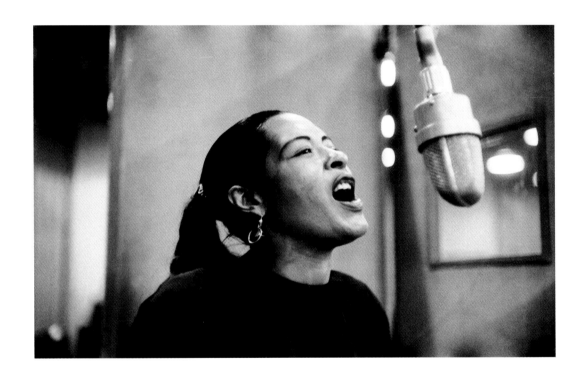

PAGE 159, OPPOSITE & ABOVE: Billie Holiday recording *Lady in Satin*, New York, December 1957.
PAGES 162-163: A party in the Persian Room of the Plaza Hotel with trumpeter Buck Clayton, right, New York, September 1958.

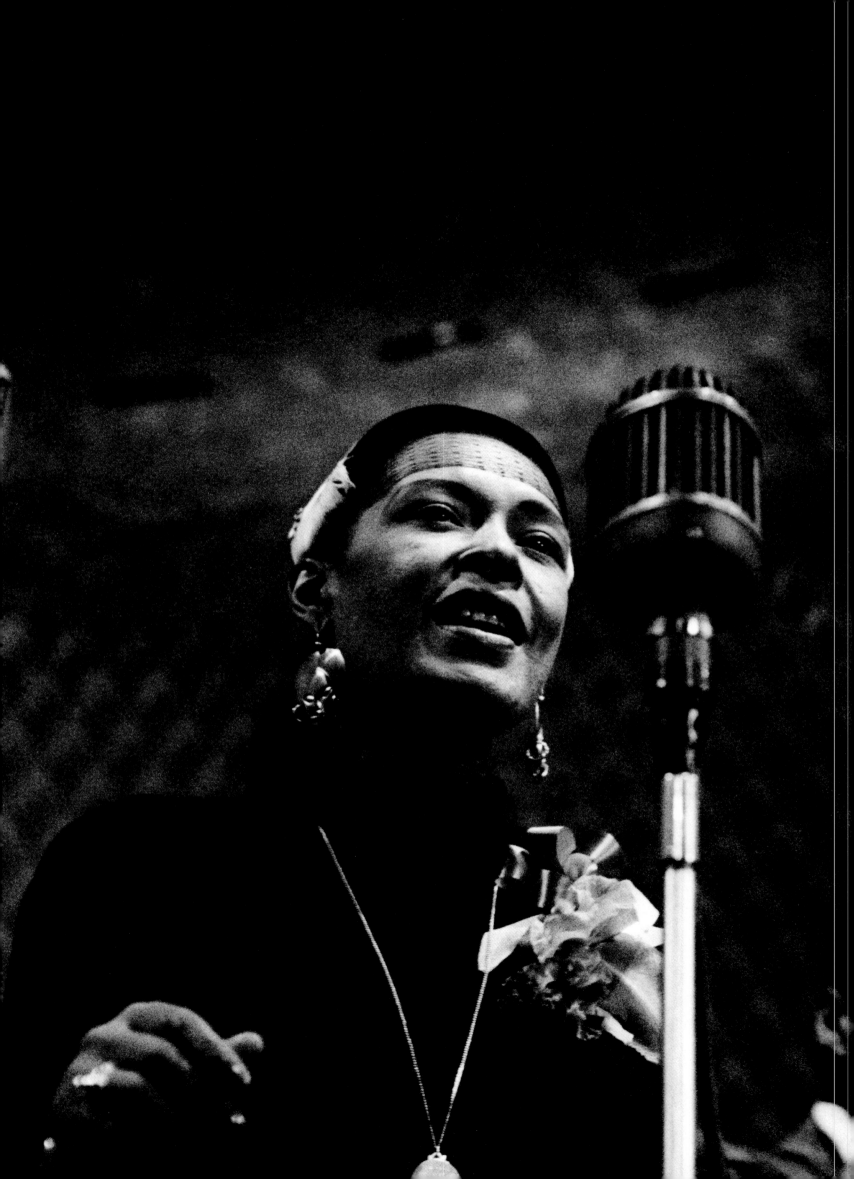

DUKE ELLINGTON

IN ITS LONG HEYDAY, the Duke Ellington Orchestra was jazz's ultimate ensemble. Ellington's dapper leadership and countless nights on the road shaped his band into a gathering of luminous soloists with an impeccable blend, equally capable of propelling dancers and enthralling a concert audience. And with his intuitive collaborator Billy Strayhorn, Ellington made his band the research-and-development lab for jazz to come—for advanced harmonies, for structural experiments, for exotic ingredients as well as earthy ones. Looking for the precedent to any jazz innovation? It's almost guaranteed to be somewhere in the Ellington repertory.

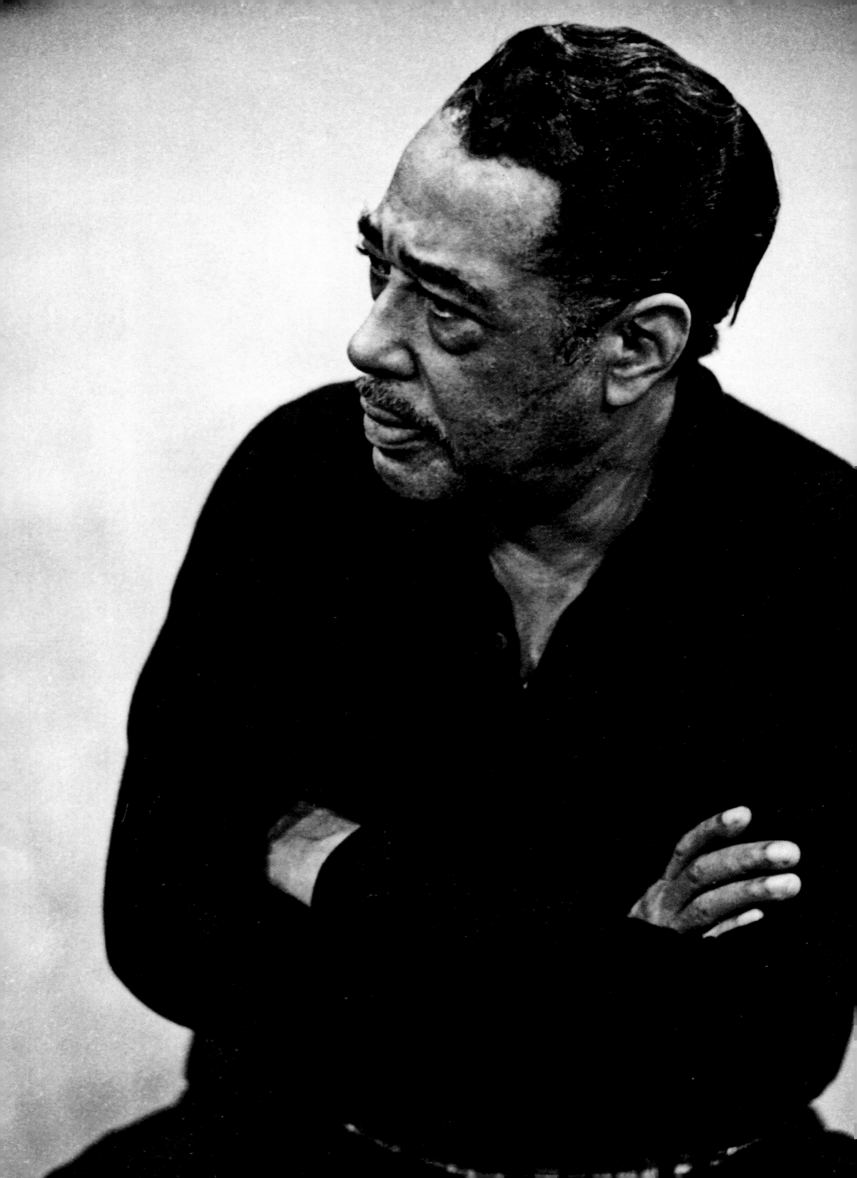

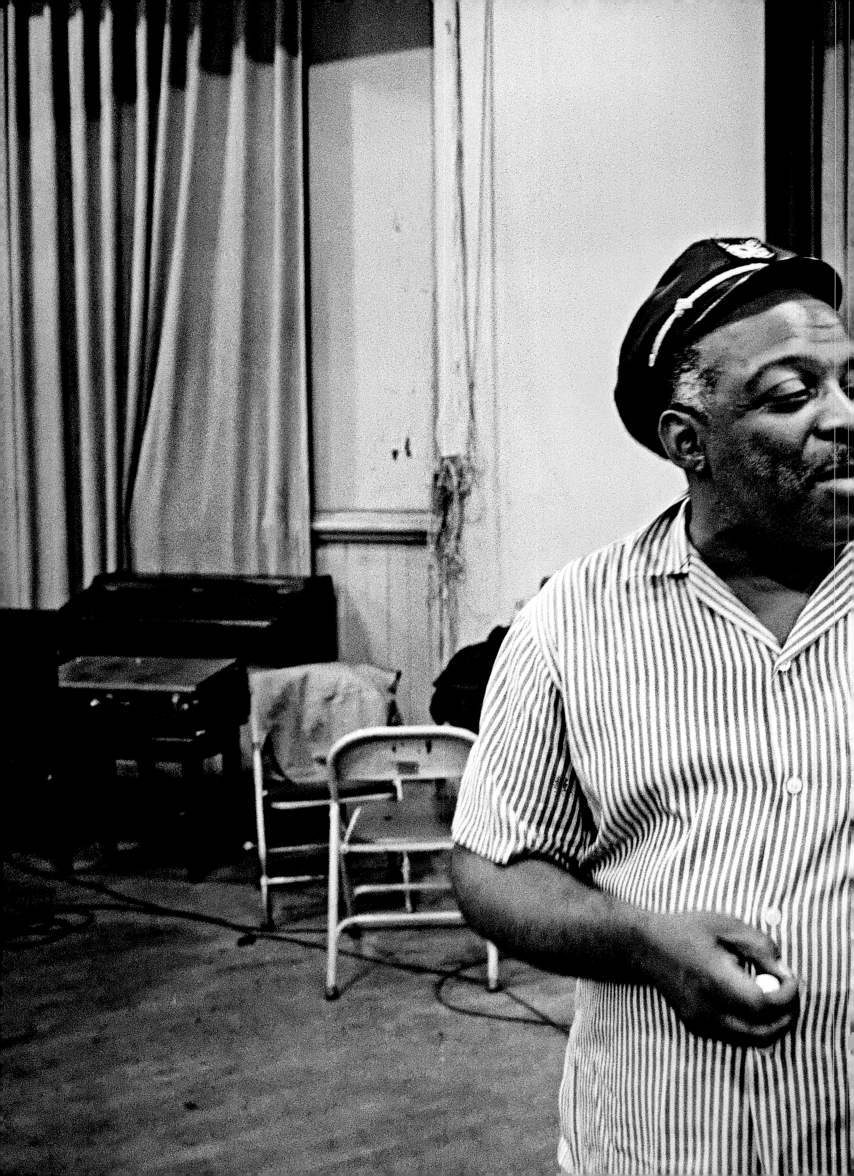

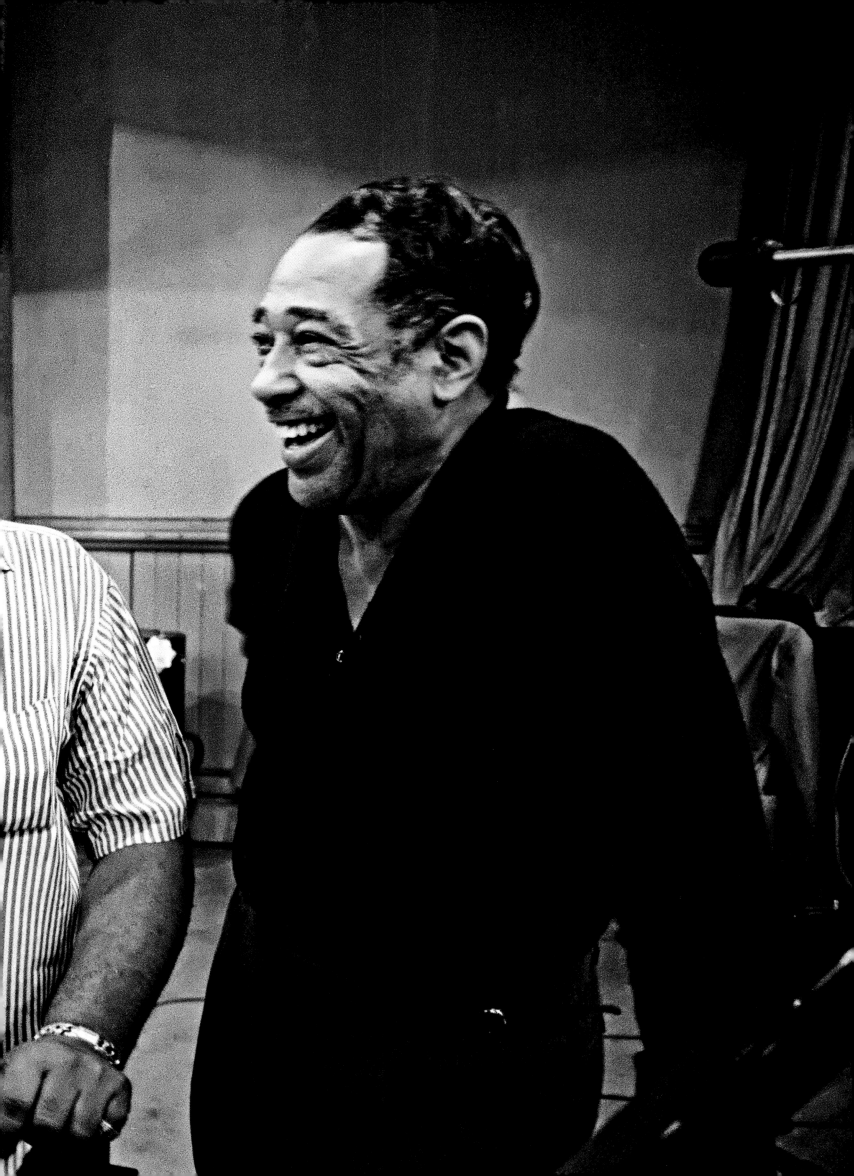

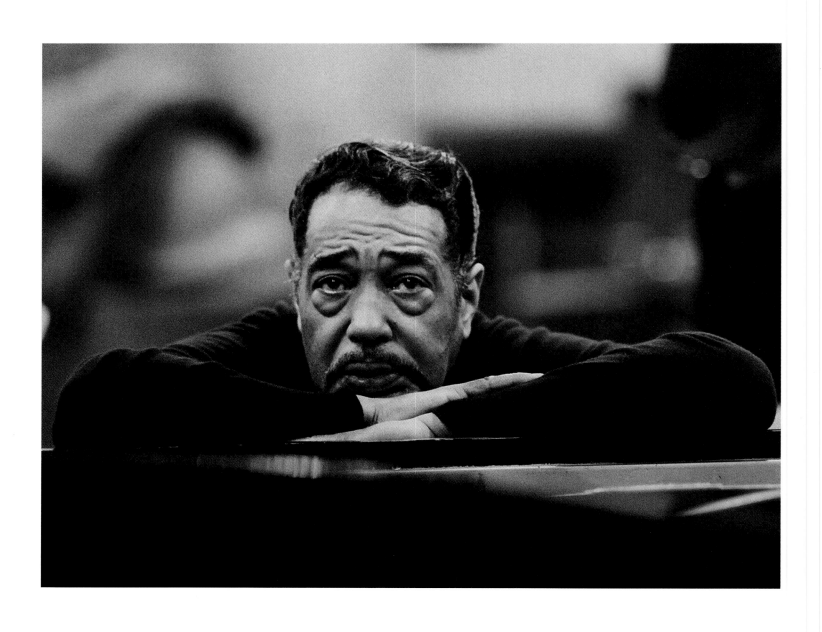

PAGE 165: Edward Kennedy "Duke" Ellington, 1959.
PAGES 166-167: Recording *First Time! The Count Meets the Duke* with Bill "Count" Basie, left, July 1961.
ABOVE: Taking a break at 30th Street Studios, December 1959.
OPPOSITE: Recording the soundtrack to Martin Ritt's *Paris Blues*, starring Sidney Poitier, March 1962.

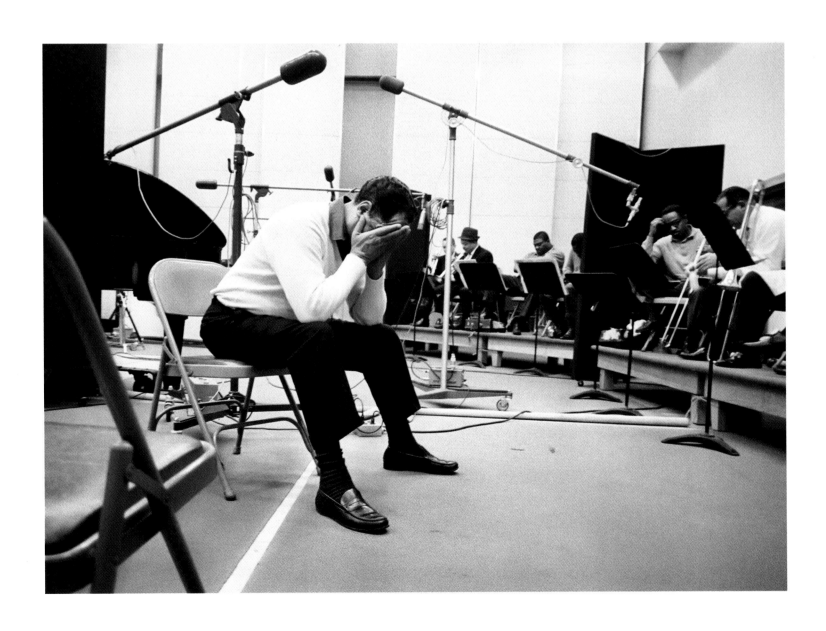

ABOVE: With author Langston Hughes, right, at the Newport Jazz Festival, July 1956.
PAGES 172-173: With trumpeter John Birks "Dizzy" Gillespie, left, recording "U.M.M.G. (Upper Manhattan Medical Group)" for Ellington's *Jazz Party*, February 1959.

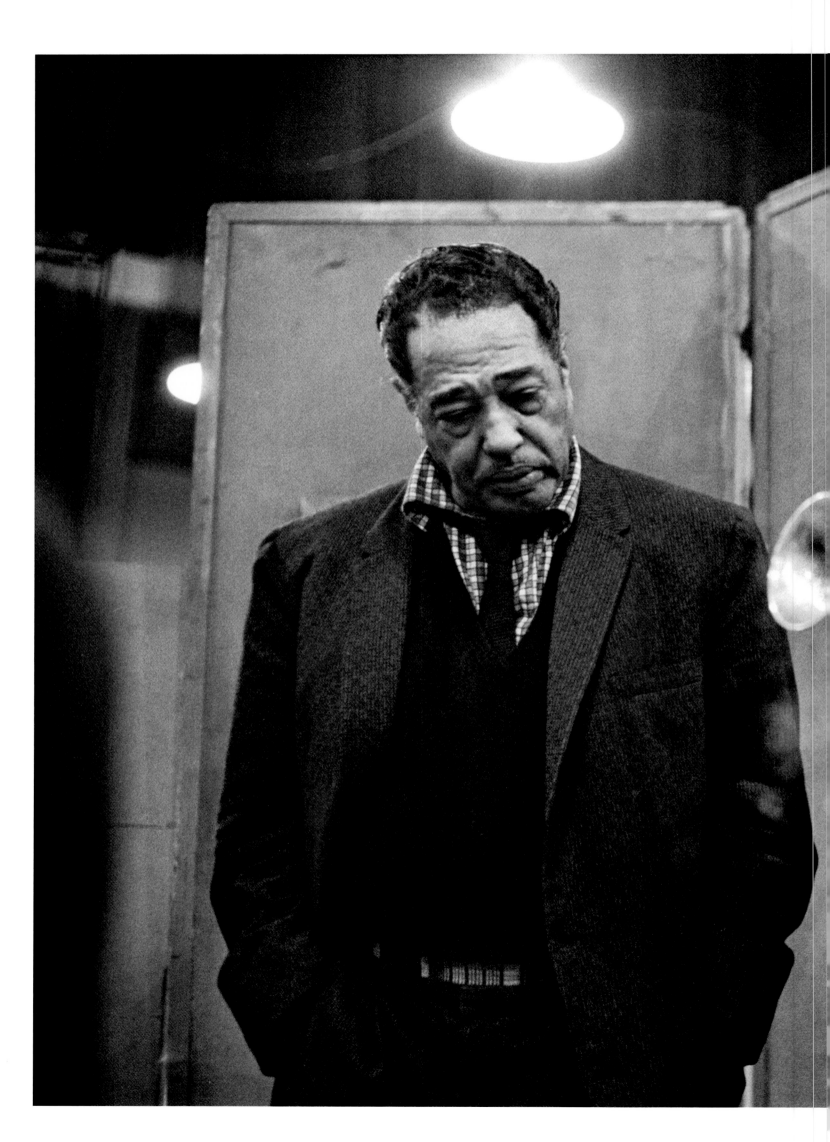

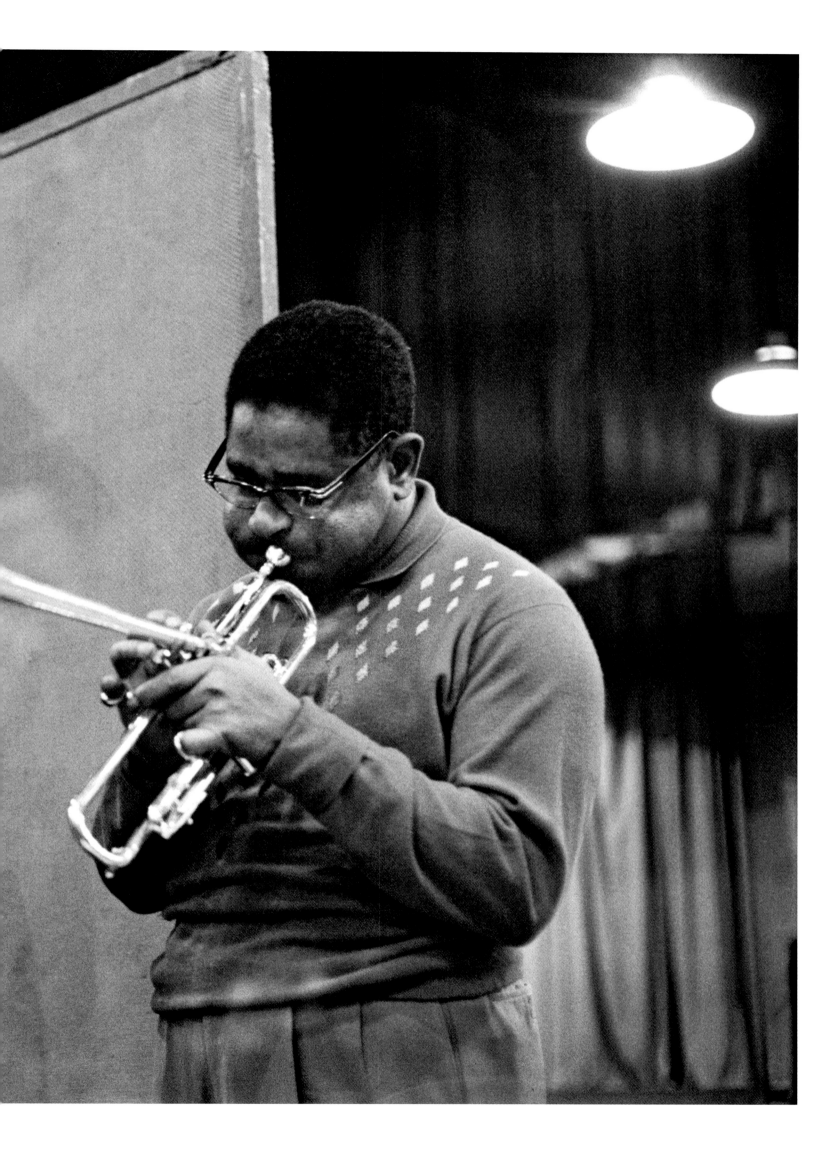

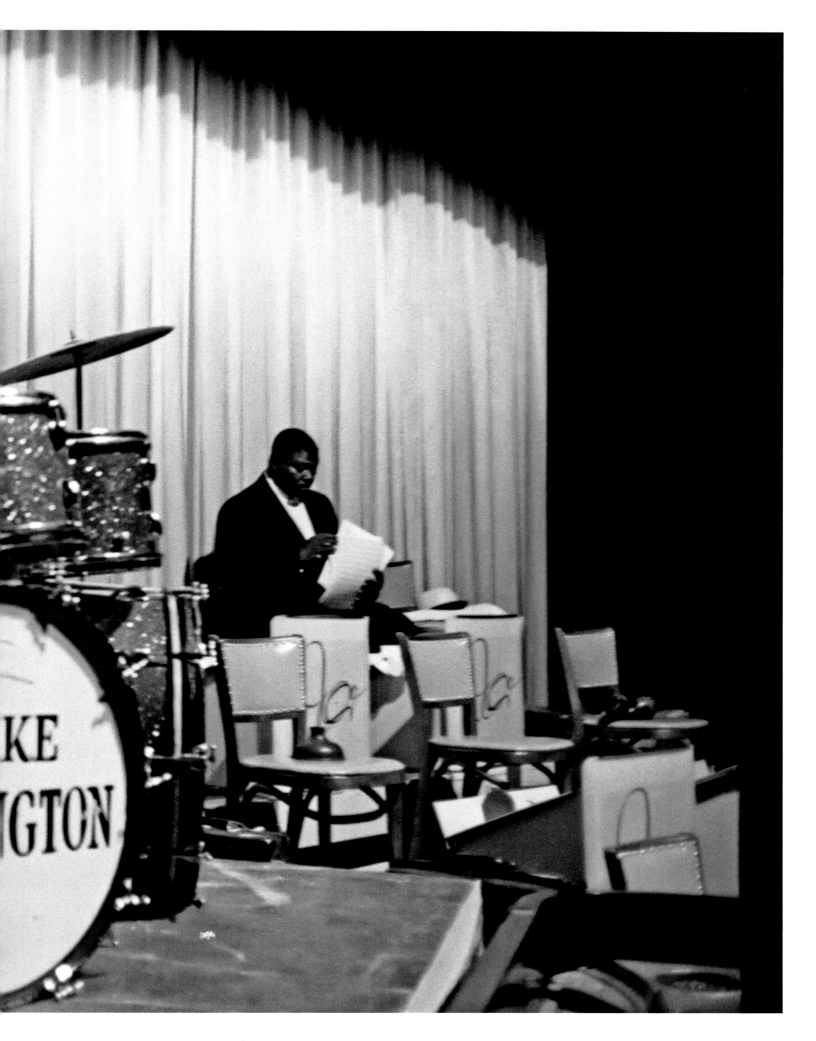

The Duke Ellington Orchestra on the road, 1957.

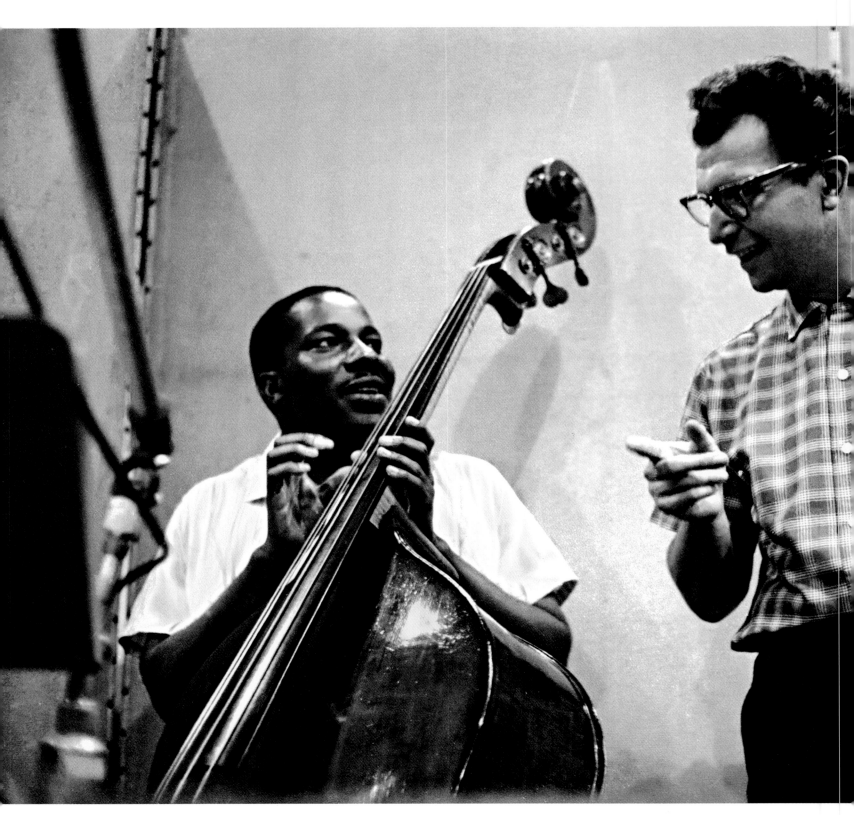

Collaborating with "The Judge," bassist Eugene Wright, 1959.

DAVE BRUBECK

AFTER THE BEBOP REVOLUTION, the pianist Dave Brubeck made jazz approachable in the 1950s, garnering pop-sized audiences for small-group jazz that didn't pander. There was something down-home and hymnlike in Brubeck's blocky chords, and the contrast between his piano and Paul Desmond's airy, nonchalant alto saxophone lines was distinctive. Desmond's composition "Take Five"—in an eccentric 5/4 meter—became a genuine if unlikely hit single, making the 1959 album *Time Out* jazz's first million-seller, even in the rock-and-roll era.

Dave Brubeck recording *Time Out* with the Dave Brubeck Quartet, July 1959.

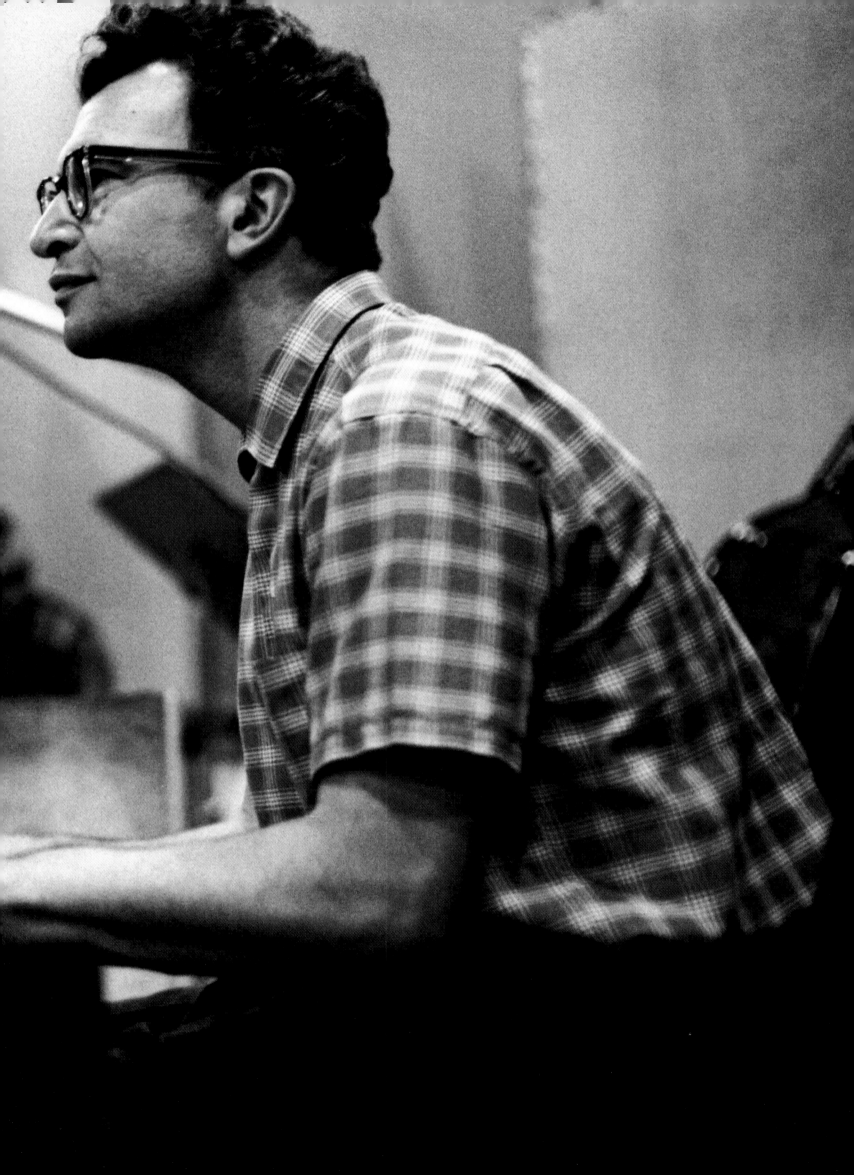

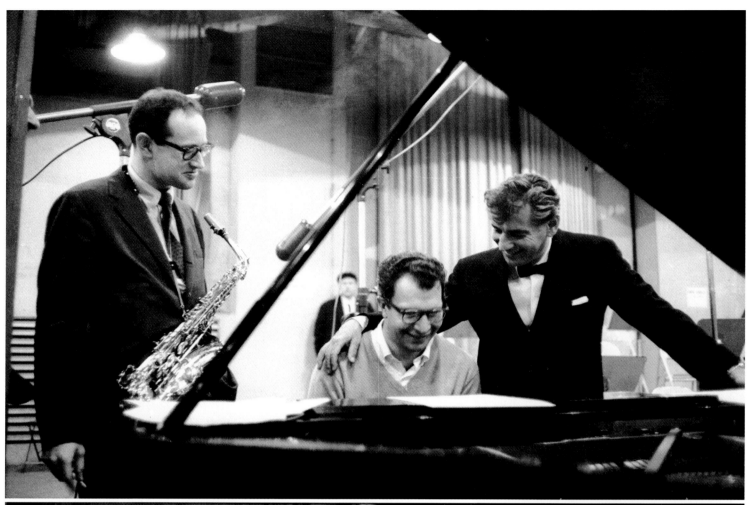

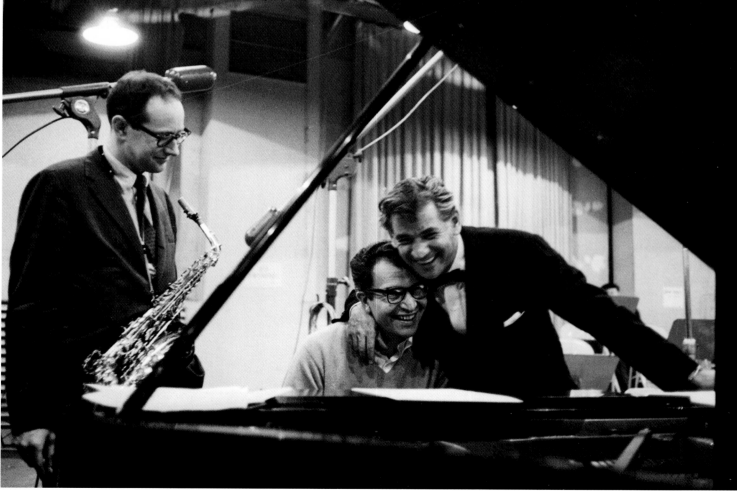

TOP, ABOVE & OPPOSITE: Recording *Bernstein Plays Brubeck Plays Bernstein* with
alto saxophonist Paul Desmond, left, and Leonard Bernstein, February 1960.

CHARLES MINGUS

THE SOUND CHARLES MINGUS GOT from his bass was the attitude of his music: burly, rooted, pugnacious. He had the history of jazz in his résumé: backing up Louis Armstrong, then helping foment bebop with Charlie Parker and Dizzy Gillespie. By the mid-1950s he was making his own kind of modern jazz, one that was always mindful of a larger African-American musical diaspora—of blues, gospel, Caribbean music, and field hollers as well as the Ellington legacy and the convolutions of hard bop. His compositions could glide, swing, bop, or brawl—and sometimes do them all before they were through.

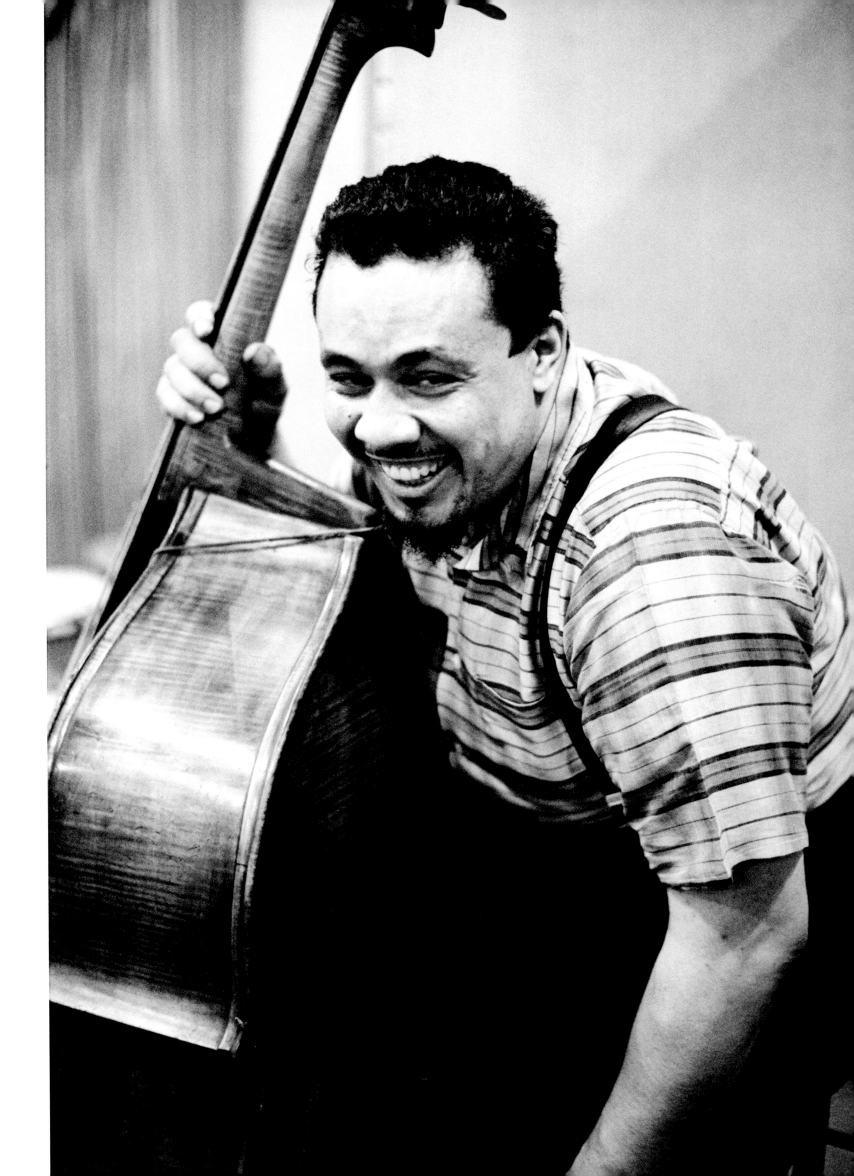

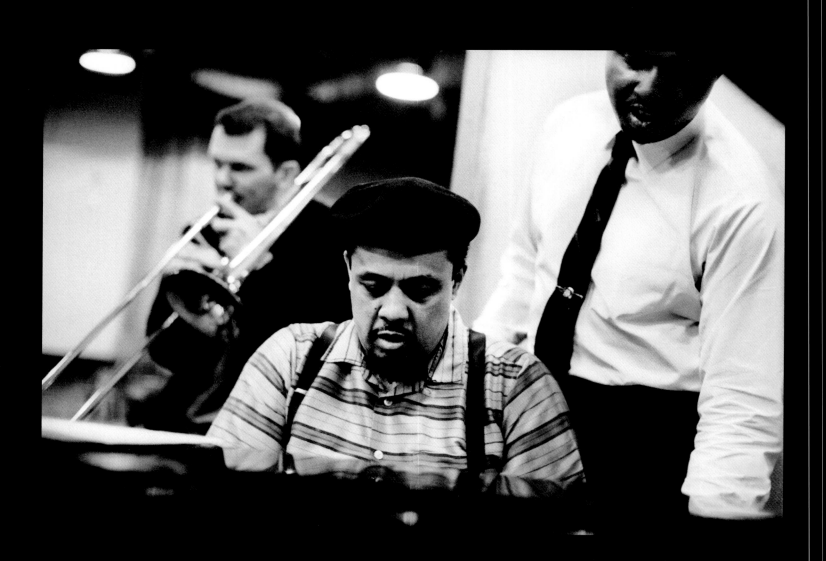

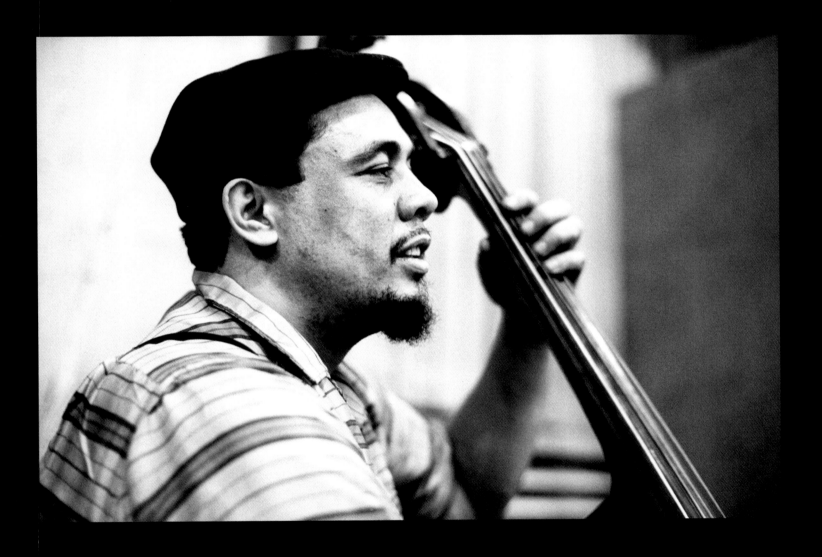

PAGE 183, OPPOSITE & ABOVE: Charles Mingus recording *Mingus Ah Um* with trombonist
Jimmy Knepper, opposite left, and pianist Horace Parlan, opposite right, May 1959.

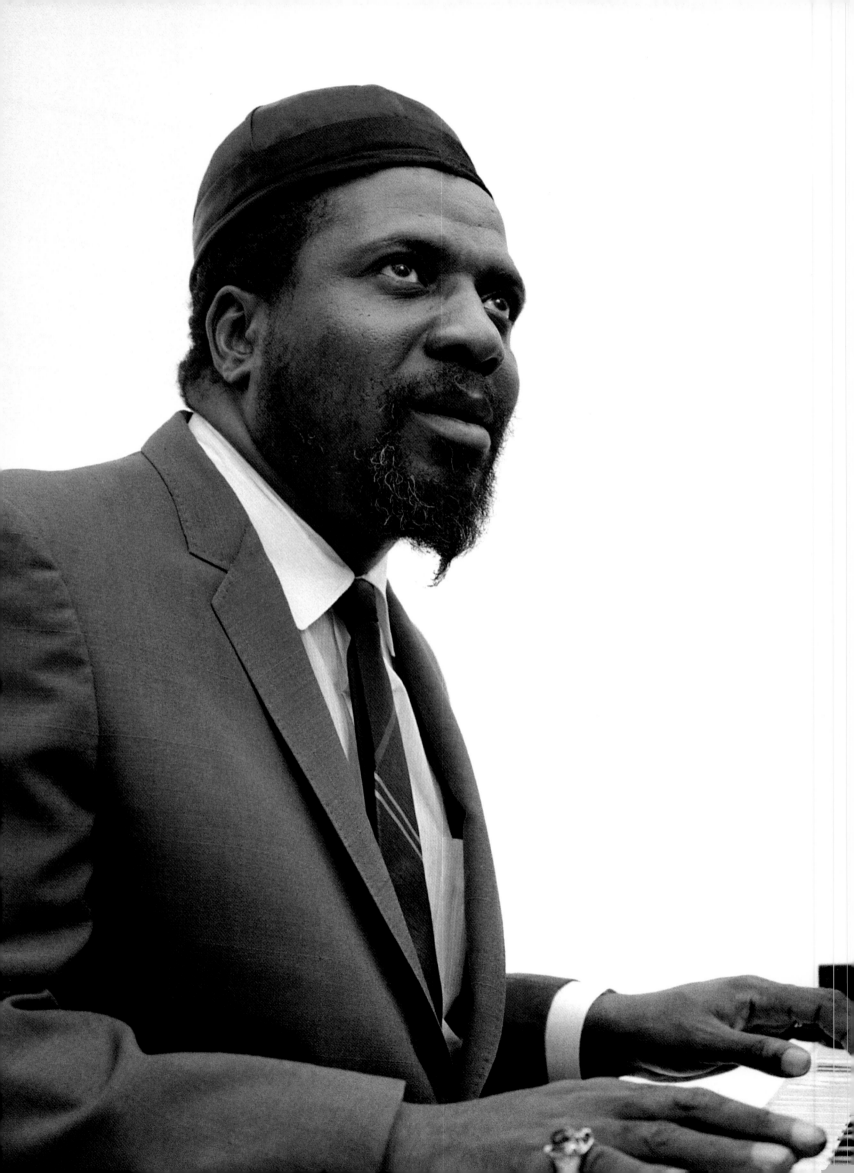

THELONIOUS MONK

THE PAUSES WERE AS IMPORTANT as the notes in the music of Thelonious Monk, the pianist who helped instigate bebop, then stood outside it. His compositions were jagged and ungainly on the surface but followed their own internal logic: splinters of dissonance turning into tunes that jerked ahead, hesitated, then veered off at the least expected angles. His tempos were leisurely compared to bebop's sprints; his timing was a marvel of lumpy silences and casual momentum, cagey and inimitable (though many tried). In his last decade, before he died in 1982, the silences grew as his mental health failed. Monk released his last studio album as a leader in 1971 and gave his last public performance in 1976. For his last six years, he didn't touch the piano in his room.

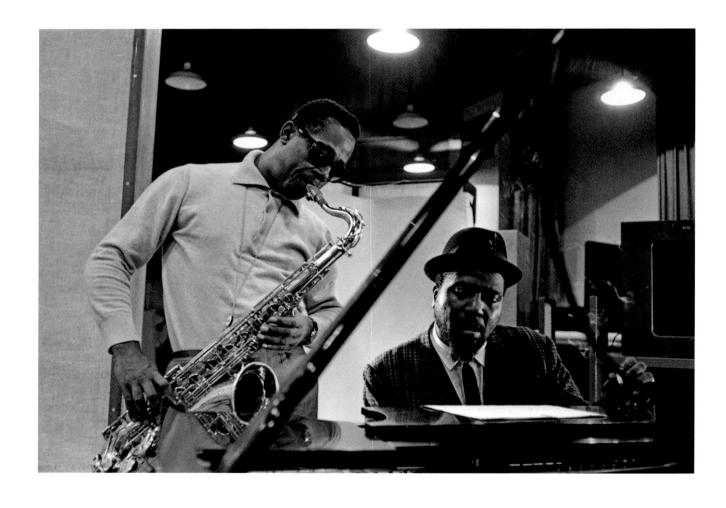

PAGE 186: Thelonious Sphere Monk, August 1965.
ABOVE: Making *Monk's Dream*, his debut album for Columbia
Records, with tenor saxaphonist Charlie Rouse, left, November 1962.
OPPOSITE: Solo Monk.

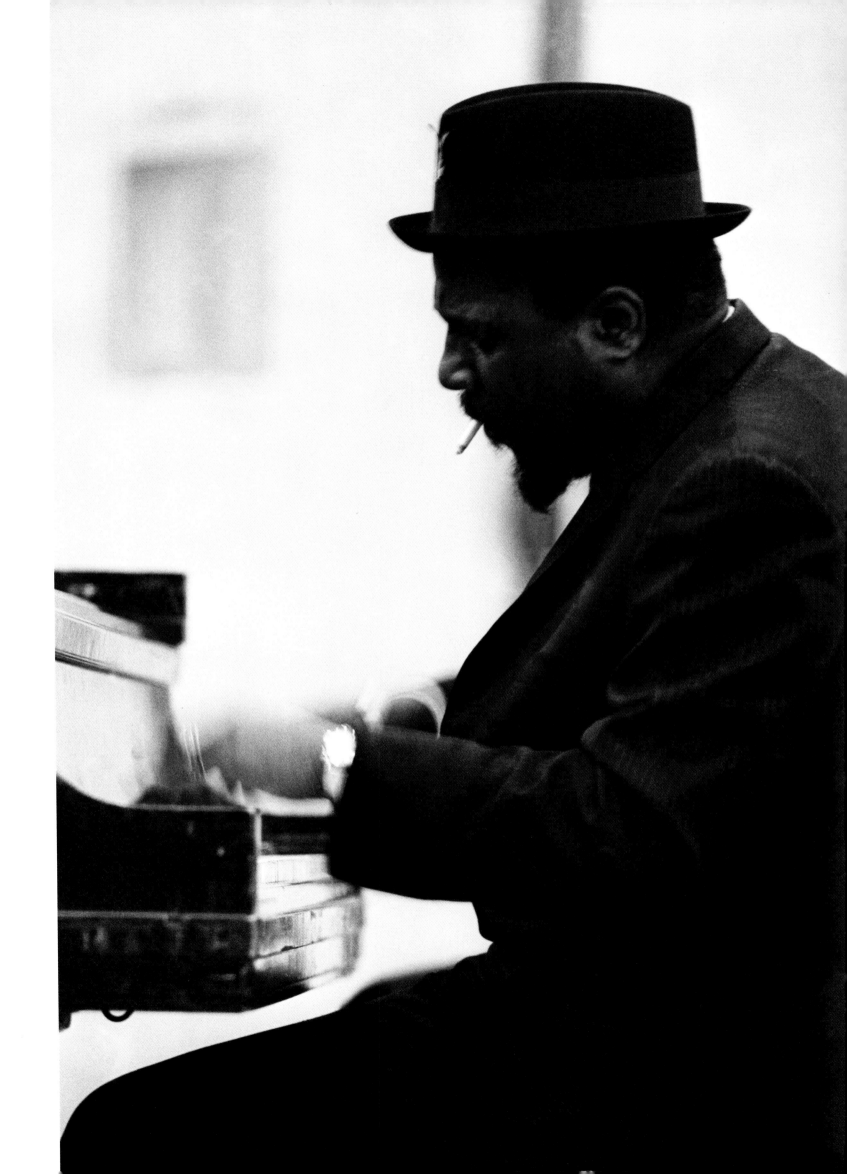

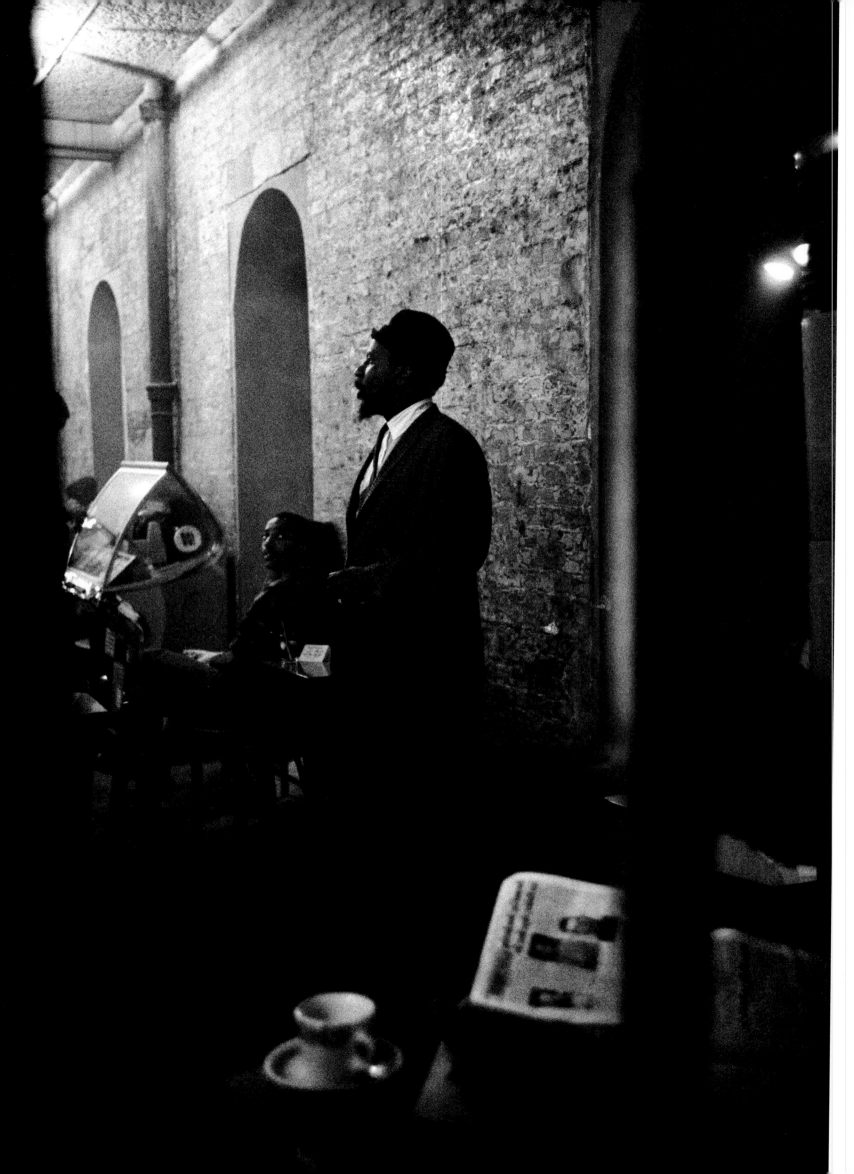

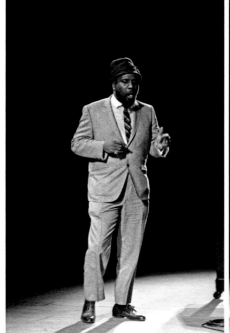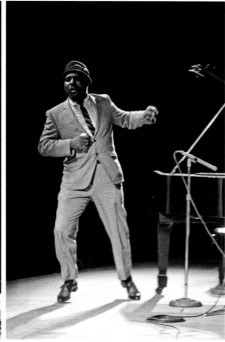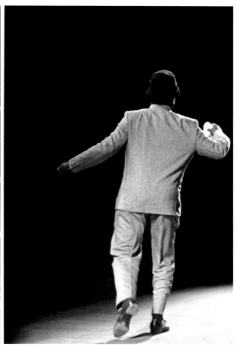

OPPOSITE: Between sets at the Blue Angel nightclub, New York, July 1963.
ABOVE: At Philharmonic Hall, New York, January 1964.

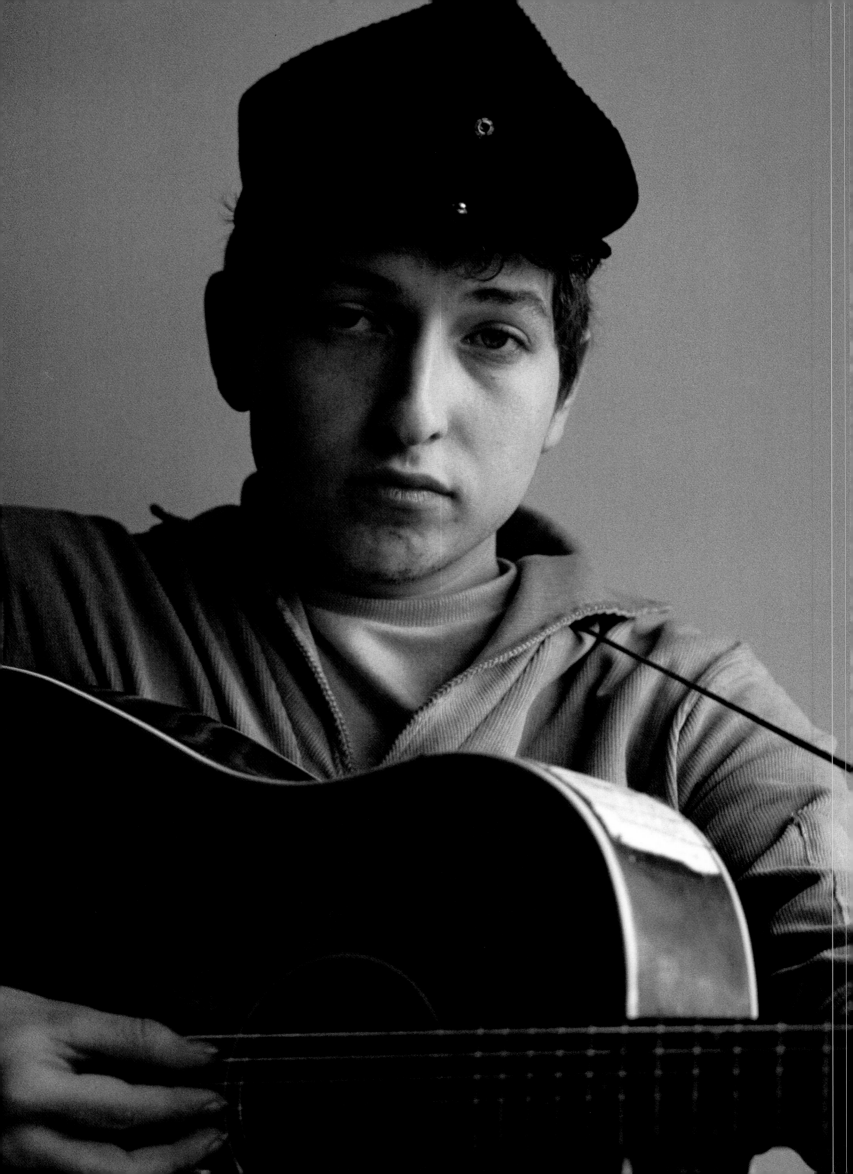

BOB DYLAN

THE SCRAWNY, BABY-FACED, raw-voiced songwriter from Minnesota who hit the Greenwich Village folk scene like an epiphany wasn't always as camera-shy as he is now. New to the music business, he allowed his label photographer, Don Hunstein, into recording sessions and into his neighborhood. A photo of Dylan and his girlfriend at the time, Suze Rotolo, walking up a slushy Jones Street on a cold day became the album cover of *The Freewheelin' Bob Dylan,* the first full-length showcase for Dylan as a songwriter. To Hunstein's camera, Dylan was still, for the moment, a local phenomenon, a talented kid; he turned twenty-two three days before the album's release. Fame would make that candor disappear.

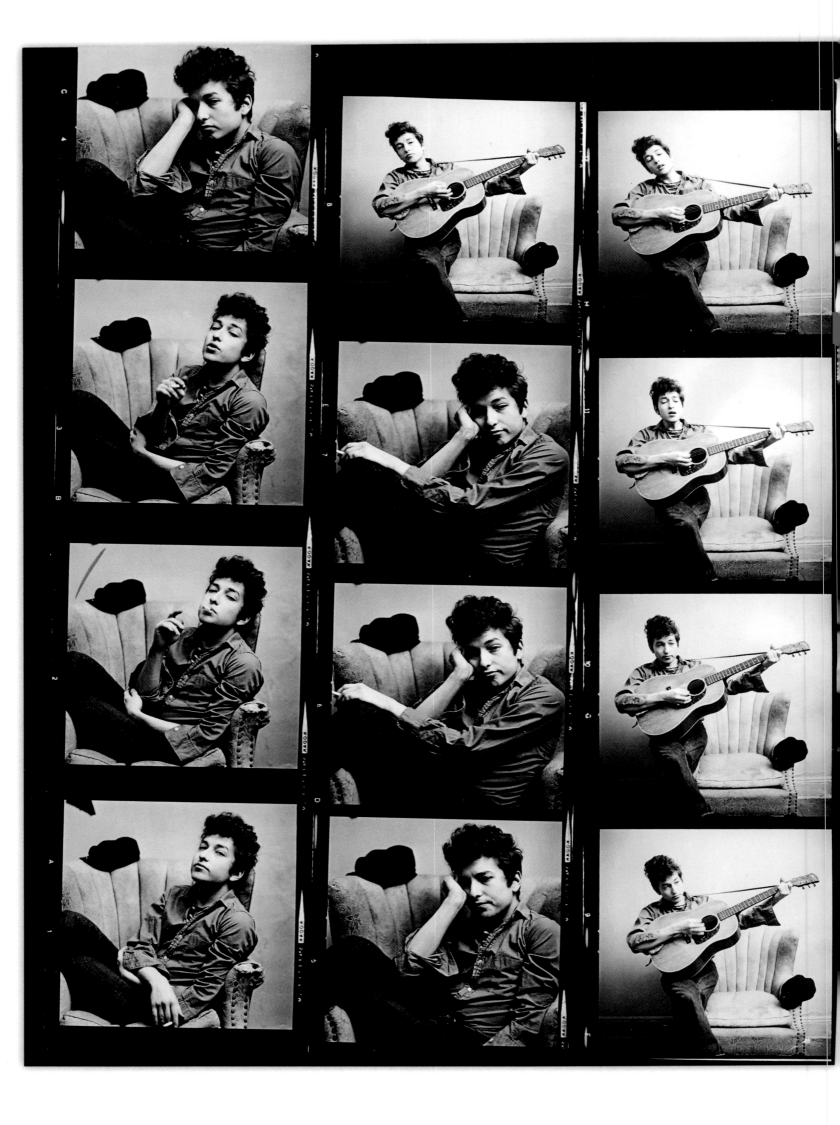

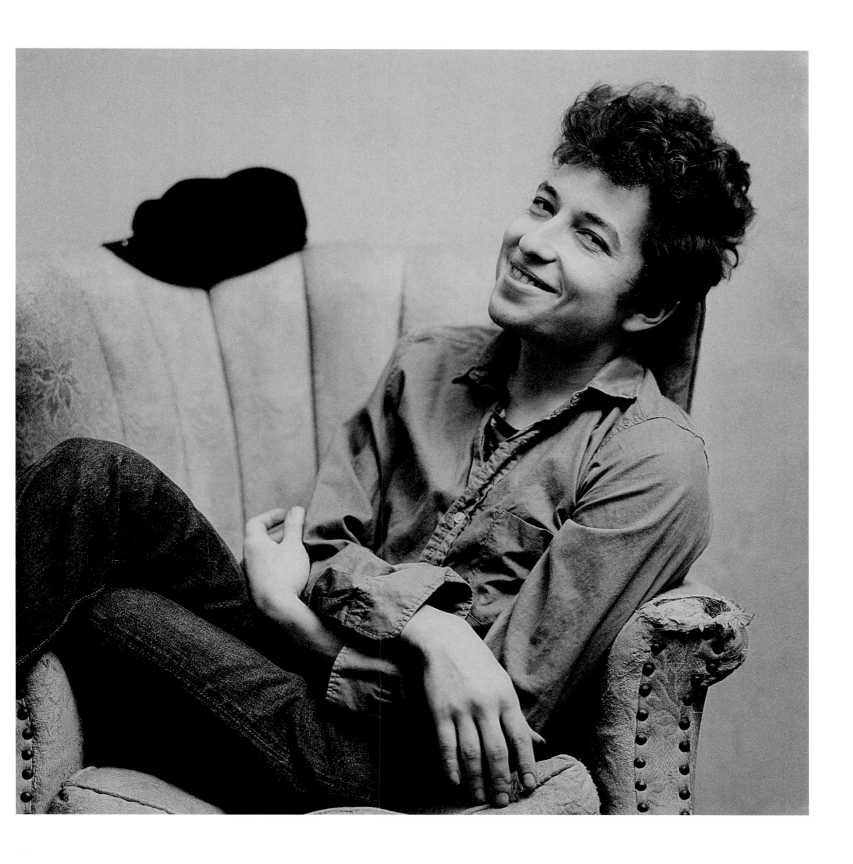

PAGE 192: Photoshoot for the cover of his debut LP, *Bob Dylan*, New York, December 1961.
OPPOSITE & ABOVE: At home in his Greenwich Village, New York, apartment, February 1963.

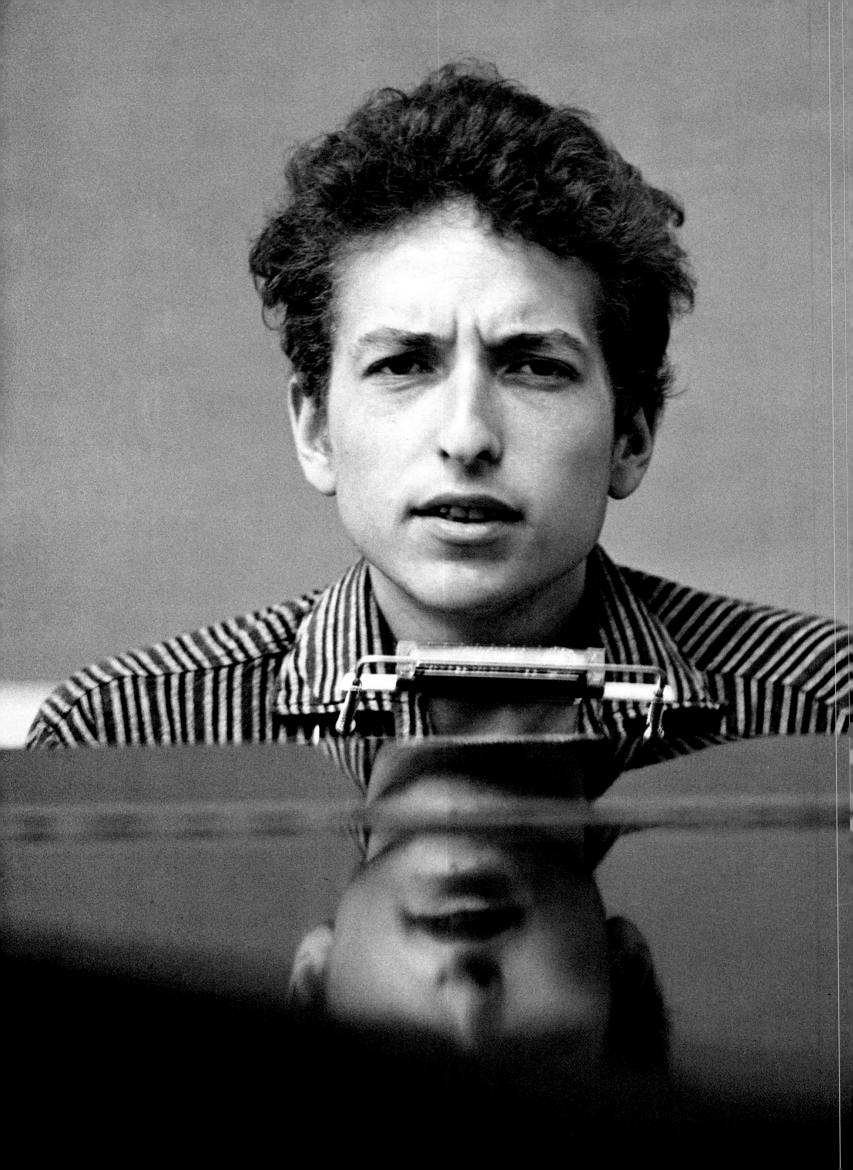

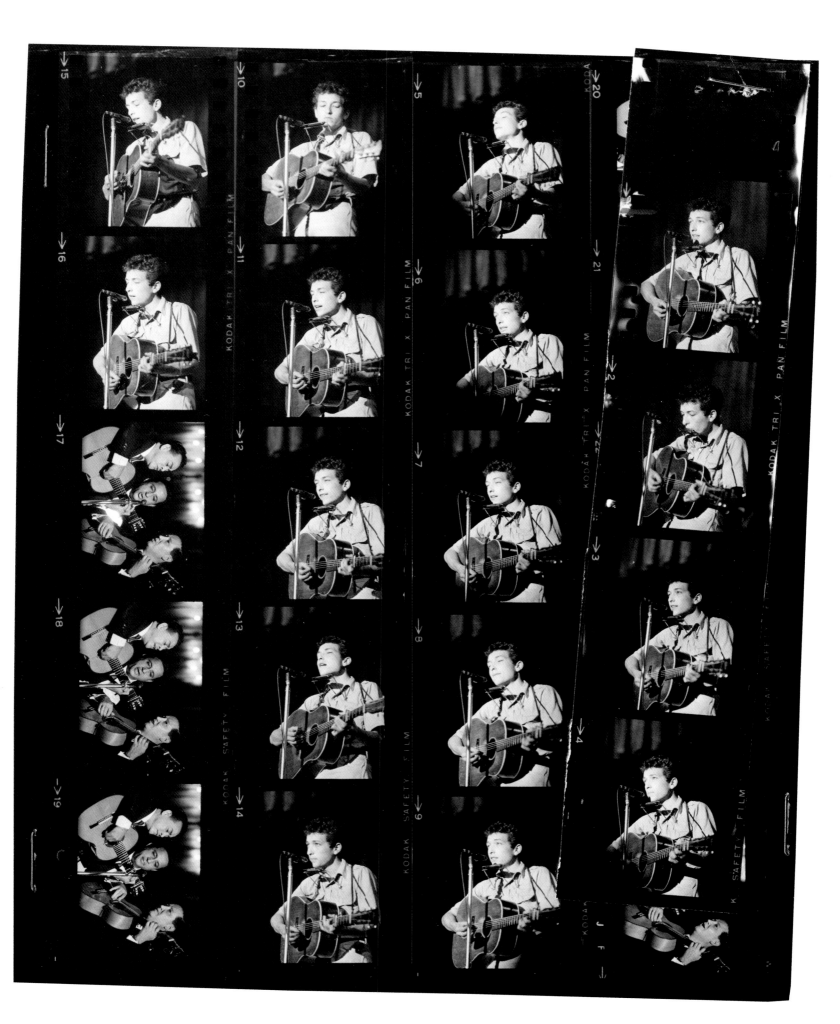

PAGE 196: Sessions for his second album, *The Times They Are a-Changin'*, August 1963.
PAGE 197: On stage at the Columbia Sales Convention with Trio Los Panchos,
Puerto Rico, July 1963.
OPPOSITE: West Fourth Street, New York, February 1963.

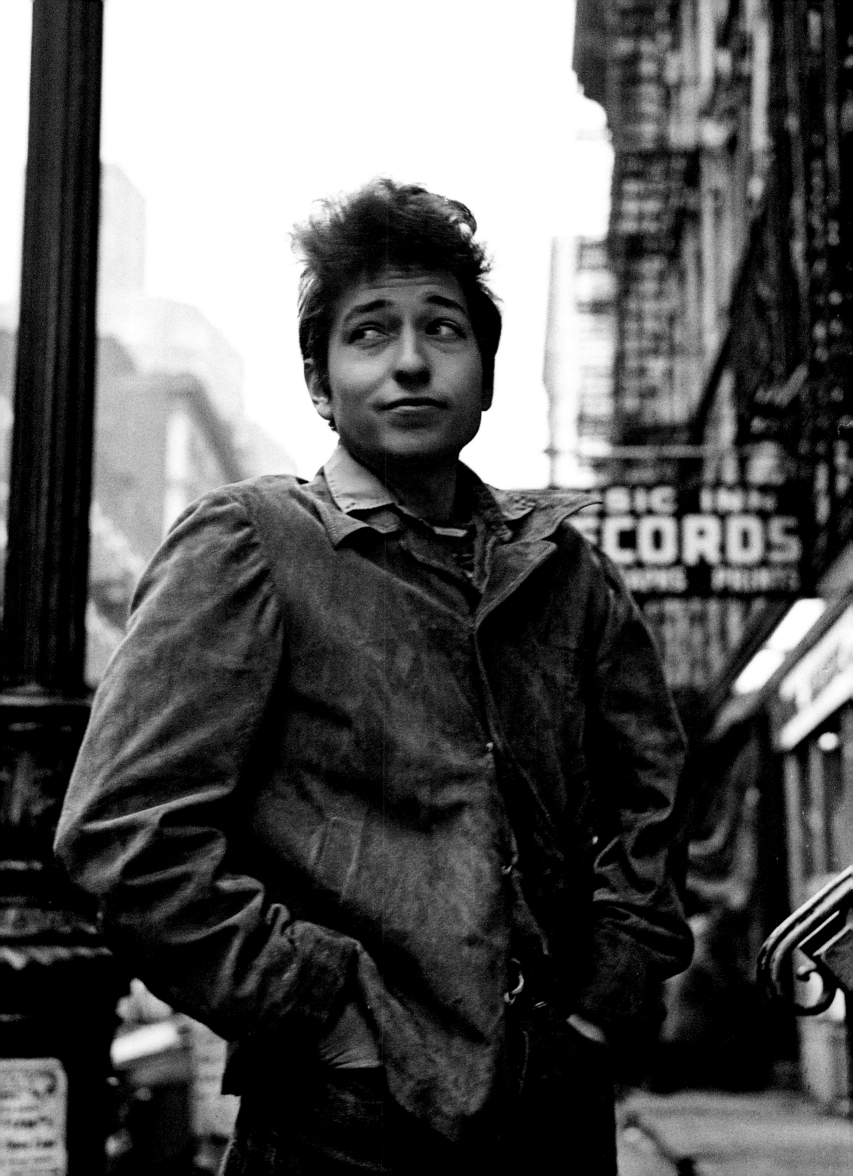

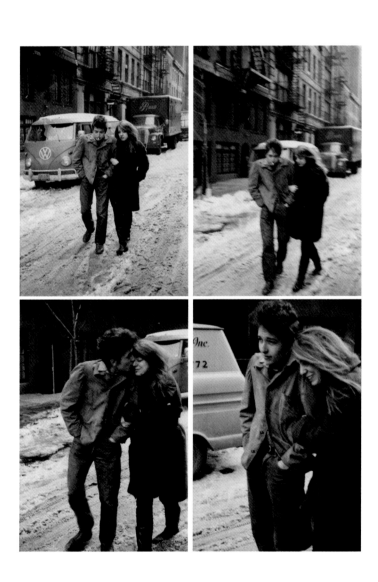

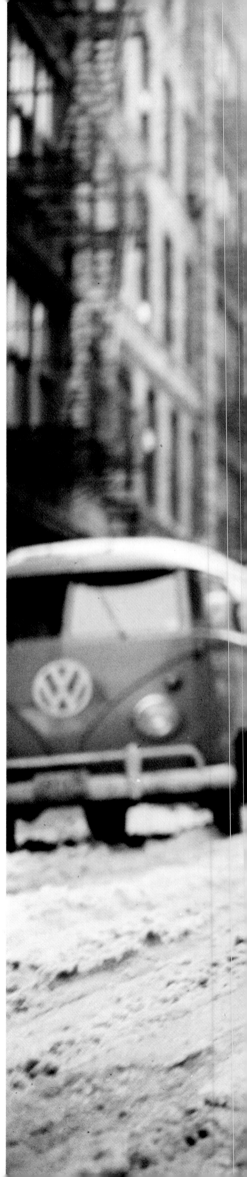

ABOVE & RIGHT: Creating the cover of *The Freewheelin' Bob Dylan* with girlfriend Suze Rotolo, February 1963.

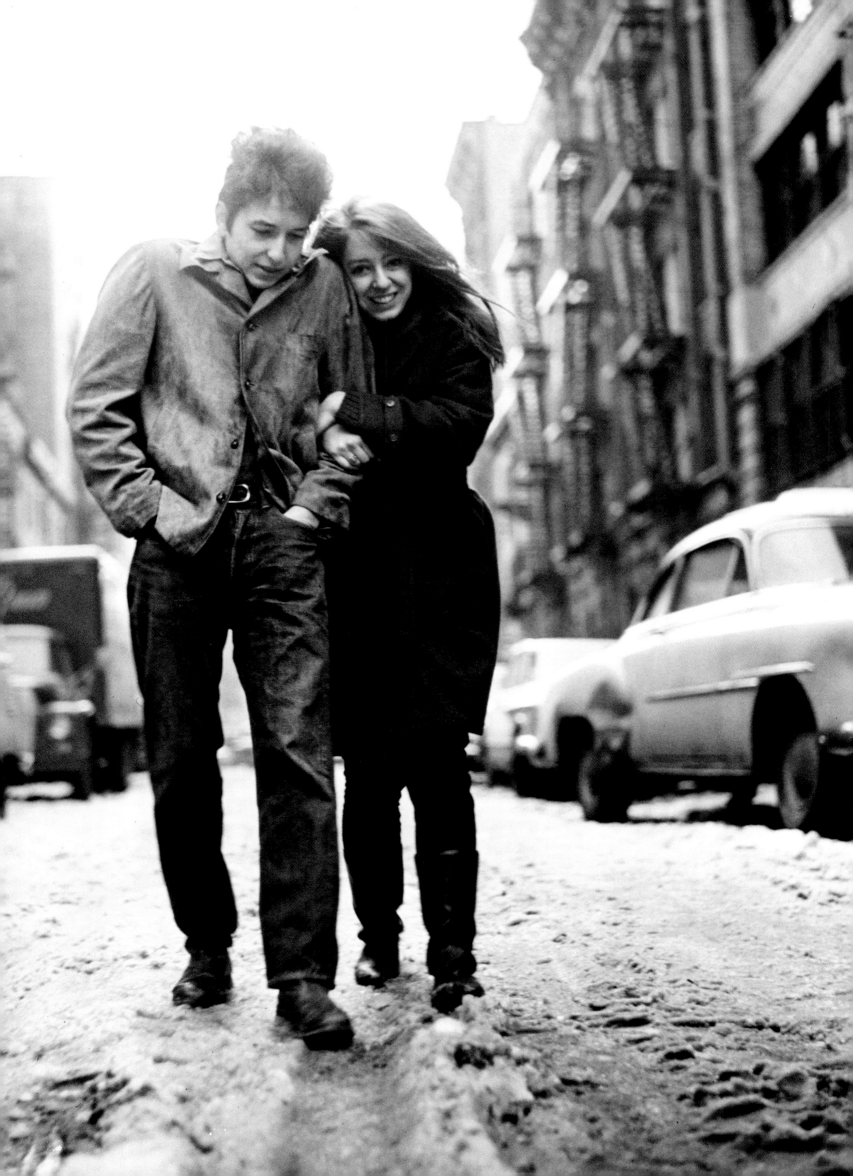

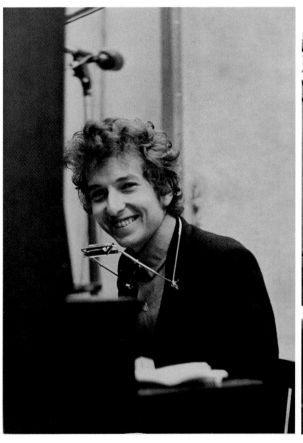
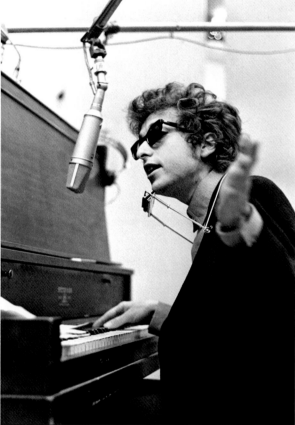

ABOVE & OPPOSITE: Recording *Highway 61 Revisited*, June 1965, weeks
before his electric set would cause an uproar at the Newport Folk Festival.

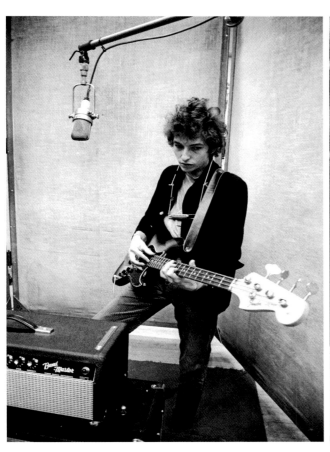
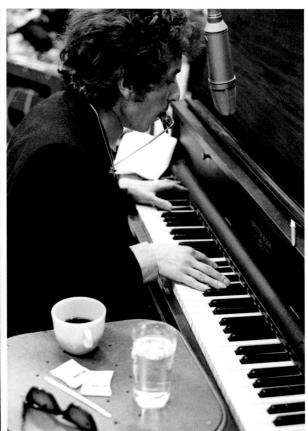

SIMON AND GARFUNKEL

THEY WERE ALWAYS AN ODD PAIR, Paul Simon and Art Garfunkel, with a Mutt-and-Jeff height difference and a decidedly uneven workload: Simon was the songwriter, guitarist, and lead singer; Garfunkel the backup voice. But they were friends and longtime collaborators who had been recording teen pop as Tom and Jerry—with a very modest success in the Everly Brothers–styled "Hey, Schoolgirl"—before they became folk-rock's reigning duo. That was inadvertent; unbeknownst to Simon and Garfunkel, their producer overdubbed a backup band onto their folky original version of "The Sounds of Silence" for the hit that established their career and opened up their music. The vocal blend kept Simon and Garfunkel together through the 1960s; their personalities moved them apart.

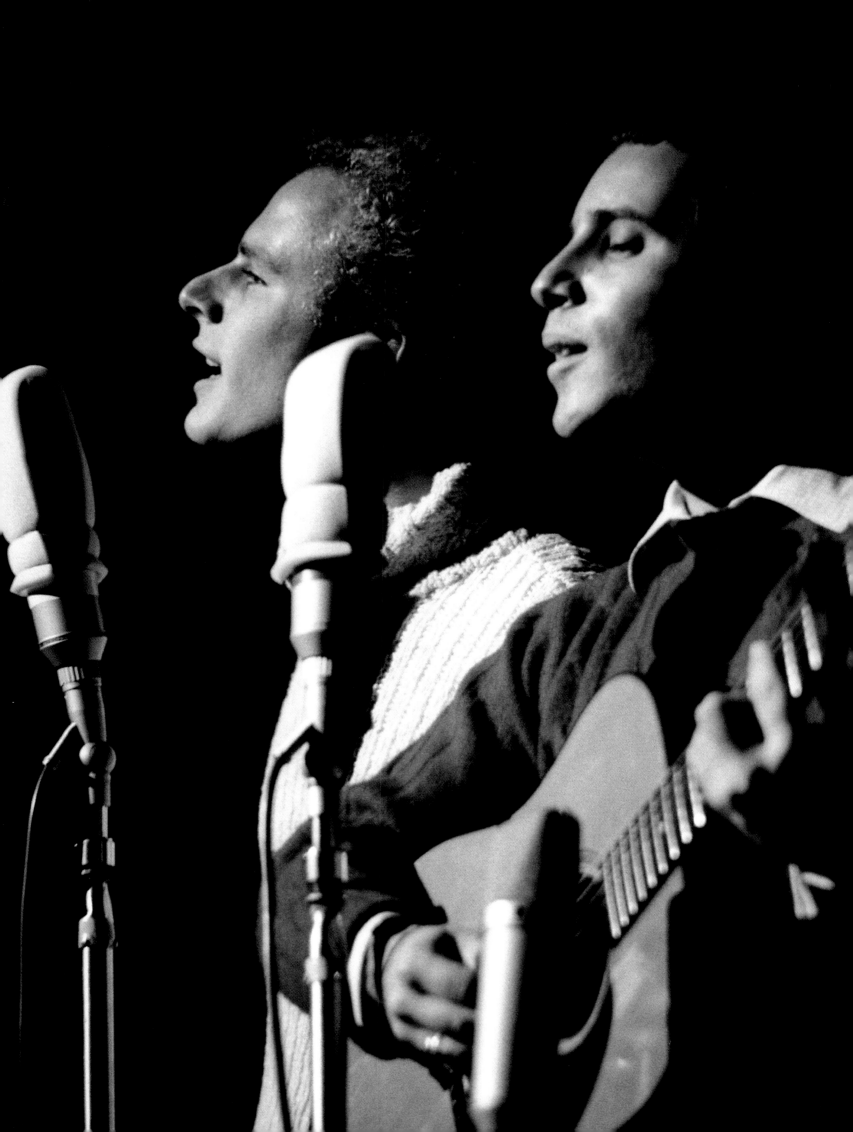

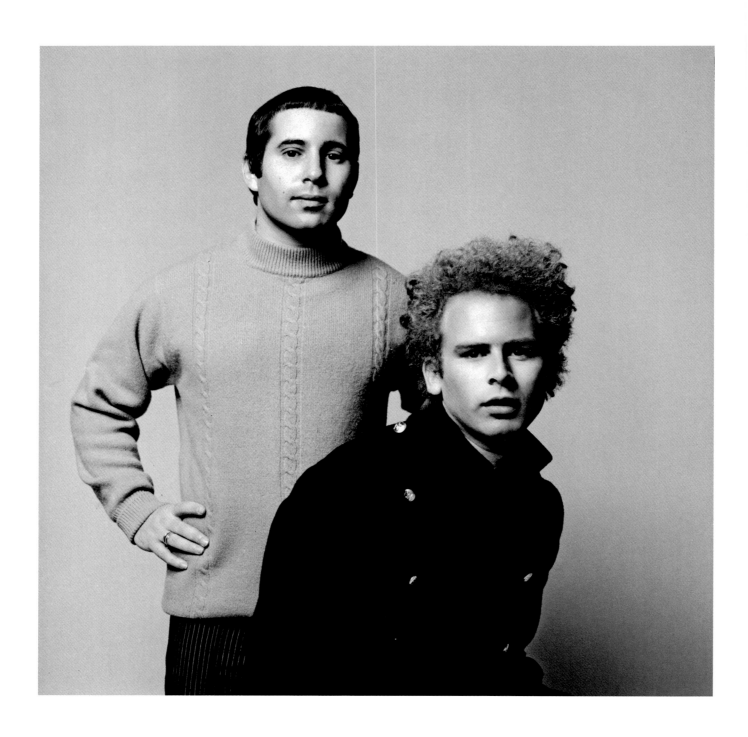

PAGE 205: Art Garfunkel, left, and Paul Simon at Philharmonic Hall,
New York, January 1967.
ABOVE & OPPOSITE: Portrait session for *Bookends*, October 1966.

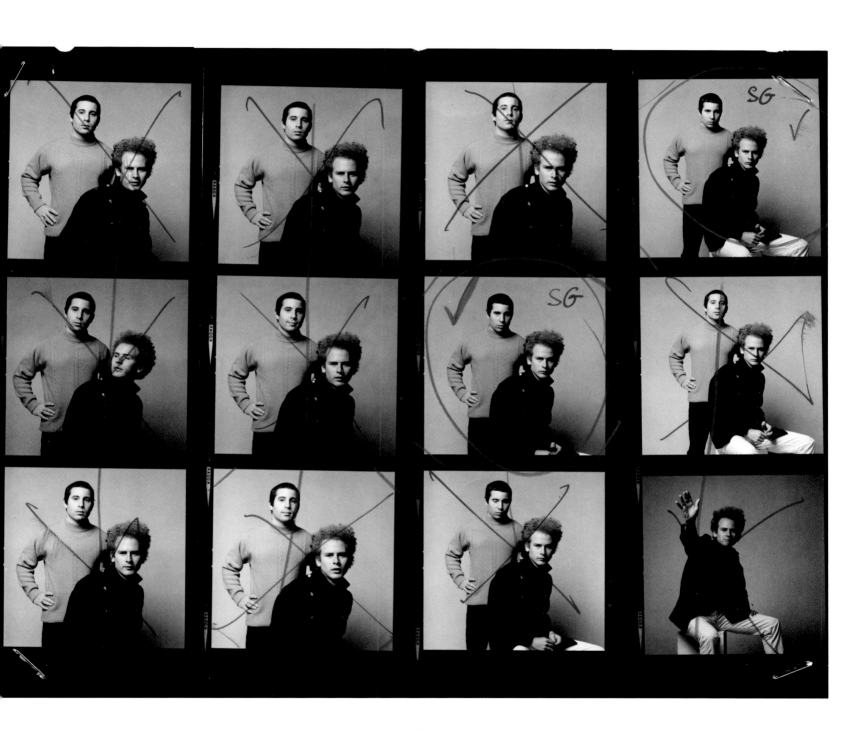

Washington Square Park, New York, March 1966.

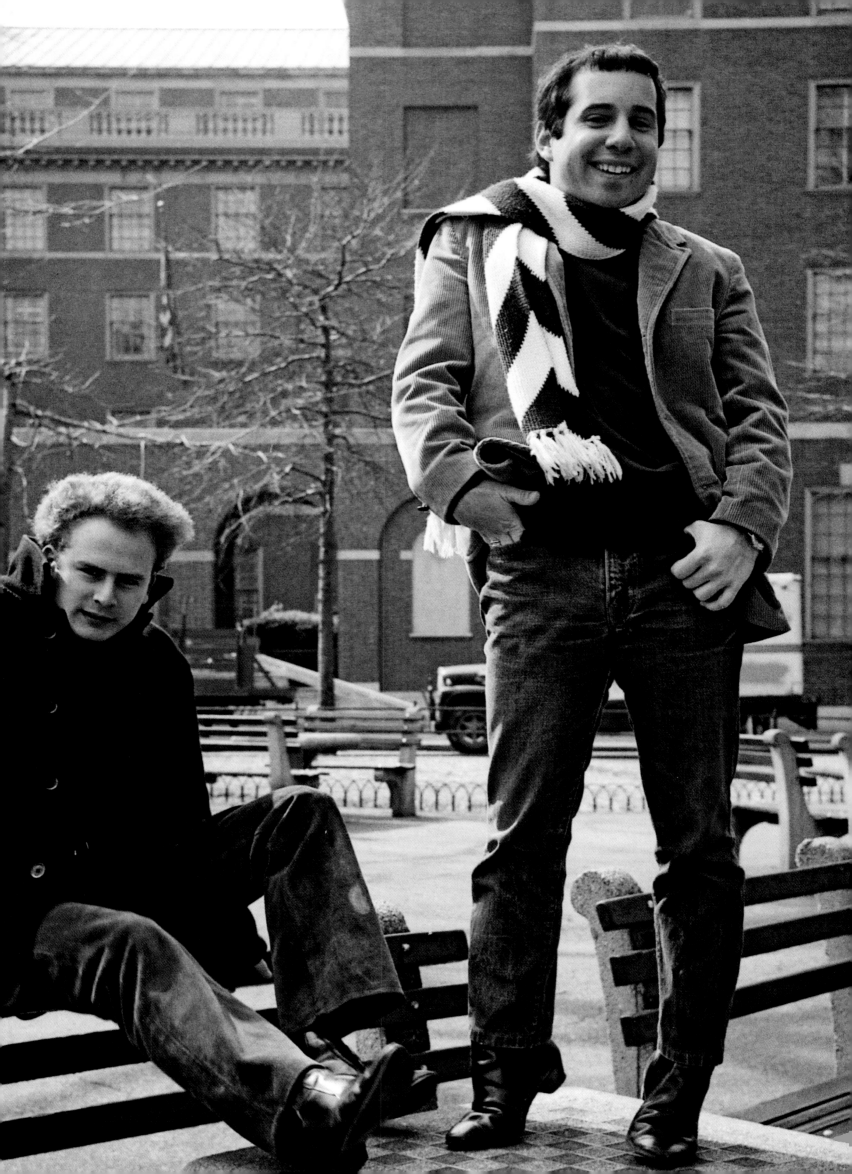

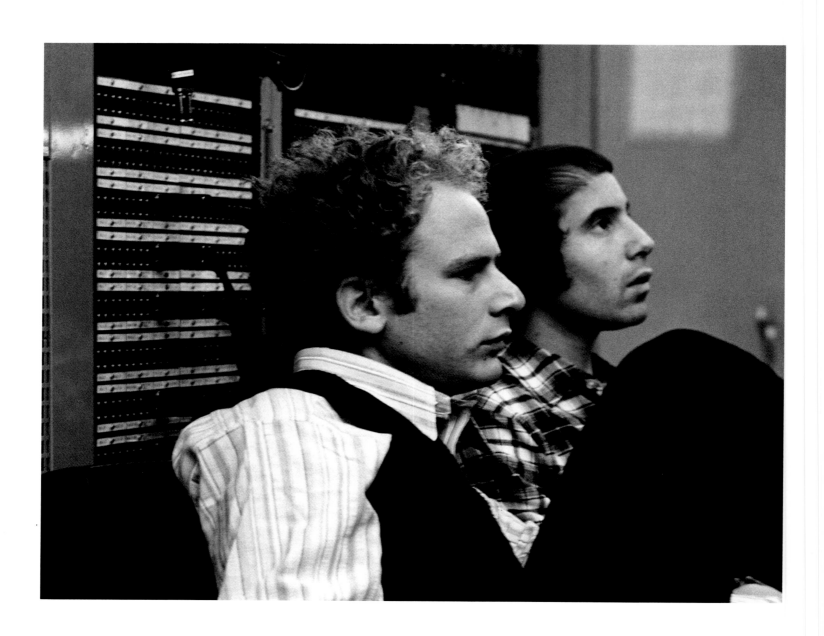

ABOVE & OPPOSITE: Recording session for *Bridge Over Troubled Water*, October 1969.

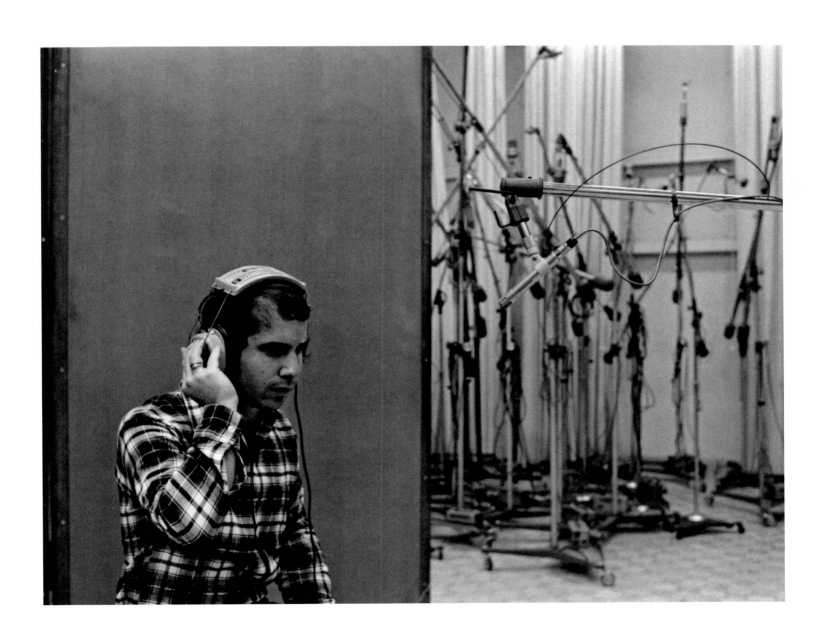

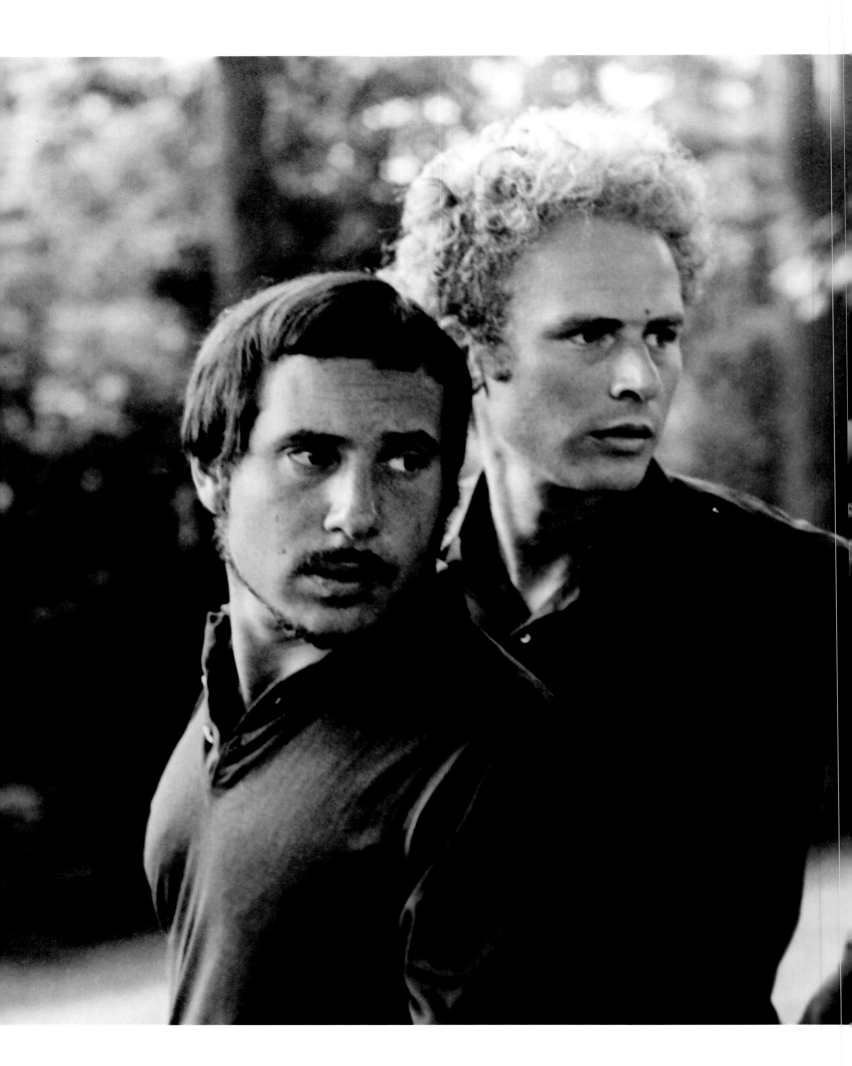

One month after "Mrs. Robinson" was named Record of the Year at the Grammy® Awards, April 1969.

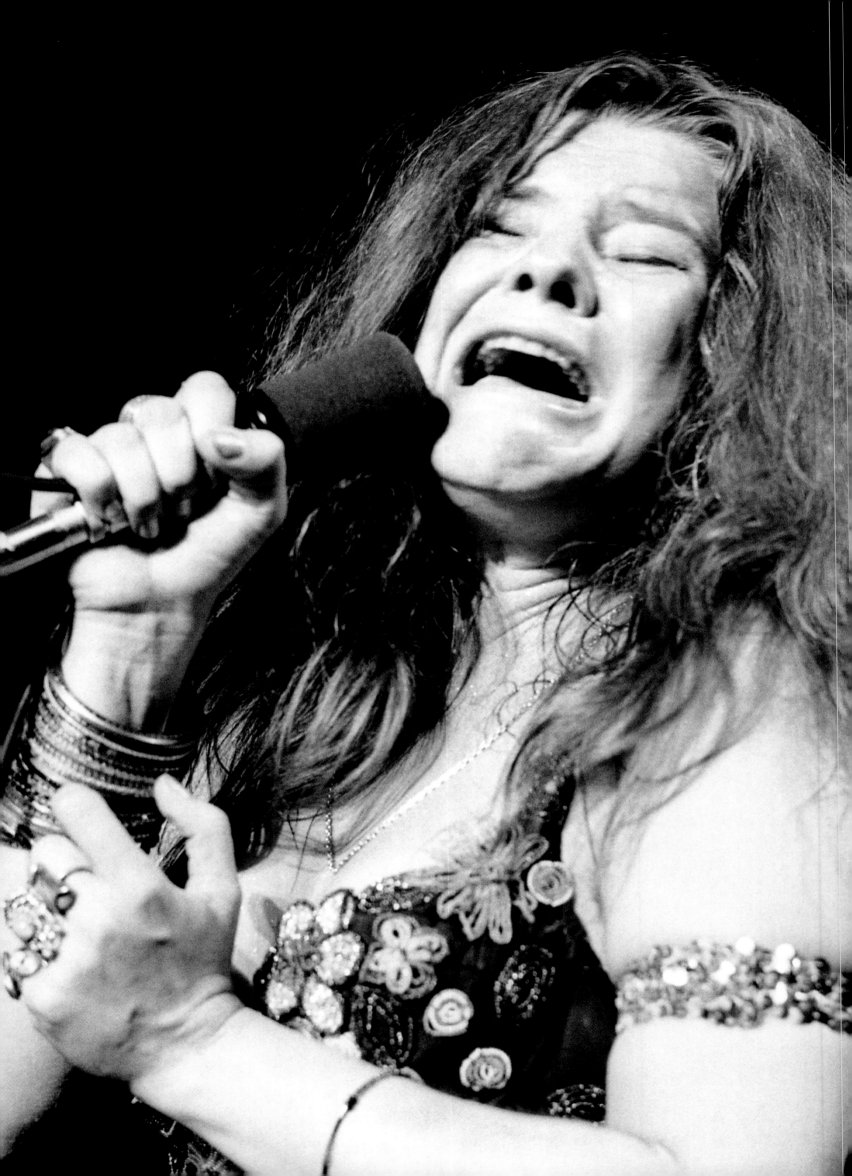

AFTERWORD

by JON PARELES

With the simple flip of a digit from the 1960s to the 1970s, it suddenly seemed everything had changed. The communal Aquarian Age had not dawned, and Woodstock nation had disappeared with the summer of 1969. Vietnam was still at war, and the civil-rights dream of integration had given way to separatism and factionalism.

In the music business, a new sense of calculation was setting in. With baby boomers coming of age as consumers and as a new mass audience, the fertile creative disarray of the late 1960s was fast being systematized and exploited. Free-form radio was being replaced by stations with limited playlists—"underground" variations on the Top 40—and by researched formats that targeted separate segments of the audience: by age, by race, by gender.

Filling those new niches, musical genres started splintering, too. There would be not just rock but pop-rock, hard rock, blues-rock, heavy metal, and eventually punk rock and new wave; not just soul but funk and smooth soul and vocal-group soul; not just jazz but smooth jazz and jazz-rock fusion. The roster of Columbia Records and its growing number of associated labels mirrored that diversity, becoming especially strong with

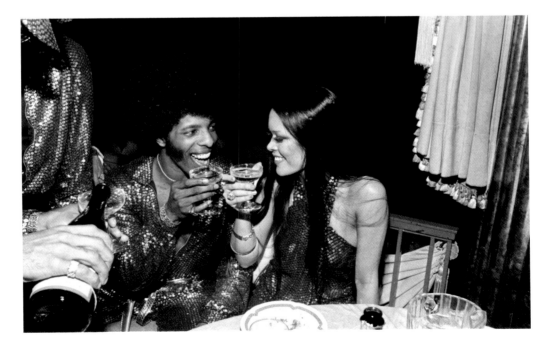

OPPOSITE: Janis Joplin performing in Puerto Rico, 1968.
ABOVE: Sylvester Stewart, aka Sly Stone, and Kathy Silva after their wedding
at Madison Square Garden, June 1974.

singer-songwriters—Billy Joel, Phoebe Snow, Bill Withers, James Taylor—and in soul music with groups like Earth, Wind & Fire, the Isley Brothers, Labelle, and, in the mid-1970s, the Jacksons (including Michael).

Musicians, meanwhile, were growing more self-conscious about fame, and about the public images that Hunstein's work would provide for them. Sunglasses grew larger; backstage access dwindled. The casual, approachable, behind-the-scenes images of musicians at work that Hunstein offered in the 1950s and 1960s were rarer. They were giving way to the costumed and posed. Though Hunstein still found opportunities for unposed shots, he also played up his formal portraiture, which offered different photographic messages. The costumes, in the madcap efflorescence of 1970s fashion, became flashier, more theatrical. Musicians were becoming glittering emissaries of celebrity, sci-fi apparitions, rhinestone cowboys and cowgirls. Fewer pop stars pretended to be everyday people; they aspired to be icons.

Hunstein brought his lighting and compositional skills to these images, his sense of geometry and depth. Yet he also, clearly, brought the same sense of observant rapport he'd brought to Glenn Gould or Duke Ellington: the sense that photographer and musician were doing a job together. These performers aren't distant, unapproachable stars. They're fellow humans, caught in a shared moment.

ABOVE: Mitch Miller, head of A&R for Columbia Records from 1950 to 1965.
OPPOSITE: Miles Davis in the studio with companion Eleana Steinberg, New York, March 1978.

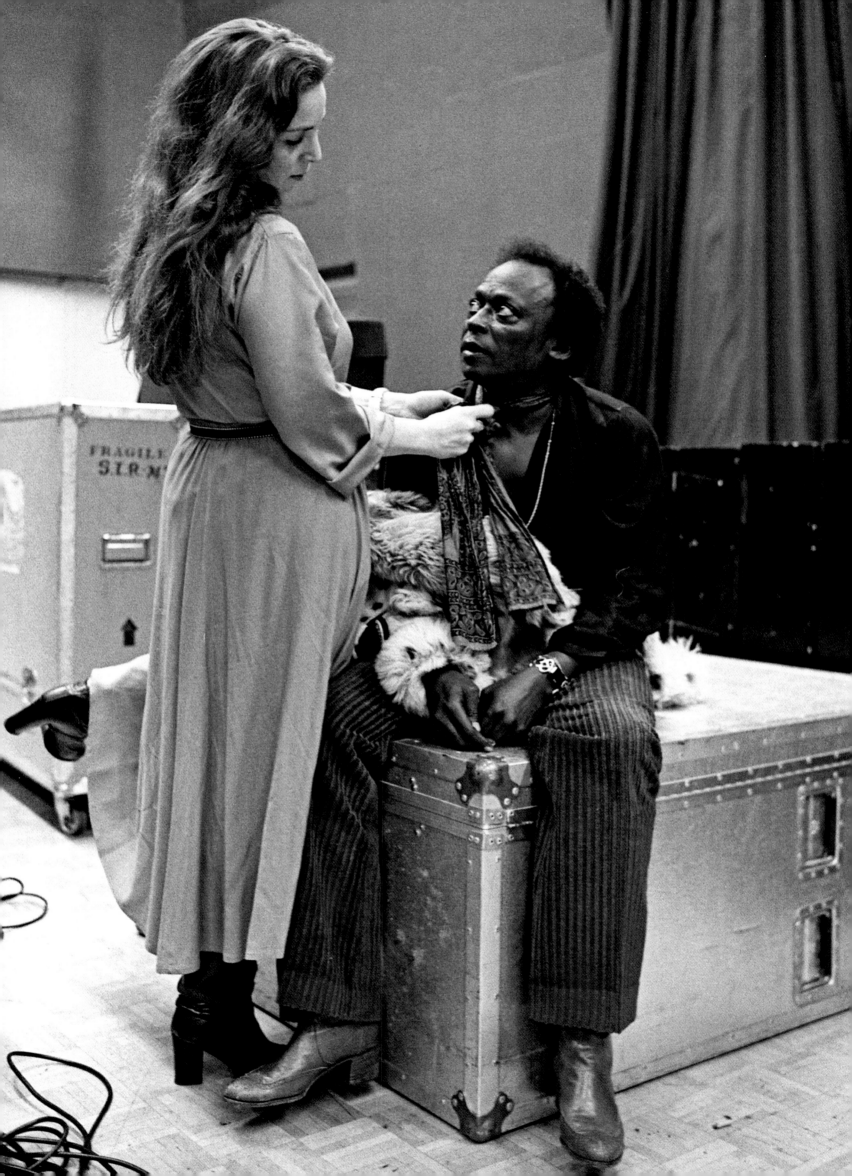

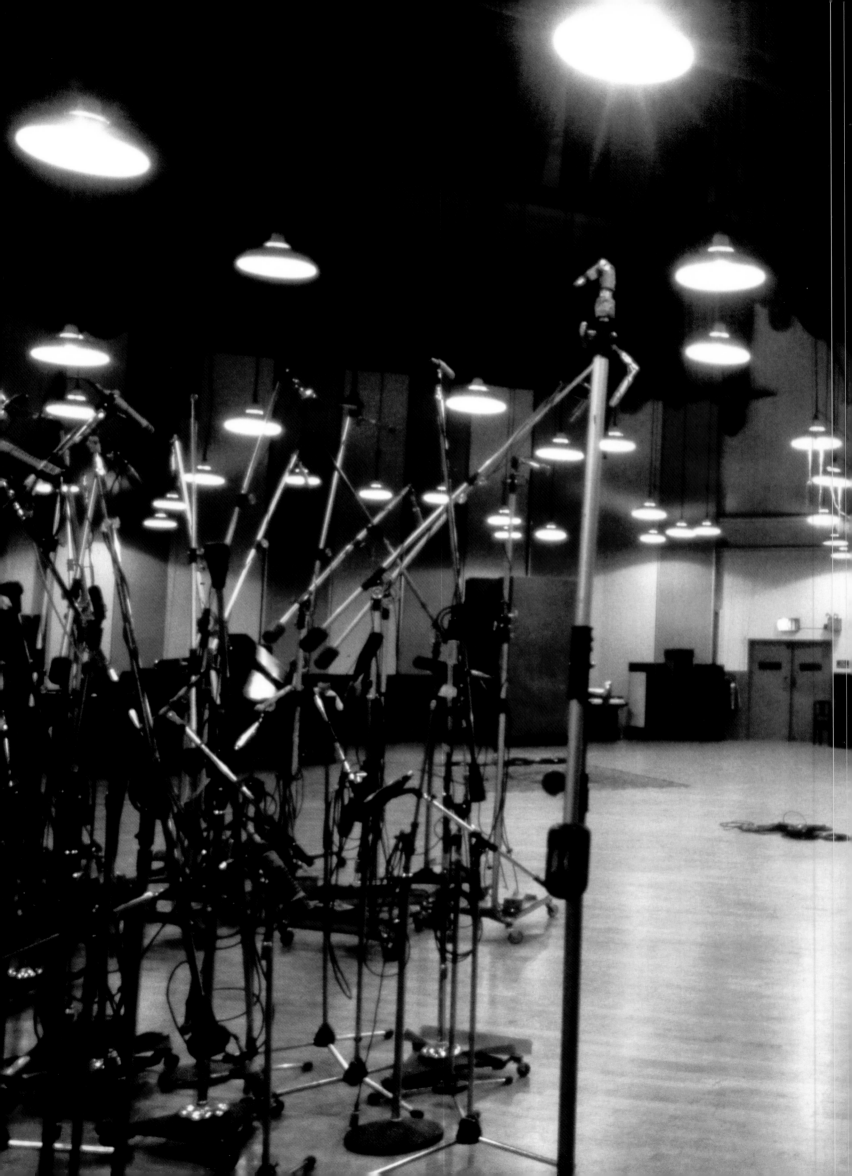

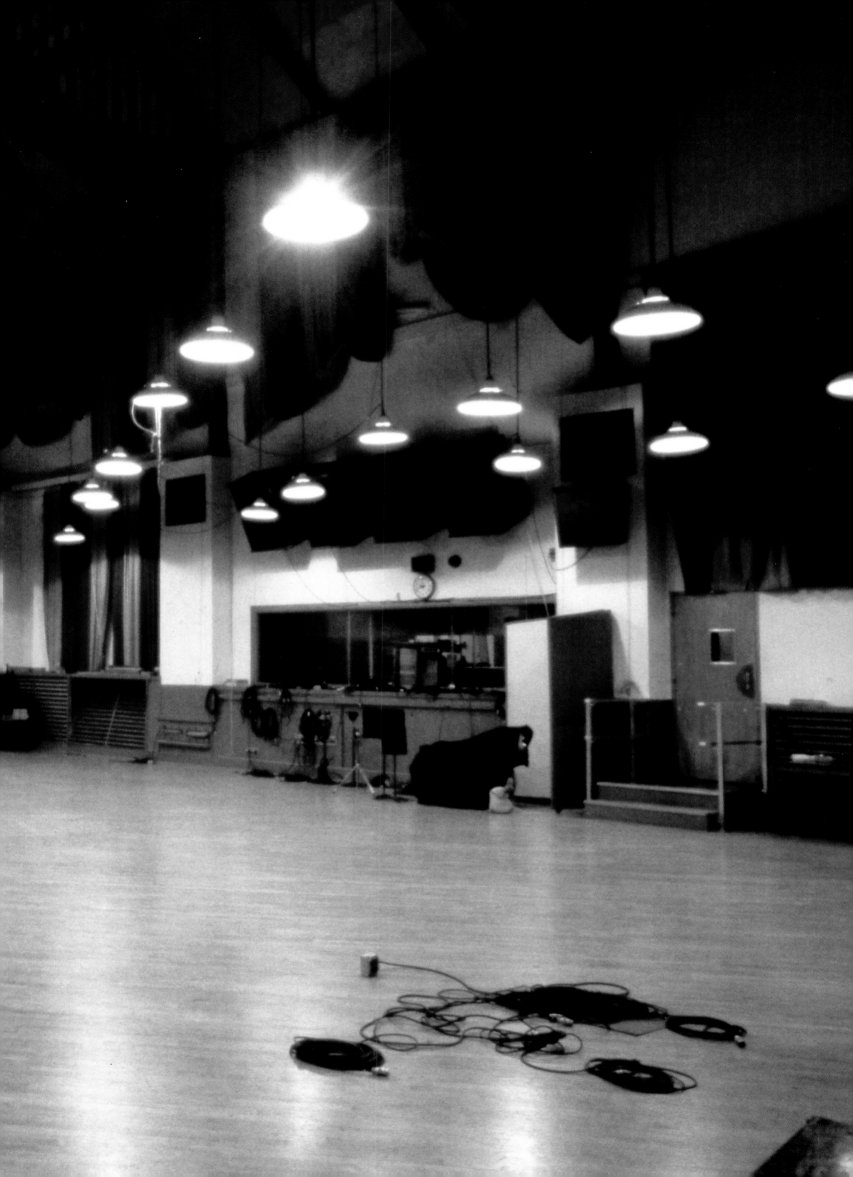

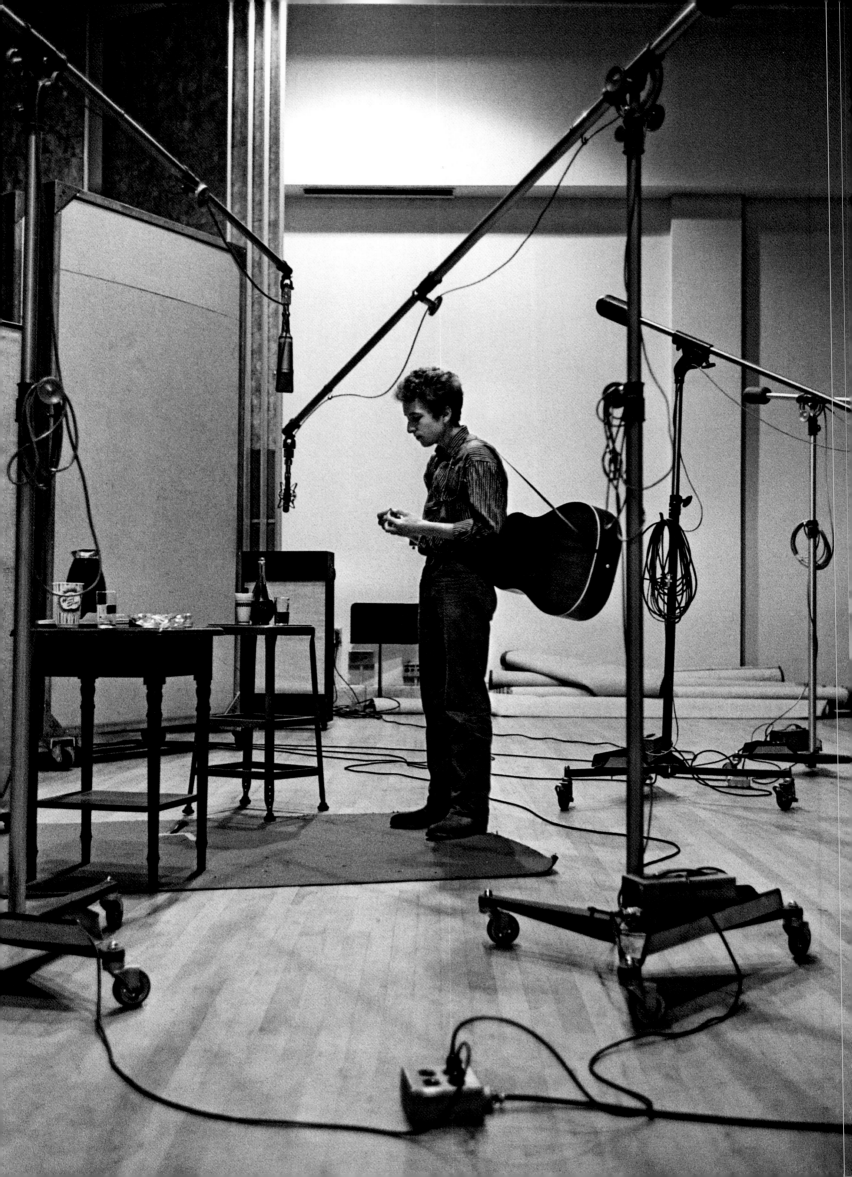

ACKNOWLEDGMENTS

Don Hunstein would like to thank the artists in the book for welcoming him into their world, and for enriching ours.

Special thanks to Tom Tierney, guardian of the flame at Sony Music Archives in New York, for his direction. Thanks also to Sony Music archivists Michael Panico and Che Malik Williams for their guidance.

Thanks to Eric Baker at Eric Baker Design for his artistry and inspiration.

A debt of gratitude to Danny Bennett, Jay Krugman, Dawn Olejar, Marty Erlichman, Peter Fletcher, Tracy Quinn, Robert Scott, Ed Blau, Russell Gloyd, Iola Brubeck, Alan Bergman, Jeff Kramer, Juanita DeSilva, Faye Perkins, Sue Mingus, Bridget Nolan, Lou Robin, Jeff Rosen, John Scher, Eddie Simon, Vince Wilburn Jr., Erin Davis, Darryl Porter, Gwen Quinn, Tracey Jordan, Erin Spurlock, Nicole Johnson-Cooke and ABKCO, and the estates of Leonard Bernstein, Glenn Gould, Igor Stravinsky, Mahalia Jackson, Benny Goodman, Louis Armstrong, Billie Holiday, Duke Ellington, and Thelonious Monk.

Thanks to Michael Madden, Raoul Goff, Roxy Aliaga, and Leigh Mitnick at Insight Editions.

Thanks to Don's many champions at Sony Music/Legacy Recordings, especially Richard Story, Adam Block, John Jackson, Rob Santos, Gil Aronow, Jennifer Goodman, and Toby Silver.

Thanks to Don's venerable colleagues from the Columbia Records Photo Studio, including Aram Avakian, John Berg, Bob Cato, Marvin Koner, Urve Kuusik, Rosalind Levin, Hank Parker, Vernon L. Smith, and Sandy Speiser.

Thanks to Tim Anderson, Vic Anesini, Ray Bardani, Bob Belden, Steve Berkowitz, Gretchen Brennison, Michael Brooks, Tom Burleigh, Denise Cabrera, Tom Carrigan, Ian Cartwright, Matt Cavaluzzo, Mike Cimicata, Tom Cording, Tina Hunstein Cornell, Bo Corre, Dominick Costanzo, Marshall Crenshaw, Michael Cuscuna, Clive Davis, Didier C. Deutsch, Bruce Dickinson, Mandy Eidgah, Adam Farber, Seth Foster, Anthony Fountain, Gregg Geller, Gabriela Gibb, Richard Gold, Sam Gomez, Charles L. Granata, Lisa Del Greco, Randy Haecker, Roy Halee, Anthony Heilbut, Jeffrey James, Jeff Jones, Robert Leslie Jones, Matthew Kelly, Marc Kirkeby, Donna Kloepfer, Bryan Koniarz, Al Kooper, Glenn Korman, Michael Kull, Frank Laico, Jim Lane, Jeff Magid, Patti Matheny, Keith McCarthy, Dan Mortensen, Nedra Olds-Neal, Joseph M. Palmaccio, Jim Parham, Fred Plaut, Al Quaglieri, Steve Rosenthal, Seth Rothstein, Tom Ruff, Darren Salmieri, Al Smith, Steve Shapiro, Timothy J. Smith, Barry Taylor, Henry Towns, Maria Triana, Joseph Vitale, Mark Wilder, Dar Williams, Doug Wygal, and Adam Zelinka, for their singular contributions.

Thanks to Friends of 30th Street, where Don captured so many iconic images.

And finally, warm regards to DeeAnne Hunstein, Don's devoted wife and companion.

PAGES 218-219: An empty 30th Street Studio awaits.
OPPOSITE: Bob Dylan recording *The Times They Are a-Changin'*, August 1963.

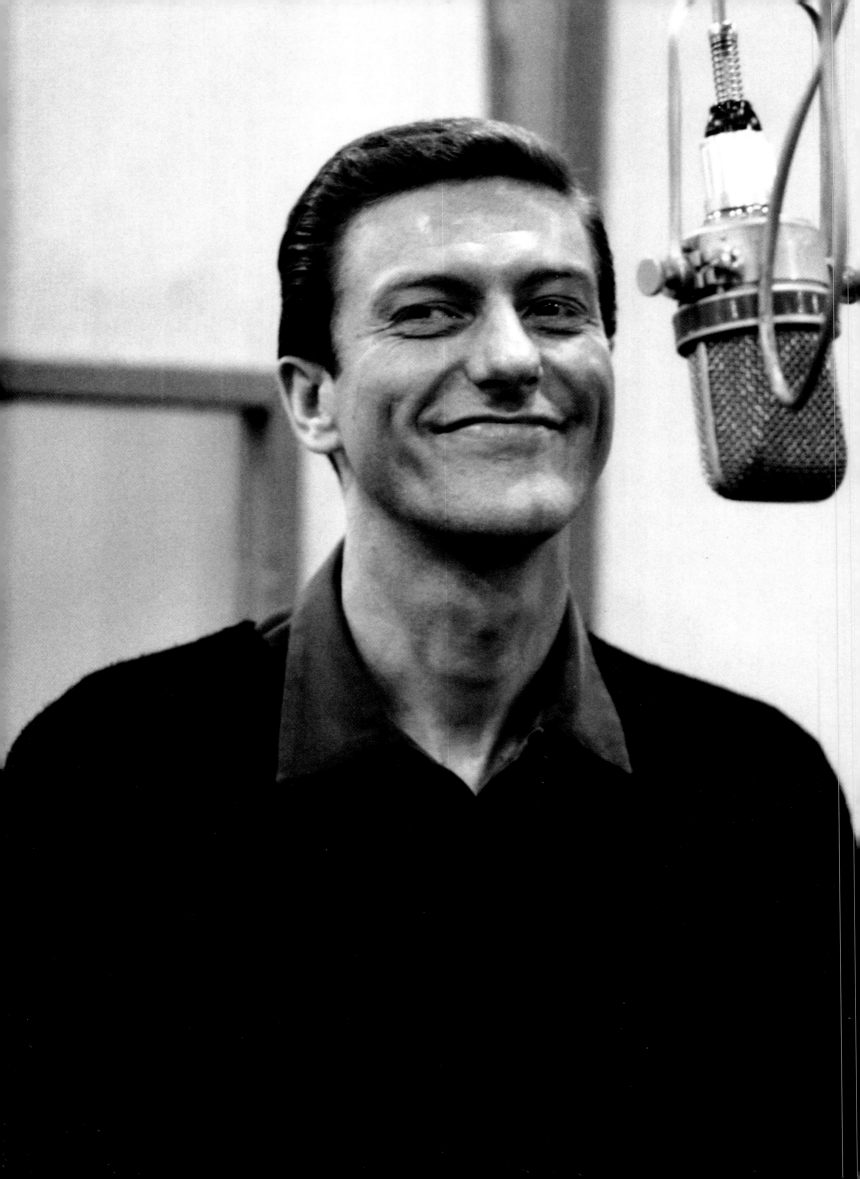

PLAYLIST INSPIRED BY

KEEPING TIME: *The Photographs of Don Hunstein*

All songs controlled by Sony Music Entertainment.

BARBRA STREISAND
"People"
Funny Girl, 1964

JOHNNY MATHIS
"That Old Black Magic"
Wonderful Wonderful, 1957

TONY BENNETT
"Love for Sale"
The Beat of My Heart, 1957

GLENN GOULD
"Aria"
Bach: The Goldberg Variations, 1955

LEONARD BERNSTEIN
"Rhapsody in Blue"
Gershwin: Rhapsody in Blue; An American in Paris, 1959

IGOR STRAVINSKY
"Le Sacre du Printemps"
Columbia Symphony Orchestra Conducted by Igor Stravinsky, 1961

RAVI SHANKAR
"Máru-Bihág"
The Sounds of India, 1957

MAHALIA JACKSON
"It Don't Cost Very Much"
Live at Newport 1958, 1958

DUKE ELLINGTON AND HIS ORCHESTRA
"Black and Tan Fantasy"
Ellington at Newport, 1956

ARETHA FRANKLIN
"This Bitter Earth"
Unforgettable: A Tribute to Dinah Washington, 1964

TAMMY WYNETTE
"D-I-V-O-R-C-E"
D-I-V-O-R-C-E, 1968

JOHNNY CASH
"Long Black Veil"
Orange Blossom Special, 1965

CASSIUS CLAY
"The Gang's All Here"
I Am the Greatest, 1963

BENNY GOODMAN
"King Porter Stomp"
The Great Benny Goodman, 1956

LOUIS ARMSTRONG AND THE ALL-STARS
"Ain't Misbehavin'"
Satch Plays Fats, 1955

BILLIE HOLIDAY
"But Beautiful"
Lady in Satin, 1958

MILES DAVIS
"Blue in Green"
Kind of Blue, 1959

DAVE BRUBECK
"Strange Meadow Lark"
Time Out, 1959

CHARLES MINGUS
"Goodbye Pork Pie Hat"
Mingus Ah Um, 1959

THE THELONIOUS MONK QUARTET
"Monk's Dream"
Monk's Dream, 1962

BOB DYLAN
"Girl from the North Country"
The Freewheelin' Bob Dylan, 1963

SIMON AND GARFUNKEL
"Homeward Bound"
Parsley, Sage, Rosemary and Thyme, 1966

PURCHASE THE FINE ART PHOTOGRAPHY OF DON HUNSTEIN

Rock Paper Photo, the definitive online fine art photography gallery featuring iconic images of legendary artists, is pleased to offer collectors an exclusive selection of timeless work by acclaimed photographer Don Hunstein. Each image is available for purchase as a fine art limited edition print and meticulously produced to museum standards.

Visit our website to view the complete Rock Paper Photo collection, obtain edition information including available sizes and prices, and complete your purchase.

For more information
please call 855-777-7476 (RPP-SHOP)
or email info@rockpaperphoto.com.

www.rockpaperphoto.com
www.rockpaperphoto.com/keepingtime

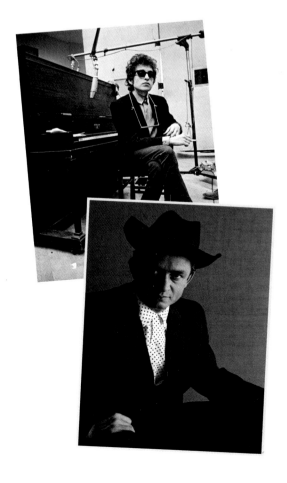

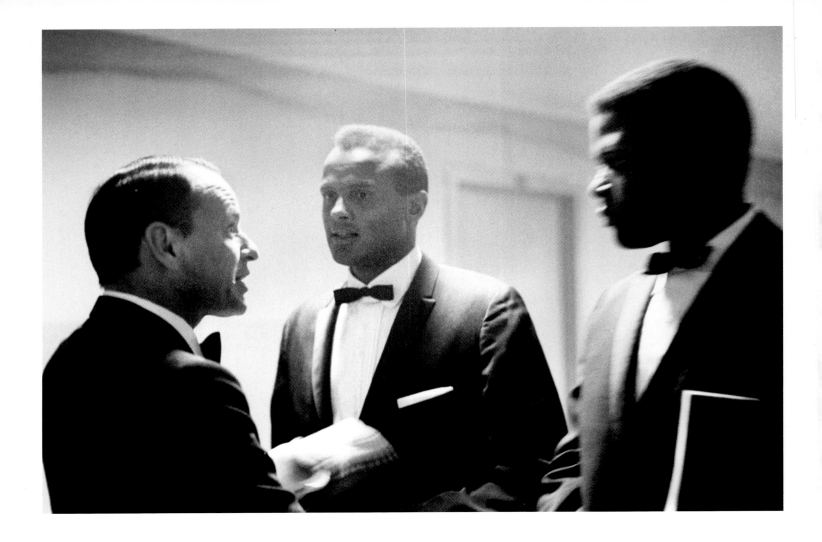

INSIGHT EDITIONS

PO Box 3088 • San Rafael, CA 94912

www.insighteditions.com

Find us on Facebook: www.facebook.com/InsightEditions

Follow us on Twitter: @insighteditions

Library of Congress Cataloging-in-Publication Data available.

ISBN: 978-1-60887-224-4

Insight Editions, in association with Roots of Peace, will plant two trees for each
tree used in the manufacturing of this book. Roots of Peace is an internationally
renowned humanitarian organization dedicated to eradicating land mines
worldwide and converting war-torn lands into productive farms and wildlife
habitats. Roots of Peace will plant two million fruit and nut trees in Afghanistan and
provide farmers there with the skills and support necessary for sustainable land use.

Manufactured in China by Insight Editions

COLOPHON

PUBLISHER: Raoul Goff

ACQUIRING EDITOR: Michael Madden

ART DIRECTOR: Chrissy Kwasnik

EDITOR: Leo Sacks

PHOTO EDITOR: Leigh Mitnick

PROJECT EDITORS: Kelli Fillingim and Roxy Aliaga

PRODUCTION MANAGER: Jane Chinn

INSIGHT EDITIONS would like to thank Don and DeeAnne Hunstein,
Robbie Schmidt, Ian Cartwright, John Jackson, Toby Silver, Jennifer Goodman,
Adam Block, Thomas Tierney, Che Malik Williams, Jon Pareles, and Leo Sacks
for all their hard work and continued support.

PAGE 1: Bob Dylan, June 1965.

PAGES 2-3: Miles Davis recording *Porgy and Bess* as re-imagined by arranger
Gil Evans, 1958.

PAGE 4: Billy Joel along Sixth Avenue before the release of *Piano Man*, New York,
July 1973.

PAGES 6-7: Pianist Vladimir Horowitz at Carnegie Hall, 1965.

PAGE 8: Johnny Cash, January 1960.

PAGE 10: (TOP) The Sharks meet the Jets in *West Side Story*, New York, October 1957;
(MIDDLE) Leonard Bernstein, February 1963; (BOTTOM) Aretha Franklin recording with
the Clara Ward Singers, summer 1961.

PAGE 11: (TOP) Johnny Cash, November 1960; (MIDDLE) Miles Davis recording
Kind of Blue, 1959; (BOTTOM) Bob Dylan recording, June 1965.

PAGE 222: Actor-singer Dick Van Dyke recording *Bye Bye Birdie*, 1960.

ABOVE: Frank Sinatra, left, singer Harry Belafonte, center, and actor Sidney Poitier
at John F. Kennedy's inauguration, Washington D.C., 1961.

ENDPAPERS: Photos from *New York* by Don Hunstein, published in 1962 by Spring
Books/The Hamlyn Publishing Group, Ltd. Used by permission.

10 9 8 7 6 5 4 3 2 1